KARAOKE AROUND THE WORLD

Karaoke Around the World is a book for our times. ... Impressively grounded in solid research, both archival and ethnographical ... a wonderful, thorough, and well-balanced study of the multi-faceted quality of something that is both commodity and technology, culture and music, interactive and self-expressive, local and global. ... This is an excellent book to teach in classes on Japan, global and East Asian popular culture, ethnomusicology, and mass media ... impressive and instructive!

Journal of Japanese Studies

The karaoke machine is much more than an instrument which allows us to be a star for three minutes. The contributors to this lively collection address the importance of karaoke within Japanese culture and its spread to other parts of the world, exploring the influences of karaoke in such different societies as the United Kingdom, North America, Italy, Sweden, Korea and Brazil. They also consider the nature of the karaoke experience, which involves people as singers, co-singers and listeners.

Karaoke Around the World was first published in the 'Routledge Research in Cultural and Media Studies' series, edited by David Morely and James Curran. The publisher and the editors are grateful to David Morely for his contribution to the book's publication.

KARAOKE AROUND THE WORLD

Global technology, local singing

*Edited by Tōru Mitsui
and Shūhei Hosokawa*

London and New York

First published 1998
by Routledge
11 New Fetter Lane, London EC4P 4EE

Simultaneously published in the USA and Canada
by Routledge
29 West 35th Street, New York, NY 10001

First published in paperback 2001

Routledge is an imprint of the Taylor & Francis Group

Typeset in Times by Florencetype Ltd, Stoodleigh, Devon
Printed and bound in Great Britain by
TJ International Ltd, Padstow, Cornwall

British Library Cataloguing in Publication Data
A catalogue record for this book is available from the British Library

Library of Congress Cataloging in Publication Data
Karaoke around the world: global technology, local singing/edited
by Tōru Mitsui and Shūhei Hosokawa.
p. cm. – (Routledge research in cultural and media studies)
Includes bibliographical references and index.
Contents: The genesis of karaoke/Tōru Mitsui
– The effects of karaoke on music in Japan/Hiroshi Ogawa – Karaoke and
middle-aged and older women/Shinobu Oku – The adaptability of karaoke
in the United Kingdom/William H. Kelly – From TV to holidays: karaoke in
Italy/Paolo Prato – Filling voids along the byway: identification and
interpretation in the Swedish forms of karaoke/Johan Fornäs – Singing
in a cultural enclave: karaoke in a Japanese-Brazilian community/Shūhei
Hosokawa – The karaoke dilemma: on the interaction between collectivism
and individualism/Casey Man Kong Lum – Karaoke in East Asia/
Akiko Ōtake and Shūhei Hosokawa.
1. Karaoke – History and criticism. I. Mitsui, Tōru, 1948– .
II. Hosokawa, Shūhei, 1955– . III. Series.
ML3795.K22 1998
306.4'84–dc21 97–19902
 CIP
 MN

ISBN 0–415–16371–4 (hbk)
ISBN 0–415–25854–5 (pbk)

CONTENTS

PART III

FIGURES

TABLES

CONTRIBUTORS

Johan Fornäs is Professor of Media and Communication Studies at Stockholm University, Sweden. His main focus of research is on cultural studies, popular music and youth culture. His books include *Cultural Theory and Late Modernity*, *Youth Culture in Late Modernity* and *In Garageland: Rock, Youth and Modernity*.

Shūhei Hosokawa is Associate Professor of Humanities at Tokyo Institute of Technology. His main interest is in the historiography of Japan's popular music and the culture of the Japanese–Brazilian community. His articles were published in such international journals as *Cultural Studies*, *Semiotica* and *Popular Music*, and his publications in Japanese include *Rhetoric of Walkman* (1981) and *Aesthetics of Recorded Sound* (1990).

William H. Kelly completed his D.Phil. in social anthropology at the University of Oxford in 1998, and now is a postdoctoral research fellow at the University of Manchester. The title of his doctoral thesis is 'Empty Orchestras: An Anthropological Analysis of Karaoke in Japan'.

Casey Man Kong Lum is Associate Professor of Communication and Media Studies at the William Paterson College of New Jersey and is author of *In Search of a Voice: Karaoke and the Construction of Identity in Chinese America*. His teaching and research interests include media ecology, culture and communication, inter-cultural communication, the ethnography of audience reception of media and Asian Pacific American media and culture. His work has also appeared in a number of journals and books.

Tōru Mitsui is Professor of Musicology and English at Kanazawa University, Japan, mainly in charge of popular music studies at the graduate school. He served as the Chair of IASPM (the International Association for the Study of Popular Music) 1993 to 1997. His numerous writings range from *Bluegrass Music* (1967) to *'You are My Sunshine': The Music and Politics of the American South* (1989) and *The Story of Jeans* (1990).

Hiroshi Ogawa is Professor of Mass Communication at Kansai University, Osaka. He has long been interested in the sociology of culture, especially music, and he is the author of *Society Doing Music* (1988) and *Music and Society in the Media Age* (1993).

Shinobu Oku graduated from Tokyo University of Arts, and is now a professor at Wakayama University. Her main research interests are in the field of music education. Her recent papers have been concerned with changes in the 'musicality' of the Japanese people under the impact of Western music. She has had books, papers and articles published in English, French and German as well as in Japanese.

Akiko Ōtake is a writer and essayist. She has worked in various areas such as photography, travelogue and popular culture. Her books include *Dogs on Asphalt, Bali: The Kingdom of the Fantastic, Hunters of Eye: Photographers in Postwar Japan, Transparent Fish: Travelling Through Okinawa* and *Karaoke Crosses Over the Ocean.*

Paolo Prato is a sociologist and essayist. He has worked in areas including mass media, pop music and popular culture. His works include *Travel and Modernity: The Imaginary of Transport Between 1800 and 1900* (1989), *Pop and Rock Dictionary* (1996) and *Black and Soul: The Giants of Afro-American Music* (1995). He has co-edited the 'Italian issue' of *Cultural Studies.*

ACKNOWLEDGEMENTS

We thank all those who were involved in a series of panel discussions and individual papers in the past eight years, from which this book has been developed. We are particularly grateful to JAL (Japan Airlines) Foundation for realizing the last group endeavour by hosting an international forum in Kanazawa, Japan, on 24–25 August 1996. We appreciate the kindness and generosity of JAL Foundation for financially encouraging us to publish this book.

JAL Foundation inaugurated the Asian Forum in 1993 with the aim of researching the 'possibility of creating a transnational community within Asia and Oceania'. Each year leading scholars and university students are invited to participate in the Forum, together with young Japanese. The 1996 Asia Forum titled 'Transnational Popular Culture – Focusing on the Internationalization of Music' was substantially a panel on karaoke around the world, with Kazuko Hohki as the keynote speaker, and Tōru Mitsui, Hiroshi ·Ogawa, Casey Lum, Shūhei Hosokawa, Jingjik Lee and Tony Mitchell as panelists.

The whole forum was organized by Professor Daisaburō Hashizume of the Tokyo Institute of Technology as its moderator, and we express our gratitude to his advocacy of the serious study of karaoke in general and his proposition to plan an international panel.

INTRODUCTION

Tōru Mitsui and Shūhei Hosokawa

Towards an ethnography of everyday singing

Musicological studies of popular music have mostly been concerned with songs rather than singing, and with professional singers and composers rather than non-professionals. The former emphasis is related to the primacy of the written over the aural in musicologist methodology, while the latter derives from aesthetic preferences, and implicitly differentiates and distances the musicologist from the lay audience. Although much has been written about professional singers and composers, musical and verbal forms, and even about the grain of voice of such eminent singers as Elvis Presley and Johnny Rotten, amateur singing – and amateur music-making in general – have been excluded from the traditional perspective of musicology.

There is, however, a branch of musicology and sociology – of music – that has investigated the area outside professional music-making. Yet, both critical theories since Adorno and empirical sociology since Paul Lazersfeld have treated the public audience as no more than habitual consumers and receivers, or as a source of quantitative data. They suppose that people's attitudes and preferences towards music are mere reflections of their social position or of false consciousness cunningly manipulated by the industry.

Ethnomusicologists since Alan Merriam have coped with performing practice and focused on orality, improvisation technique, social setting and musical meaning. The intervention of industry, the capitalistic economy and electric/electronic technology, however, has generally been far from their concern. 'Unplugged', non-industrialized music-making has largely been regarded as the most authentic. Acoustic instruments and musicians who are assumed to be independent of relentless capitalism have been central to ethnomusicological fieldwork (see Béhague 1984).

It is only since the 1980s that a series of works have questioned the conventional practices of the three correlated disciplines and examined music-making from more flexible, more perceptive and more idiosyncratic perspectives. Social history and ethnography are two of the new resources

1

now used to conceive of music as social and cultural practice. Not only symphonic orchestras but also weekend chorus groups and school brass bands contribute to the musical life of an English or American city, with the boundary between professional and amateur musicians as well as between musicians and audience being flexible and negotiable (Finnegan 1989; Livingston *et al.* 1993). Not the Beatles but the unknown Jactars show how the 'Liverpool Sound' is constructed by geography, the class system, the mass media, the local and national music industry and personal life histories (Cohen 1991). By the same token, the rock'n'roll scene in Austin, Texas, keeps on rocking and rolling even after Stevie Ray Vaughan's death, due to the musicians 'who have not reached stardom but who continue to struggle through performance' and the 'fans who identify with that con-stitutional struggle' (Shank 1994: xiii). The astonishing revival and survival of polka in Polish-American and Slovenian-American communities owes much to weekend musicians (Keil *et al.* 1992). By putting the spotlight on 'hidden musicians' living under the surface of professional-oriented institutions, studies such as those mentioned above contribute to the 'de-professionalizing' of the subject matter of music studies.

Many of those studies also examine the relationship of amateur activities to the music industry, and in so doing elaborate the concept of place or site in musical practice. Intimately related with the concept of locality, theories of globalization and colonialization and ethnicity/identity politics have become common, if not obligatory, meeting and passing points for new approaches to contemporary music practice. These theories, however heterogeneous they may be, generally show the interplay of close but asymmetric links between production and consumption, locality and glob-ality, identity and alterability; or to use a phrase by George Lipsitz, 'how interactions among the artists, audiences, and apparatuses collectively create the world of musical production, distribution, and reception' (Lipsitz 1993: x).

Technology obviously intervenes in every facet of these 'interactions' and the collective creation and experience of sounding sites, ranging from a micro-world inside headphone space to Stevie Wonder's globally broad-cast performance at the closing ceremony of the Atlanta Olympic Games 1996, and from dinner music in Katmandu to U2's Zooropa concert at Wembley Stadium. We are not only talking about state-of-the-art equip-ment used by megastars and multinational corporations, but also about regular carbon microphones, monaural tapes and cheap music videos. Welcome to Karaokeland.

Karaoke questions that nobody wanted to ask

The karaoke machine, an electric/electronic apparatus designed especially for amateur 'hidden singers', and the topic of karaoke singing, are the

subject of this volume. Karaoke was born in the early 1970s in Japan and has since spread to many countries around the world: countries in the Pacific Rim, East Asia, North America and Europe. At first glance, this subject appears to be too trivial to be worthy of serious attention. In fact, karaoke has often been condemned as harmful to musical sensibility by music teachers, as a vulgar pastime by social commentators, and as an ephemeral fad by journalists. This volume, however, does not attempt to counter these superficial criticisms by celebrating karaoke as 'democratic', 'pleasurable' or 'musical' – all of which would be equally banal. It is not our intention to exaggerate the cultural status of karaoke ('symbol of the times') or downplay it ('ear paralyser').

Our aim is to situate the triple existence of karaoke, as *technology*, *place* and *musical behaviour*, in its social and cultural context, on the one hand, and to examine the 'journeys' of the karaoke apparatus and its global/local effects, on the other. The karaoke machine is more than just a machine that allows one to be a star for three minutes. It combines at the same time musical technologies, personal experiences and collective memories that go far beyond microphones and pre-recorded accompaniment. Whether karaoke experiences are aesthetically better or worse than other types of musical experiences such as concert-hall listening, garage band rehearsal, MTV viewing or pub singing is not our present concern.

Rather, we will try to discover what underlies karaoke experiences, which involve people as singers, co-singers and listeners, and the cultural meanings produced by the resonance and dissonance between technology, place and behaviour. None of these three elements determines the others. Diverse as they are, contributors to this volume seek to unveil the technological, spatial, communicative, ethnic, national, political, musical and gender aspects of karaoke in specific places and times. We hope that our collaboration will provide satisfying answers to a variety of questions which surround this phenomenon as well as suggesting possible ways of theorizing contemporary music practice. Before plugging in this apparatus, however, it will be helpful to introduce several basic topics related to karoaoke.

A selected survey of karaoke literature

The oldest documentation, though unintentional, of the formal development of karaoke can be found in the newsletter, *Uta* [song], published by the publicity department of Crescent in Kōbe, one of the first karaoke manufacturers. Until the fifth issue dated 15 April 1977, their product was called 'Crescent Juke', reflecting the origin of karaoke equipment in the juke-box. (The first issue was published in January 1976.) An embryonic serious discussion of karaoke was first published in 1979 in a book based on panel discussions on popular music in Japan (Satō *et al.* 1979).

The karaoke phenomenon was probably first covered by the American and European press in 1983, when *Time* magazine reported on the popularity of karaoke as 'Closet Carusos: Japan reinvents the sing-along' (*Time* 1983). A vivid description of a Tokyo karaoke bar was given, fictionally, by David Lodge in his first piece of 'Academic romance' (Lodge 1984; see Chapter 1, p. 31), while the first academic observations on karaoke by an overseas ethnomusicologist appeared in 1984 (Keil 1984). A little later a journalistic report was given in an illustrated book, *Beats of the Heart: Popular Music of the World*, as part of the chapter, 'Sukiyaki and chips: the Japanese sounds of music' (Marre and Charlton 1985). A description of karaoke was presented, in July 1985, at the third conference of IASPM (the International Association for the Study of Popular Music) by Yoshihiko Tokumaru and Linda Fujie, as the first paper on karaoke ever given at an academic conference (Tokumaru and Fujie 1985), although this is not generally known because the proceedings of the conference remain unpublished.

In the same year an issue of *Time* magazine reported the inroads of 'a nifty electronic device from Japan called the *karaoke*' into the US market, giving examples of its use in small churches, the University of Nebraska's Psychiatric Institute and Songmasters' Graceland Recording Studio and Singalong Shop across the street from Elvis Presley's Memphis mansion (Reed 1985). One of the first articles in Britain on karaoke was 'Now karaoke is catching on in Britain', a report by John Peel on a karaoke competition hosted by a Japanese duo, the Frank Chickens (Peel 1987). The fact that 'the oriental art of Karaoke sing-song has reinvented itself to invade the humble British drinker' was discussed in January 1988 in *The Face* (Champion 1988), which was followed the next month by another article in the *New Musical Express* (*NME* 1988). Several months later, in October 1988, the growth of karaoke, 'the Japanese practice (or art) of vicarious stardom through singing with a microphone to the accompaniment of a pre-recorded orchestra', was discussed at a conference of the US branch of IASPM by Ron Riddle (*RPM* 1989: 11–12). Then, in an American local paper, the arrival of karaoke was announced and described: 'many clubs are offering karaoke nights with prizes for the best and, many times, the worst singers' (Parch 1990). Both in Japan and overseas the popular press showed an interest in karaoke out of curiosity until the end of the 1980s.

Probably the first published attempt to search for the origins of karaoke was an article that appeared in a monthly, *Gendai*, by Issei Tomizawa (Tomizawa 1989). It was followed a year later in a more formal way by a chronological history of karaoke in the April 1990 issue of the first karaoke monthly, *Gekkan Karaokefan*, which had been published in Ōsaka since September 1985 (*Gekkan Karaokefan* 1990). In 1989 a similar glossy monthly for karaoke users, *Karaoke Dog*, began publication in Tokyo,

featuring news about popular singing stars and lyrics and music of newly released songs. Across the sea in April 1990 *Monthly Encore* was first published in South Korea as a karaoke monthly.

A further critical discussion of karaoke was attempted by Keizaburō Maruyama in a general magazine, *Bungeishunjū*, late in 1989 (Maruyama 1989), although both this attempt and its expanded version in book form (Maruyama 1991) remained speculative. The first symposium dedicated to karaoke was held in March 1990, in Ōsaka, as the third Kansai-area meeting of JASPM (the Japanese Association for the Study of Popular Music) (which was then being inaugurated) as well as the 38th meeting of the now defunct Association for the Study of Everyday Life and Music. For this event numerous newspaper articles about karaoke in the 1980s were compiled in a privately printed booklet and distributed to participants (Kimura 1990). This interdisciplinary discussion resulted late in the year in a 24-page booklet (Karaoke Symposium 1990). In fact 1990 can be regarded as the real beginning of the scholarly study of karaoke. After the second symposium on karaoke was held in Ōsaka in September, a panel on karaoke was formed as part of the second annual conference of JASPM, at the University of Fine Arts of Tokyo in November 1990, with talks by three of those who had presented papers at the Ōsaka symposium as well as comments on the industry by an executive of Dai'ichi Kōshō, a leading manufacturer of karaoke equipment (JASPM 1991). It is also worth mentioning that in 1990 Richard Middleton expressed an interest in karaoke probably without having personally experienced it (Middleton 1990: 97).

It was at this time that statistics regarding the karaoke industry and its market became available through the first white paper by a karaoke manufacturer (Clarion 1990). A much wider and more detailed coverage of the industry and market was given in a leading music-trade weekly *Confidence* in the same year (1990). Around the same time the first academic thesis on karaoke was submitted for the degree of BA in Australia, which was based upon the author's fieldwork in Tokyo (Macaw 1990). Six months later, in July 1991, on the other side of the globe one more thesis, this time an MA thesis, was submitted in the field of social anthropology at Oxford, and was also partly based on the author's fieldwork in Japan (Kelly 1991). Both well-researched theses were obviously very informative to readers outside Japan. Just after the submission of this MA thesis by an American, a paper on the origin of karaoke was presented at the sixth conference of IASPM, held in Gosen near Berlin, with the presumption that karaoke was then sufficiently recognized internationally not to warrant a basic description of its presentation and adherents (Mitsui 1995). Around the same time some introductory comments on karaoke in English were published as part of *A Guide to Popular Music in Japan* (IASPM–Japan 1991: 25). Then, several months later, another panel on karaoke was held at the third annual conference of JASPM: 'Technology and music

– karaoke spreading beyond Japan' (JASPM 1992; Mitsui 1992). Meanwhile, across the ocean in Chicago a paper on karaoke, 'Issues of stardom, authorship and identity in karaoke', was presented, on 12 October 1991, at a conference of the US branch of IASPM by Robert Drew, who was doing research on karaoke in Philadelphia for a doctoral dissertation in communications (Drew 1994).

In the same year, 1991, while an article in a Nashville newspaper reported on karaoke clubs for Japanese executives in New York (Fanning 1991), *Billboard* magazine reported that Nikkōdō 'has turned to Music City musicians, producers, and studios to create a steady flow of software for its karaoke (sing-along) equipment', and that prior to opening its Nashville office it had donated a karaoke system to the Country Music Hall of Fame (Morris 1991). Then *Variety* reported on the promotion of karaoke hardware and software in the United States not only by Nikkōdō but also Dai'ichi Kōshō, Pioneer, JVC and Sony, noting that 'currently there are about 10,000 taverns, clubs and discos in the US featuring karaoke' (Coopman 1991). Nikkōdō's introduction of karaoke in Nashville resulted in a discussion of karaoke as the new mediator of oral tradition in the South (Cusic 1991). It was also in 1991 that the word karaoke appeared in the *Oxford Dictionary of New Words*. Later in the year in the UK, the *Observer* ran an advertisement for 'home karaoke machine[s]' in its weekly colour magazine: 'Please order early for Christmas delivery' (*Observer* 1991).

The year 1992 began with the submission of an MEd thesis on karaoke at Kōbe University, with the title, 'On the change of musical experience depending on technology: a study of karaoke singing in everyday life' (Makita 1992; author's translation). From early May to late June *Yomiuri Shimbun*, a leading national paper in Japan, published a series of articles on karaoke, trying to cover as many aspects as possible, ranging from its origin to academic studies (*Yomiuri* 1992), after which a detailed history of the karaoke 'box' was given by a sociologist (Satō 1992) and revised a year later (Satō 1993). On 25 July 1992, the first international symposium on poor pitch sense in singers was held in Nagoya, Japan, where two papers dealt with karaoke singing as a source of embarrassment (Murao 1994; Walker 1994). The same year also saw the publication of a psychological paper on karaoke entitled 'The effect of karaoke on behaviour: an examination by personality and the evaluation of singing ability' (Niimi 1992; author's translation). In the meantime, the new edition of *Worlds of Music: An Introduction to the Music of the World's Peoples* included a chapter on Japan, in which Linda Fujie discussed karaoke in association with *enka* (Fujie 1992: 366–9).

Then, in 1993 a Finnish ethnomusicological journal, *Musiikin Suunta*, published a special issue on karaoke, reviewing karaoke bars in Tampere and giving the early history of karaoke in Finland (*Musiikin Suunta* 1993).

In São Paulo Shūhei Hosokawa's article on karaoke singing among Japanese-Brazilians was published in Portuguese (Hosokawa 1993). Karaoke's influence in Germany was discussed in the same month, June, in a paper which dealt with its role as a disseminator of folksongs, presented at the 23rd International Ballad Conference of the Kommission für Volksdichtung held in Los Angeles (Wienker-Piepho 1993). Less than three weeks later, on 11 July, an international session on karaoke was organized by Tōru Mitsui at the 7th conference of IASPM in Stockton, California, with Hiroshi Ogawa, William Kelly, Heather Macaw, Shūhei Hosokawa and Robert Drew as speakers on 'Karaoke throughout the world' (IASPM 1995), while one more paper on karaoke was presented independently at the same conference (Fornäs 1993). It was coincidental that the July issue of a Japanese monthly *Gendai-no Esprit* featured video games and karaoke, with seven articles on some aspects of present-day karaoke (*Gendai-no Esprit* 1993). Around the same time a New York weekly published a feature story about a romance arising through karaoke singing (O'Malley 1993). In October a journalistic account of the emergence of karaoke was published as a book (Asakura 1993), while an amusement-trade monthly in English focused on karaoke (*Japan Amusement Monthly* 1993). October also saw a paper on karaoke presented at an annual conference of the American Folklore Society held in Eugene, Oregon, in which karaoke was discussed as an indicator of significant changes in the nature of entertainment and tradition (Nichols 1993). Then in November the first book ever written in English on karaoke was published in Oakland, California, *Karaoke: The Bible*, which is 'Everything you need to know about karaoke, including the history, software, hardware, commercial shows, and future of karaoke' (Gonda 1993).

Meanwhile, a report was given in Canada on the use of karaoke at a hospital in Toronto to encourage client participation with music by a nurse manager and a nurse scientist (Maveley and Mitchell 1994). Then an interesting discussion of karaoke by Johan Fornäs, entitled 'Karaoke: subjectivity, play and interactive media', was published in the first issue of a new journal of communication research in Nordic countries, *Nordicom* (Fornäs 1994). In another European country, 'Kouta and karaoke in modern Japan: a blurring of the distinction between *Umgangsmusik* and *Darbietungsmusik*', an article based on a rather simplistic dichotomy between Western 'modernization' and a 'non-Western musical culture', was published in April (Hesselink 1994). Later in 1994 *TDR* (*The Drama Review*) published an article which discussed karaoke in Asian-American communities in the greater Los Angeles area: '"I want the microphone": mass mediation and agency in Asian-American popular music' (Wong 1994).

A Japanese entertainment-trade journal in English, *Japan Amusement Monthly*, ran a series of articles, interviews, statistics and advertisements concerning karaoke in 1995, giving a kind of unofficial white paper of the

karaoke industry ('Consider Karaoke' 1995). Hosokawa's study of karaoke among Japanese-Brazilians, the first glimpse of which was given at the session in Stockton, California, in July 1993, was published as part of his book on music among Japanese-Brazilians in September 1995 (Hosokawa 1995). At the same time an American anthropological PhD dissertation on *enka* discussed karaoke with which *enka* is closely linked (Yano 1995). In the next year a monthly, *Tonchi*, gave a series of reports on karaoke in several countries in Asia by Akiko Ōtake (Ōtake 1995), which was revised and enlarged as a book in 1997 (Ōtake 1997). Meanwhile, in January 1996, a book on karaoke written by Casey Lum was published in America, which discussed 'Karaoke and the construction of identity in Chinese America' (Lum 1996). Lum was invited along with Shūhei Hosokawa, Hiroshi Ogawa and Tony Mitchell (from Sydney) to speak at the JAL Asian Forum held in Kanazawa on 24 August 1996. The forum, which was coordinated by Tōru Mitsui and chaired by Daisaburō Hashizume, was to a large extent a panel on karaoke in different countries. The latest academic publication is 'Embracing the role of amateur: how karaoke bar patrons become regular performers' by Robert Drew (Drew 1997), while in Honolulu another entertainment book in English, *Karaoke: Sing Along Guide to Fun and Confidence*, was published in late 1996 (Shirai 1996).

Singing digitally

Present-day karaoke equipment consists of five functional parts:

1 Sound source (analogue tape, laser disc or compact disc).
2 Visual source (video tape or laser disc).
3 Microphone (wired or wireless).
4 Sound and visual distribution (from manual operation to telecommunication).
5 Accessories (echo chamber, automatic scoring system, etc.).

These five functions are necessarily correlated with each other. (For a discussion on early technical attempts, see Tōru Mitsui, Chapter 1 in this volume.)

Visual karaoke first appeared in 1982 when Pioneer put 'Laser Karaoke' on the market. This was a laser disc (LD) which contained some twenty songs, and was followed in the next year by similar LDs by Victor and Matsushita. Then in 1984, simultaneously with the release of the first CDs, Sony began to market CD karaoke. Soon this format, which was also digital, was incorporated into karaoke machines because of its facility for instant song selection as well as much better sound quality. The fact that digital source quality cannot deteriorate was significant for karaoke operators,

who were annoyed by the tape noise caused by repeated use. A spin-off of CD called CD graphics (CD-G), that is, digital sound plus non-animated image, was released in 1985 or 1986. Owing to LD's better visual quality, although it still involved time-consuming image-editing and song-selection processes, machines which were good both for CD graphics and LD were used until the end of the 1980s. Commonly called 'Super Impose', they displayed lyrics recorded on such formats as CD-G, CD-ROM and Memory Disk in sync with images transmitted from a different set of playback equipment. Unlike an LD system (sound–words–image unit), this system enables image data to be independent of sound-and-words data. It quickens the release of new songs on karaoke format and saves the cost of image production. It is now used for every telecom karaoke.

CD graphics was not, however, the first karaoke product with a visual component. October 1992 saw the release of a new product by JVC Victor called Digital Vision (DV), one 12-inch CD with 57 minutes of sound and dynamic image. The visual quality was not as good as LD, but the size was smaller for the convenience of small bars and clubs, who welcomed it.

The latest generation of karaoke technology is telecom or cable karaoke, which appeared on the market in 1992 (Taitō's X-20000) and soon captured public and business attention. Now each singer requests his/her favourite song and sings along with the audiovisual track transmitted through a telecommunication network. This system solves the problem of the absence of the latest pop songs from the songbook by adding thirty or forty hit songs to the repertoire each month. Teenagers are, in fact, so demanding about catching up with the latest fad that they cannot wait for the laser disc, which is usually released a few months after the hottest chart-oriented songs have come out.

The disadvantages of telecom karaoke, however, are inferior sound quality due to limited capacity for actual ISDN (Integrated Service Digital Network) cable, and uniformity of image, since visual video images are made not for each song as on a laser disc but, rather, for each mood. The same image of a sad-faced girl strolling on a beach, for example, is used for many romantic tunes. A recent model has several hundred images classified into two dozen categories such as 'Teen romance', 'Twenties romance', 'Adult romance', 'Wedding', 'Revolt', 'Languishing', 'Dream', 'Outsider', 'Bad boys', 'Comic', 'Dancing', 'Sexy' and 'Winter', among others, that are available for users. Sometimes the image automatically selected has little to do with the lyrics or is repeated for two songs with similar 'mood'. To avoid such problems, newer models have more sophisticated devices for image selection. The audience can sometimes 'zap' the images, just as they do on their televisions at home.

The relationship between song and image on the one hand (technological level), and between singing and image, on the other hand (behaviour level), has completely changed. 'Virtual reality' karaoke, for

example, allows singers to watch themselves singing on a monitor with specific backdrops which they can choose by touching icons. It is not important for us whether this device is actually related to 'virtual reality'. What should be stressed is that any technological trend is likely to be applied to karaoke equipment in Japan. The karaoke industry is big enough to invest in new technology, and the desire of consumers to sing in new settings is so insatiable that the manufacturers have strong incentives for further R&D research. Because of the Japanese national obsession with singing along with technology, karaoke reflects the technological *status quo* of consumer culture.

Compared to sound and visual sources, the microphone has undergone fewer changes, with greater durability and the dominance of wireless equipment as the main improvements. Yet some new models have accessories such as choral effects, in which one voice can produce as many as five harmony parts, and correction devices which regulate off-key intervals. It is anticipated that, ultimately, a machine might have vocal metamorphosis effects or change of timbre at command, providing, say, Sinatra-like vocal quality for 'My Way' and Madonna-like quality for 'Like a Virgin'.

To sum up, there are principally two types of equipment used in Japan in 1997: telecom karaoke and LD/CD karaoke. Kei'ichi Shioya, the chief of Dai'ichi Kōshō's Technological Development Section says:

> Each has its own unique set of advantages. Package media products [LD/CD] are already well accepted by the night-club market, and there are quite a few karaoke boxes that still swear by them. Furthermore, as yet, you do not get the large numbers of video images and backdrops that are a given with package media products.
>
> There is also a generational factor, as systems like the DAM [Dai'ichi Kōshō's telecom system] will not be readily accepted in those clubs and bars where most of the clientele is older people. In these locations, package systems will continue to thrive. Also, bars and clubs which emphasize providing their karaoke customers with extra service will want to have both package and non-package media on hand to give the clientele the widest possible song selection.
>
> On the other hand, night-clubs that are frequented by younger office workers have found DAM to be most useful. The moral of the story is that two differing media will be used in those operations best suited to one or the other [*sic*].
>
> (Ikuo Arachi, *Japan Amusement Monthly*, 1995: 71)

In October 1995, the home-use telecom karaoke, X-55, was released by Taitō (*Quark*, April 1996). The hardware costs about ¥65,000 (US$650) and its users are required to pay ¥1,500 per month and ¥30 per song. It

is not as expensive as using a karaoke box. Other manufacturers marketed similar types of equipment in 1996 and the home-users of karaoke are broadly separated into two categories: the older ones for LD/CD and the young for telecom.

Micro-Jack-in-the-box

As important as the evolution of hardware technology is the invention of a new type of karaoke space, known as the 'karaoke box'. As Ogawa explains in Chapter 2, the karaoke box is a compartment provided with a karaoke system and with a capacity for five to ten people. It is said that the earliest 'boxes' appeared for the first time in 1985 on a vacant lot on Okayama as converted large trucks (see *Sankei-shimbun*, 16 July 1994; in Taiwan, however, there had been small-cell karaoke spaces before 1985). The privatization of Japan National Railways in 1987 led to the disposal of a large number of used containers, which were recycled as karaoke boxes. The misleading name of 'box' may derive from this origin. Those earliest boxes were placed on the outskirts of a city and customers had to drive there. The homely decorated containers functioned as a substitute for tiny living rooms in Japanese houses. Similar compartments or small rooms for karaoke singing have appeared, since 1988, in leisure places such as game centres, bowling alleys and in buildings in urban areas, which house a number of independent business concerns. In 1991 the number of indoor 'boxes' surpassed that of outdoor 'boxes' (converted containers), and today container karaoke has almost disappeared while entertainment areas in Japanese metropolises are flooded with tall buildings which are equipped with only karaoke 'boxes' where several hundred people sing and enjoy different songs at the same time. *Pia*'s annual karaoke map, or a 'Yellow Page of Karaoke', mainly used by party organizers, list hundreds of karaoke places in the Tokyo area along with their pictures, advantages, prices and users', and owners' comments on them.

The diffusion of the indoor karaoke box had immediate effects both on the industry and on users. On the industry side, it facilitated the central control system which was later connected to telecommunication networks. For customers it opened the market to female and young consumers who were reluctant to go to karaoke bars dominated by middle-aged men. With the increase of karaoke boxes, the daytime market has become significant with the influx of new kinds of customers (see Oku, Chapter 3 in this volume). The dissociation of singing from alcohol has been an important consequence of the spread of karaoke boxes, since traditionally no non-professional singer would dare to sing in public completely sober. In other words, the karaoke box gave birth to 'sober' singers and this has greatly expanded the karaoke market. The gross income of the karaoke industry has doubled since 1986 (¥200 billion, roughly US$2

billion) to 1991 (¥400 billion), and doubled again (tripled in dollar basis) in 1995 (¥1 trillion). The female and youth market was undoubtedly the driving force behind this extensive industrial development.

In 1989, while the number of karaoke boxes was drastically increasing all over Japan, two crimes involving minors took place in karaoke boxes: one concerned rape and the other the death of a schoolboy from alcohol shock. In the latter case, the person who sold the lethal beverage to a group of minors and the owner of the karaoke box in question were arrested shortly afterwards. Similar cases followed these, causing the police to regard the karaoke box as 'a hotbed of delinquency', associated with sexual crimes and drug peddling. In many prefectures, new regulations were imposed, or existing ones amended, to keep the karaoke box safe and respectable. Limited admittance for minors was one measure taken. Another measure was to add a window through which the inside can be seen from outside. Fukuoka, a southern city, for example, established a code which requires the window to be larger than one-twentieth of the floor space, while Hyōgo Prefecture, whose laws are restrictive against karaoke boxes, stipulates that the window should be larger than 25 cm × 120 cm and that there should be no obstacles, such as curtains, to obstruct a view of the inside (Nagai 1993: 131ff). This surveillance device not only guarantees the propriety of social conduct in the enclosed space but also differentiates the karaoke box from 'private bathrooms' used for sexual services which obviously do not have such windows. Under the excuse of 'protection of youth from a harmful environment', the karaoke box has been put under stricter police control than the prostitution establishment. Nagai's research on the surveillance of enclosed space is unique in the karaoke literature because it reviews not the singing itself but how the spaces created for singing result in social conflicts. As Ōtake and Hosokawa will show in Chapter 9 in this volume, the karaoke box in other countries throughout East Asia faces similar issues.

Mimesis and identity

The first music scholar to investigate the karaoke phenomenon was not Japanese, but an American ethnomusicologist, Charles Keil, who visited Japan in the summer of 1980 and published an impressionistic but insightful piece called 'Music mediated and live in Japan' (1984; 1994). He discusses karaoke as one of four examples of the simultaneous use of recorded sound and live performance in public that he observed in Japan. What struck him in mediated-and-live performance was 'the humanizing or, better still, the *personalization of mechanical processes*. Japanese are not afraid to match themselves against the perfection and strictures of pre-recorded accompaniment or to match their own voices to bright star models in public' (1994: 253; our emphasis).

Keil was also impressed by the impassioned expressions of singers as they hold the microphone, charging it with their emotions. What this ethno-musicologist found so surprising can be seen today in America as well. Americans also seem to be happy to imbue the microphone with emotion and to try to match themselves against the perfection of pre-recorded sound. Have they been Japanized, or is this simply a matter of a certain practice of mediated-and-live performance being diffused around the world? Keil's remark that Japanese karaoke singers 'match their own voices against bright star models in public' should perhaps be modified to include Americans as well. Like the hundreds of Frank Sinatras and John Denvers in American karaoke bars, most Japanese are aware of the futility of matching themselves against singing star models. If Japanese singers appear to be imitating leading singers, it is partly because they are obliged to do so in the social space of the karaoke bar. As Ogawa explains in Chapter 2 in this volume, the implicit rules that govern this space require customers to perform with enthusiasm, regardless of their singing ability, and mimetic overacting appeals not only to narcissistic karaoke singers themselves, but also to their supportive audience. A reluctant singer is much more disliked in such a place than those whose singing ability is relatively inferior.

Another reason for imitation in karaoke singing might be the so-called *mochiuta* [repertoire] system, that is, the rule that a song that is closely associated with a particular recording artist cannot be covered by other artists, as if this singer had an exclusive right to sing it. This unwritten rule evolved in the 1930s when such major record companies as Victor, Columbia and Polydor started to operate 'song assembly lines', which included exclusive contracts with composers, lyricists, arrangers and singers, in order to dominate the music industry. Each record company set up its own music publisher and was aligned with a particular film company, producing many hit songs through the appearances of singers in films. Through such consolidated management, the monopolization of a song by a particular singer was taken for granted by both the industry and the public. (Foreign songs, which were generally called 'jazz songs' at that time, were exceptions.) It was in the 1960s that the system of exclusive contracts became outdated and in the 1970s singer–songwriters, charac-terized by newer idioms, made inroads into the popular music scene, with rock/pop artists virtually abolishing the rule thereafter.

Generally speaking, a Japanese amateur singer tends to identify himself or herself, when singing a certain song, with the professional singer who recorded it first. This tendency is quintessentially exemplified by a long-standing amateur show, broadcast by NHK, called *Amateur Singing Contest*. It is no wonder that many karaoke users, especially elderly ones, try to emulate the original singer as the one and only model. 'Express your own feeling', suggest the authors of many teach-yourself singing

books, but how? Although the imitative practice of Japanese karaoke singers is less concerned with conformism than with 'an assertion of individualism, skill, and personal competence before others' (Keil 1994: 253), the singer cannot escape from the compulsory model set by a pre-recorded accompaniment. This is truer in the case of singers in karaoke bars than young users of karaoke 'boxes'.

The behaviour of Japanese singers is conditioned to some degree by the way their favourite songs were produced, that is, through the aforementioned assembly line. Quoting Ruth Benedict on a Zen episode of Japanese expertness in reproducing the picture one has in mind by single, 'one-pointed' action, Keil concludes that this 'principle of perfect mimesis, the execution of image in action . . . could be a theme connecting musical mediated-and-live practices to the well-known ascendancy of Japanese factory production and technical achievements' (1994: 254).

The imitation of a model singer can also be observed in American mass media in the form of standardized shows. This trend began in the radio era, as seen in the Carmen Miranda impersonator depicted in Woody Allen's film *Radio Days*, but it is television that has expanded it into a widely received phenomenon. There are Elvis Presleys, Tom Joneses, Edith Piafs and Julio Iglesiases all over the world. Television shows, being visually oriented, focus more on the outer appearance of participants – their hairdo, costume, gesture, and so on – than on singing. Japan had a similar show called *Sokkuri Show* [Look-alike show] in the 1960s, but it only lasted for five years. Since the 1970s several female singers have emerged from TV singing contests for children (aged up to the low teens). Some of them, such as Momoe Yamaguchi, actually became top show business stars as well as symbols of the times.

The personalization of technology

Takumi Satō, a sociologist, in his social history of the karaoke box, explains how an electrically mediated voice produces different effects on the Japanese:

> It is true that karaoke, even a karaoke box, appears to be a means and apparatus for recovering interpersonal communication, in that communal singing is the purpose for which it is used. What is significant, however, is not that people get together and sing, but that singing is mediated by machine and filtered through the indispensable microphone. Here is a crystalisation of communication in contemporary Japanese society. The contemporary Japanese sensibility that finds Eros in the fusion of a live voice and a microphone-mediated machine sound is fundamentally different from the European type of mass identity, similar to that at the *utagoe*

movement [socialist mass singing movement in the late 1950s and early 1960s], which finds pleasure in collective live singing.

(1992: 118–19; see also 1993: 109)

Though Satō does not make it clear why the Japanese in particular are attached to a 'mechanical voice whereas "Europeans" have more empathy with "collective live voices"', his remark might give us a clue to understanding how modes of communication differ between Western and Japanese (and other Asian) karaoke-bar customers.

The pleasure of karaoke singing lies, as is noted by Johan Fornäs in Chapter 6 in this volume, in the experience of listening to one's own voice coming from an electronic apparatus. This self-reflective experience is what Satō calls the Eros that arises from the voice fused with electronically treated sound.

The technology issue is pursued further by Fornäs, whose chapter leads to a discussion of subjectivity, with Derridean deconstruction of the singing voice resonating with the self-body. His notion of a 'disappearing act' or of 'filling the gaps' in one's multiple identities is especially revealing if we ask why karaoke *aficionados* indulge in 'the intensified vacillation between self-forgetting involvement and self-mirroring, self-objectifying reflexivity'.

The blend of pre-recorded sound and live performance itself is not new in Japan. It can be traced back to 1933. The popular hit song 'Tokyo Ondo' [*ondo* is a traditional round-dance], set off an unprecedented craze all over Japan, and also in some Japanese colonial territories. Crowds of people danced it in open spaces, circling around a combination of record-player and live drumming performed in the centre of the circle. This type of dancing, with record-plus-live accompaniment, often using 'Tokyo Ondo' is still very common in Japan during the O-bon festival; Keil witnessed a similar performance half a century later. A recording alone can be used for dancing, but the drumming beat in a record is often reinforced by a team of *taiko* players. Unlike the spectacular *taiko* ensembles that are now internationally known, *ondo* players do not show off their technique, but modestly add snaps and accents to the recorded sound. This is not 'music-minus-one' but a music-plus-one performance.

What is remarkable about 'Tokyo Ondo' is that its mediated-and-live form has evolved no further in Japan over fifty years in spite of the ever-increasing sophistication of the technology used in song factories. 'Tokyo Ondo' has been frozen for decades because it has been ideologically tied to summer folk festivals and visually characterized by *yukata*, a summer kimono, worn by the majority of participants, and *uchiwa*, a traditional bamboo and paper fan. The dance represents 'old Japan'. This 50-year-old mediated-and-live practice belongs to the 'old' face of the national culture. In contrast, as mentioned above, karaoke has continuously kept pace with new technological developments.

Possessed by a microphone: karaoke discourses in Japan

The numerous publications in Japan related to karaoke show the depth of the country's obsession with machine-accompanied singing. There are at least three monthly magazines targeted at middle-aged amateur singers of *enka* (*Karaoke Taishō, Karaokefan* and *Karaoke Journal*) and one for elderly people (*Hatsuratsu*). They include not only the words and music to new and old songs, together with practical suggestions for singing, and letters from readers (indispensable pages for regular subscribers), but also such miscellaneous pieces of extravagant information as karaoke gymnastics (for correct breathing), karaoke cooking (for proper vocalizing), karaoke fortune-telling (for romantic encounters) and karaoke comics (for self-caricaturization).

In addition to these karaoke periodicals, karaoke sections are an indispensable part of many general magazines. *Zappy*, a pop music magazine launched in March 1997, is supplemented by a 30-minute CD with the 'hooks' of more than 60 songs, which are processed by a 'sound navigator' (a phrase which sounds more fashionable to pop fans than 'disc jockey'). The songs recorded are correlated to 'New Single Selection' pages, in which readers find musical information on each tune, including 'key', 'rhythm', 'tone range' and 'modulation'. The lyrics of some songs ('the *must* titles of this month') are published with pinpoint pieces of editorial advice added on lyric lines, such as 'Here you relax' and 'Powerful shout'. Moreover, readers are not only informed of which telecom karaoke network(s) the songs are on, but can also be provided with lyric sheets through paid fax services. As many new songs are used as the theme songs of TV shows and TV commercials, many readers are already familiar with the melodies and can sing them as soon as they are put on the networks. This shows how karaoke is now situated in the midst of the whole organization of the music industry.

A sense of the Japanese national obsession with karaoke is given when one watches a show on NHK Satellite TV, *Karaoke Dōjō* (*dōjō* was originally a training hall for traditional martial arts). This is a two-hour show, which involves public participation and is broadcast from various cities and towns. Local winners are invited to take part in an annual national round held in Tokyo. All the judges are known composers and lyricists, and the champion of each year's national round is given a chance to sign with a record company (the 1997 champion, however, prefers to work for her family's fish shop).

When the Japanese talk about the world-wide spread of karaoke, they often emphasize the 'made-in-Japan-ness' of this machine. It has become a national symbol as well as a favourite topic of daily conversation.

Generally speaking, discourse on karaoke is written for the public at large and can be classified into five categories:

16

1 Technical discourse.
2 Fitness discourse.
3 Socialization discourse.
4 Culturalist discourse.
5 Religious discourse.

Technical discourse

A major part of karaoke discourse centres on vocal training, including lessons based on a special notation system (for breath, vibrato, falsetto and other vocal techniques), 'abdominal breathing' (a crucial technique to improve singing), and the appropriate way of using the microphone. Each writer has a preferred method for learners to achieve the proper vocal technique: putting chopsticks inside your mouth while singing to make sure that you are properly vibrating your larynx or watching yourself in a mirror to adjust your posture and the shape of your mouth.

This type of discourse usually begins with a statement to the effect that nobody is 'tone-deaf', or that tone-deafness is not something one is born with. Obviously good singers, or those who believe they are, need not read it. As Naoki Ueno, who runs his own singing schools in Tokyo, writes:

> A voice is not innate. It should be disciplined. Whether it is a 'good voice' or a 'hard-to hear voice' depends upon how it is trained. A person with a bad voice was not born with it, but came to have it. You can make your face and style look better. Similarly, you can 'improve' your voice.
>
> (1996: 7)

Encouraging readers to sing with self-confidence seems more important than vocal training itself.

Fitness discourse

The practice of singing is sometimes recommended as physical training. Tomo'o Fukuda, who runs his own clinic and is the chairperson of the Yokohama branch of the All-Japan Association of Amateur Singers, recommends karaoke for mental and physical health (1996). It brings both 'tension' (arising when one shows off in public) and 'relaxation'; it has an aphrodisiac effect when the singer imagines what is being sung in the lyrics; it strengthens the lungs and stomach; singing ten songs is physically equivalent to running one kilometre; correct breathing is spiritually good because it is similar to Zen breathing. This doctor lists the diseases karaoke can alleviate such as: insomnia, stomach ulcers, hypertension, cardiac malfunction, sexual impotence, frigidity, menopausal problems, senility,

Alzheimer's disease, asthma, cold, rheumatism, headache, baldness and others.

According to Fukuda, singing stimulates the brain, the lungs, the intestines and even the genital organs. Furthermore, he points out that short periods of daily training are better than long but occasional periods of training and that to have a few special favourite songs is better than to sing many different tunes without being aware of the quality of one's own voice. For the aged, a romantic duet may help to rejuvenate their half-lost sexual desire; and singing from memory, without looking at the lyrics, is effective in maintaining the memory function of the brain. Of course, one should not smoke or drink too much during a singing session. Health is one of the main concerns of the Japanese, as is reflected in the publication of innumerable books on diet and exercise, and many readers' letters in karaoke magazines show how they use karaoke singing for health. Some sing after casual exercise, while others sing before going out jogging.

Socialization discourse

Another group of writings is concerned with how one should behave in karaoke space. By making implicit rules in karaoke bars explicit, this body of journalism aims at establishing a civilized space and polite human relationships. According to a book entitled *Book for Singing Karaoke Much Better* by Naoki Ueno (1993), one should respect the rules of passing on the microphone, one should listen to the singing of other customers, and not sing too well, too long, too pretentiously, too emotionally, or too bashfully.

In addition to knowing how to sing well, how to socialize in karaoke space is a serious concern for users. For example, Keizaburō Maruyama proposes seven taboos in karaoke:

1 Do not sing when you are drunk.
2 Do not sing too loudly.
3 Do not abuse the echo effect too much.
4 Do not monopolize the microphone.
5 Do not sing songs written for the opposite sex unless you want to surprise the audience.
6 Do not sing songs composed by very gifted writers (because they are usually too difficult for lay persons).
7 Do not be too narcissistic.

(1991: 51–7)

Variants of these Seven Commandments are often found in karaoke paperbacks and journals (see Ueno 1993: Part 1; *Suntory Quarterly* 1992: no 40, 63–9). Taboos are also expressed in indirect ways as can be seen in

the personal reports and letters, in karaoke periodicals, of annoying experiences in karaoke bars and boxes. For example *Suntory Quarterly* (no 40, 1992), a publicity magazine published by a major drinks company, sent out a questionnaire to 100 owners of karaoke bars, who are all women and are usually called 'mama-san', in respectable areas of Tokyo and Ōsaka, asking about their customers' desirable and undesirable behaviour. In other words, 'mama-san' is in charge of the behaviour of half-drunken clientele who wish to be her favourite customers.

What purposes do these rules serve? Apparently they serve to regulate politeness in public space. The 'don'ts' in Japanese karaoke are valued for maintaining social gender hierarchies. This preservation of discipline distinguishes the karaoke space from a place of unrestrained play.

In karaoke boxes customers are certainly freer from behavioural rules than in karaoke bars. One can even interrupt when other customers are singing and the passing on of the microphone is less formal. Nowadays high-school students not only sing songs one after another, but also use the boxes for playing games and/or dancing. These young users generally avoid slow ballads and old-fashioned songs. How to seduce members of the opposite sex is another popular theme. Many pop journals talk about romantic and/or sexual affinity with reference to musical taste, fashion trends, style and appearance, horoscopes and other relevant factors, recommending readers which songs to choose in romantic situations. The behaviour code for young users is growing more relaxed, but has not disappeared completely.

Culturalist discourse

This category denotes discourse concerning such questions as why humans sing and why the Japanese like karaoke. An example is *Hito-wa naze utau-noka* [Why do humans sing?] by Keizaburō Maruyama, a linguistic philosopher and a karaoke enthusiast. Singing is, according to him, as deeply instinctive as it is uniquely human. Assisted by Freudian theory, Maruyama conceives of singing as severely repressed in the same way as 'Desire'. For him, the libidinous pulse of singing makes us aware of our humanity. By this reasoning, the author justifies the cultural and human status of karaoke in terms of 'the use of uselessness'. His argument, based on his preference for karaoke bars, has, however, been criticized by younger sociologists who support the form of socialization represented by the karaoke box. As to why the Japanese are obsessed with karaoke, it is often noted, by Maruyama as well as others, that the Japanese are by nature fond of singing, but this explanation is questionable when one considers how many other nationalities also love singing.

Insisting that karaoke is a uniquely Japanese combination of space and technology for singing, cultural discourse writers try to link this new device

with an old tradition. These 'karaoke-centrists', who contend that karaoke is deeply rooted in the Japanese tradition of singing, ignore, or at least underrate, many other ways of singing both in and outside of Japan. The question is not whether the Japanese like singing more than other nationalities or not, but why karaoke leads to such speculation. One of the reasons is that these pro-karaoke writers need to defend their karaoke experience from anti-karaoke intellectuals who condemn it as phoney, noisy and vulgar. To sing – even along with a mechanical device – is to uncover an ancient tradition within modern life. As noted above, karaoke not only prompted the Japanese to sing, but also brought an old tradition of singing to the surface. Karaoke therefore has altered the discursive form of singing in Japanese popular culture by associating it with old Japan.

Religious discourse

Situated between culturalist discourse and fitness discourse, we find a special type of karaoke discourse, which evokes the image of the shaman in karaoke singing. The poet Mikio Sasaki considers the microphone as a 'medium for transmitting magical power' (*Nihon Keizai Shimbun*, 13 April 1990). Karaoke, he believes, is one of the deities (*kami*) in the animist tradition in Japan, in which every natural object can be sacred. Karaoke provides, according to him, a new way of purifying one's soul through the voice. The purification or exorcising of one's guilt by praying, making an offering or other means underlies Japanese vernacular religion and the Japanese sense of sacredness. For this poet, the function of the microphone is similar to that of sacred objects such as *gohei*, paper streamers attached to a wand held by folk magicians and shamans in Japanese vernacular religion. Karaoke is a means of restoring the magical power of the voice that has been lost in contemporary fast-paced life. Awakened by the primordial thrill of voicing, people become sensitive again to the 'feel of words', the essence of poetry–prayer. He explains the reasons why singers in a karaoke box are eager to grab and possess the microphone, as if in a religious ceremony: the magician does not eliminate sin (impurity) by the act of purification but transfers it to another person or to another object. By taking turns to sing, karaoke users transfer their guilt to others. The guilt formerly associated with religion might be seen as corresponding to stress in modern daily life. Extrapolating from Sasaki's 'purity-and-danger' theory, one might argue that the sense of community is based on the shared feeling of stress in our 'information society'. This theory echoes the fitness discourse to some extent. Karaoke singing is, so to speak, a zero-sum game of stress exchange. Who, then, can stop the game?

Making money with karaoke

In the world of karaoke, technology and industry go hand in hand. Except for the earliest ones, each innovation mentioned above was realized on a corporate basis and motivated and boosted by the saturation of an established market. According to *Japan Amusement Monthly*, the karaoke business today 'sees annual sales in the ¥1 trillion (US$10 billion) range' (January 1995: 67). If this is true, the size of the karaoke industry is approximately one-third that of the record industry in terms of turnover (on the international record industry, see Negus 1992 and Burnett 1996).

The karaoke market is roughly divided into the 'day' market, which is supported by housewives, high-school students and lunch-time users, and the 'night' market. Another market division is based on places: bars and clubs, boxes, restaurants and homes. Each corporation has its own strategies for each of these sub-markets.

The largest portion of the karaoke industry is hardware leasing. The purchase pattern of karaoke sets differs from that of other kinds of domestic audiovisual equipment. Unlike VCR or stereo users, who usually buy or rent video tapes, cassette tapes or compact discs one by one, karaoke purchasers invariably buy not only a machine but also ten or more packaged laser discs with a beautiful wordbook even if the number of their favourite songs is limited. Karaoke hardware and software are thus inseparably associated.

Thus, the hardware manufacturers or their subsidiaries produce software as well. In the case of telecom karaoke, this is inevitable since a telecom system by necessity has a built-in song library. Meanwhile, multinational corporations such as Sony, Thorn-EMI, Philips and Matsushita-MCA also make a profit from domestic electronics. However, the production lines of these giants go beyond audiovisual devices, to cover shavers, lamps, vacuum cleaners and other products. Karaoke manufacturers, on the other hand, are oriented towards more specific machinery and places.

Meanwhile, copyright accounts for a significant part of the karaoke industry. Some 11 per cent (¥8.3 billion, which is about US$80 million) of total fees (¥78.7 billion, about US$780 million) collected by JASRAC (Japan Society for the Rights of Authors, Composers, and Publishers) came from karaoke in 1994. Karaoke accounts for 63 per cent of performance-based collection fees (¥13.2 billion, about US$130 million), which is five times larger than the amount from concerts and three times larger than that of background music in public places (*Karaoke Journal*, July 1995: 18–19). It is also eight times larger than the fee from karaoke in 1987 (¥1 billion, about US$10 million). These figures demonstrate the prominence of karaoke in Japanese copyright business (see Mitsui 1994: 125–6).

However, the relationship between the karaoke industry and JASRAC is not always good. Frequently one finds newspaper articles on karaoke places forced to close by the authorities. Except for the cases of public nuisance (noise at night), most of these cases deal with unpaid royalties with approximately 350 cases documented in 1993 alone. It was in 1987 that the commercial use of karaoke became subject to performance rights fees. Initially, JASRAC asked karaoke venues larger than 16.5 m^2 to pay royalties based on floor area. The smaller snack bars were exempt from fee collection. In 1994, JASRAC altered this policy and requested karaoke rental companies and individual dealers to pay royalties as well, because these companies and dealers also profit from karaoke playing. In spite of JASRAC's efforts to collect royalties, they presume that no more than 60 per cent of karaoke places are paying the required fees. Uncollected fees are estimated to be as high as ¥700 million (about US$7 million). Copyright warfare continues to get worse.

Related to the copyright problem, patent royalties have also caused conflict in the karaoke industry. A karaoke machine consists of hundreds of special devices, and often a patent holder will sue a manufacturer for 'piracy' with reference to intellectual property rights law. Patent is to industrial products what copyright is to music and lyrics. For example, 'colour-synchronized lyrics' (coloured lyrics on a monitor as a song progresses), a standard device for all audiovisual karaoke machines around the world, was invented and patented by Toshiba EMI in 1983 for their working model of VTR karaoke. Although the video format began to fall into disuse the following year, giving way to LD and VHD (video hard disc) formats, manufacturers were not able to contrive a better device for lyric display than the one developed by Toshiba EMI. Knowing that a patent for this system was still under examination, some corporations incorporated it into their own machines. Toshiba's claim was finally approved in 1993 and they soon began to sue several software manufacturers for infringement of their patent. However, Toshiba has not demanded any royalties from them for fear of jeopardizing long-term business relationships, as well as of weakening the karaoke business itself (*Japan Amusement Monthly*, May 1995: 83–5). The same article reports that important devices such as 'Super Impose' and the telecom-based system were retroactively protected by intellectual property rights law so that manufacturers have to pay patent owners. For the moment, the retroactive claims have not been serious enough to subvert the karaoke business. However, it is possible that inventors outside the industry may begin to make outrageous claims for their working models. The article concludes with a proposal, to all who are involved in the karaoke industry, to carry out a serious study of intellectual property rights.

About this book

This book is a collection of articles on the historical, cultural, sociological, communicational and geographical aspect of karaoke as space, technology and behaviour. It is divided into three parts on the basis of cultural geography.

Part I deals with the country where karaoke was born and evolved, discussing the early inventors (Tōru Mitsui), the role of karaoke in the socialization process and its impact on youth culture (Hiroshi Ogawa) and women's involvement in karaoke singing (Shinobu Oku). Part II examines how the karaoke machine has been grafted on to pre-existent singing cultures in Britain (William Kelly), Italy (Paolo Prato) and Sweden (Johan Fornäs). The contrast between Italy and Britain concerning the use of the word karaoke as a political metaphor demonstrates the different frameworks of mass media and national politics in Italy (Berlusconi) and Britain (Thatcher and Major), whereas Fornäs' concept of self-reflectivity in karaoke singing reveals the central issue of general problematics regarding sound, body and technology. Part III will give readers an idea of how karaoke has 'travelled' to other Asian countries and Asian-diasporic communities. Casey Lum's chapter is based on his extensive research on Chinese-American communities in New York and New Jersey, while Shūhei Hosokawa looks into the two decades of the 'karaoke age' in a Japanese-Brazilian community. The ethnographic approach is also employed in the final chapter by Akiko Ōtake and Shūhei Hosokawa on karaoke in East Asian countries, in which the cultural interrelationships of Japan, other Asian countries and the West are discussed in terms of modernization, Japanization and localization.

We are, of course, aware of the asymmetry of this representation, particularly its lack of discussion of karaoke in Islamic and African countries, but we hope that this book will give readers an overview of the 'Eastern' origins and global diffusion of this intriguing participatory music-consumption. This combination of pre-recorded music and live singing, no longer specifically Japanese, has initiated potentially far-reaching changes in urban singing behaviour all over the world. Will the new century begin with the whole world singing together – individually?

References

Arauchi, Ikuo (1995) Special interview with Mr Kei'ichi Shioya, Chief, Technological Development Section, *Japan Amusement Monthly*, January, pp. 70–2.

Asakura, Kyōji (1993) *Karaoke-ōkoku-no tanjō* [The birth of the karaoke kingdom], Tokyo: Takarajima-sha (in Japanese).

Béhague, Gerard (1984) *Performance Practice: Ethnomusicological Perspectives*, Westport, Connecticut: Greenwood Press.

Burnett, Robert (1996) *The Global Juke-box: The International Music Industry*, London: Routledge.

Champion, Steve (1988) 'Karry on Karaoke', *The Face*, January, pp. 94–7.

Clarion (1990) *Heisei-gan'nendo karaoke-hakusho* [The white paper of karaoke, 1989], Tokyo: Clarion (in Japanese).

Cohen, Sara (1991) *Rock Culture in Liverpool: Popular Music in the Making*, Oxford: Clarendon Press.

Confidence (1990) vol. 24, no. 1227 (29 October), pp. 31, 32–3, 35–7 and 40–1 (in Japanese.)

'Consider karaoke'(1995) *Japan Amusement Monthly* (Ōsaka: Coin Journal), January, pp. 67–79; March, pp. 71–9; April, pp. 63–77; May, pp. 83–95; June, pp. 63–77; September, pp. 47–57.

Coopman, Jeremy (1991) 'Can America learn to sing along?', *Variety*, 29 July, pp. 1 and 108.

Cusic, Don (1991) 'Karaoke: high tech and the folk tradition', *Tennessee Folklore Society Bulletin* vol. 55, no. 2, pp. 51–5.

Drew, Robert (1991) 'Issues of stardom, authorship and identity in karaoke', paper presented at IASPM–USA conference, Chicago, 12 October.

Drew, Robert (1994) 'Where the people are the real stars: an ethnography of karaoke bars in Philadelphia', PhD dissertation submitted to Annenberg School for Communication, University of Pennsylvania.

Drew, Robert (1997) 'Embracing the role of amateur: how karaoke bar patrons become regular performers', *Journal of Contemporary Ethnography* vol. 25, pp. 449–68.

Fanning, Deirdre (1991) 'Japanese execs unwind with song: karaoke bars "where you do your business entertaining"', *Nashville Tennessean*, 18 February, page unknown.

Finnegan, Ruth (1989) *The Hidden Musicians: Music Making in an English Town*, Cambridge: Cambridge University Press.

Fornäs, Johan (1993) 'Listen to your voice!: Authenticity and reflexivity in karaoke, rock, rap and techno music', paper presented at the 7th conference of IASPM in Stockton, California, 11–15 July.

Fornäs, Johan (1994) 'Karaoke: subjectivity, play and interactive media', *Nordicom* (Göteborg: Nordic Documentation Center for Mass Communication Research, University of Göteborg), no. 1, pp. 87–103.

Fujie, Linda (1992) 'East Asia/Japan', in *Words of Music: An Introduction to the Music of the World's Peoples*, New York: Schirmer Books, pp. 318–75.

Fukuda, Tomo'o (1996) *Karaoke kenkōhō* [Karaoke fitness], Tokyo: Goma Books.

Gekkan Karaokefan (1990) 'Gekidō-no karaoke nijūnen-shi' [A tumultuous 20-year history of karaoke], *Gekkan karaokefan* (Ōsaka: Coin Journal), April, pp. 31–8 (in Japanese).

Gendai-no Esprit (1993) July issue featuring articles on video games and karaoke, Tokyo: Shibumnō (in Japanese).

Gonda, Thomas A., Jr. (1993) *Karaoke: The Bible: Everything You Need to Know about Karaoke*, Oakland, California.

Hesselink, Nathan (1994) 'Kouta and karaoke in modern Japan: a blurring of the distinction between *Umgangsmusik* and *Darbietungsmusik*', *British Journal of Ethnomusicology* vol. 3, pp. 49–61.

Hosokawa, Shūhei (1993) 'O feitiço do Karaoke', *D.O. Leitura* vol. 11, no. 133, June, pp. 2–3 (in Portuguese).

Hosokawa, Shūhei (1995) *Samba-no kuni-ni enka-wa nagareru* [*Enka* is heard in the country of samba], Tokyo: Chūōkōronsha (in Japanese).

IASPM–Japan (1991) *A Guide to Popular Music in Japan*, Kanazawa: IASPM–Japan, July.

IASPM (1995) *Popular Music: Style and Identity: IASPM Seventh International*

Conference on Popular Music Studies, ed. Will Straw, Stacey Johnson, Rebecca Sullivan and Paul Friedlander (Montreal: The Centre for Research on Canadian Cultural Industries and Institutions), pp. 77–8, 149–54, 177–80, 201–4, 209 and 225–8.

Japan Amusement Monthly (1993) Ōsaka: Coin Journal, vol. 3, no. 2 (October).

JASPM (1991) Report on the panel, 'Karaoke', as part of the second annual conference of JASPM, by Yukiko Tsubonō, *JASPM Newsletter* no. 7 (January), pp. 8–9 (in Japanese).

JASPM (1992) Report on the symposium, 'Technology and music – karaoke spreading beyong Japan', by Atsuko Kimura, *JASPM Newsletter* no. 11 (January), pp. 2–3 (in Japanese).

Karaoke Journal (1995) 'Enso bun'ya de shiyoryo choshugaku no 63.2% o shimeru karaoke' [Karaoke shares 63.2% of the total performance royalty fee collected], July, pp. 18–19.

Karaoke Symposium, The Committee of, (1990) 'Gendai "karaoke"-kō' [Discussing contemporary karaoke], Ōsaka: The Committee of the Karaoke Symposium, September (in Japanese).

Keil, Charles (1994) *Music Grooves*, Chicago: The University of Chicago Press.

Keil, Charles and Feld, Stephen (1984) 'Music mediated and live in Japan', *Ethnomusicology* vol. 28, no. 1, pp. 91–6.

Keil, Charles, Keil, Angeliki and Blau, Dick (1992) *Polka Happiness*, Philadelphia: Temple University Press.

Kelly, William (1991) 'Work and leisure in Japan with special reference to karaoke', unpublished PhM thesis at the University of Oxford.

Kimura, Atsuko (ed.) (1990) *Karaoke shiryōshū* [Collected clippings on karaoke], privately published (in Japanese).

Lipsitz, George (1993) 'Foreword', in Susan D. Crafts, Daniel Cavacchi and Charles Keil (eds) *My Music*, Hanover, NH: Wesleyan University Press, pp. ix–xix.

Livingston, Tamara E., Russell, Melinda, Ward, Larry, F. and Nettl, Bruno (1993) *Community of Music: An Ethnographic Seminar in Champaign-Urbana*, Champaign, IL: Elephant and Cat.

Lodge, David (1984) *Small World*, London: Secker and Warburg.

Lum, Casey Man Kong (1996) *In Search of a Voice: Karaoke and the Construction of Identity in Chinese America*, Mahwah, New Jersey: Lawrence Erlbaum Associates.

Macaw, Heather (1990) 'The origins, use and appeal of karaoke', unpublished BA thesis in the Department of Japanese, Monash University (Australia), November.

Makita, Van (1992) 'On the change of musical experience depending on technology: a study of singing by karaoke in everyday-life', unpublished MEd thesis in Music Education at Kōbe University, January (in Japanese).

Marre, Jeremy and Charlton, Hannah (1985) *Beats of the Heart: Popular Music of the World*, New York: Pluto Press.

Maruyama, Keizaburō (1989) 'Tetsugakusha-ga karaoke-ni kurūto' [When a philosopher gets infatuated with karaoke], *Bungeishunjū*, Tokyo: Bungeishunjūsha, December, pp. 412–21 (in Japanese).

Maruyama, Keizaburō (1991) *Hito-wa naze utau-noka* [Why do humans sing?], Tokyo: Asuka-shinsha (in Japanese).

Maveley, Rachel and Mitchell, Gail J. (1994) 'Consider Karaoke', *The Canadian Nurse* January, pp. 22–4.

Middleton, Richard (1990) *Studying Popular Music*, Milton Keynes: Open University Press.

Mitsui, Tōru (1992) 'Karaoke again at the conference in Japan', *RPM: The Review of Popular Music* (IASPM), no. 17, pp. 8–9.

Mitsui, Tōru (1994) 'Copyright and music in Japan: a forced grafting and its consequences', in Simon Frith (ed.) *Music and Copyright*, Edinburgh: Edinburgh University Press, pp. 125–45.

Mitsui, Tōru (1995) 'Karaoke: How the combination of technology and music evolved', *Popular Music Perspectives III: The Sixth International Conference on Popular Musik* [sic] *Studies*, Berlin: Forschungs zentrum Populäre Musik, Humbold-Universität zu Berlin, pp. 216–23.

Morris, Edward (1991) 'Nikkodo brings the karaoke business to Nashville', *Billboard* vol. 27, April, p. 31.

Murao, Tadahiro (1994) 'Concerning the *onchi* in a karaoke society: sociological aspects of poor pitch signing', in Graham Welch and Tadahiro Murao (eds) *Onchi and Singing Development*. London: David Fulton Publishers.

Musiikin Suunta (1993) no. 2 (Suomalainen karaoke). Includes 'Kaljakuppilasta karaokebaariksi' (pp. 3–14) by Jouni Kenttämies; 'Karaoke – ilmiöstä instituutioksi?' (pp. 15–22) by Kirsi Ritosalmi; and 'Karaokeyhteisö' (pp. 23–37) by Elina Niiranen and Mikko Vanhanen (in Finnish).

Nagai, Yoshikazu (1993) 'Karaoke box ni ugatereta mado', [Window fixed in karaoke box], *Gendai no Esprit*, no. 312, July, pp. 124–37.

Negus, Keith (1992) *Producing Pop: Culture and Conflict in the Popular Music Industry*, London: Edward Arnold.

Nichols, John (1993) 'Unchained melodies: karaoke night and post-colonial community', unpublished paper presented at the annual meeting of the American Folklore Society, 30 October, Eugene, Oregon.

Nihon Keizai Shimbun (1990) 'Chikyū tanken' [Intellectual exploration: interview with Sasaki Mikio], 13 April.

Niimi, Akio (1992) 'The effect of karaoke on the activity of behaviour: an examination by personality and the evaluation of singing ability', *Aichi Shukutoku Tanki-Daigaku Kiyō* no. 31, pp. 125–50 (in Japanese).

NME (1988) 'Cure for karaoke voices', *New Musical Express*, February, p. 7.

Observer (1991) advertisement for 'Home Karaoke Machine', 17 November, p. 92.

O'Malley, Suzanne (1993) 'Tuesday Night Fever: a karaoke romance', *New York* 19 July, pp. 26–33.

Ōtake, Akiko (1995) 'Asia karaoke-kaidō-o-yuku', *Tonchi*, Tokyo: Heibonsha, February, pp. 54–73; March, pp. 122–33; April, pp. 114–25; May, pp. 138–49; June, pp. 134–45; and July pp. 134–45.

Ōtake, Akiko (1997) *Karaoke umi-o-wataru* [Karaoke crosses over the ocean], Tokyo: Chikuma-shobō (in Japanese).

Parch, Andy (1990) 'With karaoke unit, you can belt'em out', *Nashville Tennessean* 10 September, page unknown.

Peel, John (1987) 'John Peel watches the Frank Chickens introduce a karaoke competition', *Melody Maker*, 1 November, page unknown.

Reed, L.D. (1985) 'Song of myself, on tape: Japanese sound-blending machines are making US melodies', *Time* 15 July, p. 74.

RPM (1989) *Review of Popular Music*, the newsletter of IASPM (the International Association for the Study of Popular Music), no. 13.

Sankei-Shimbun (1994) 'Sengo-shi kaifū' [Unsealing the post-war history], 16 July.

Satō, Tadao, Koizumi, Fumio, Inoue, Hisashi *et al.* (1979) *Ongakuka-shakai* [A musicalization of society], Tokyo: Kōdansha (in Japanese).

Satō, Takumi (1992) 'Karaoke-box no media-shakaishi' [Social history of karaoke boxes as media in Japan], *Pop Communication Zensho* [All about pop communication], Tokyo: Parco Publications, pp. 112–38 (in Japanese).

Satō, Takumi (1993) 'Karaoke-box no media-shi' [History of karaoke box], in

Takeshi Satō (ed) *Gendai-no Esprit* [L'esprit d'aujourd'hui], July, pp. 107–23 (in Japanese).

Shank, Barry (1994) *Dissonant Identities: The Rock'n'Roll Scene in Austin, Texas*, Hanover, New Hampshire: Wesleyan University Press.

Shirai, Scott (1996) *Karaoke: Sing Along Guide to Fun and Confidence*, Honolulu, Hawaii: Visual Perspectives.

Time (1983) 'Closet Carusos: Japan reinvents the sing-along', February vol. 28, p. 38.

Tokumaru, Yoshihiko and Fujie, Linda (1985) 'Karaoke of Japan: music minus one of present-day Japanese society', unpublished paper presented at the third conference of IASPM in Montreal, July.

Tomizawa, Issei (1989) 'Karaoke-sōseiki: yonin-no-ganso-wo mitsuke-ta' [The genesis of karaoke: I found four originators], *Gendai*, Tokyo, January, pp. 356–64 (in Japanese).

Ueno, Naoki (1993) *Karaoke-o motto-motto-umaku-miseru hon* [Book for singing karaoke much better], Tokyo: KK Longsellers (in Japanese).

Ueno, Naoki (1996) *Karaoke-ga gun-gun umakunaru voice training* [Voice training for much better karaoke singing], Tokyo: KK Longsellers (in Japanese).

Walker, Robert (1994) 'Will karaoke teach the world to sing in tune?', in Graham Welch and Tadahiro Murao (eds) *Onchi and Singing Development*, London: David Fulton Publishers.

Welch, Graham and Murao, Tadahiro (1994) *Onchi and Singing Development: A Cross-Cultural Perspective*, London: David Fulton Publishers.

Wienker-Piepho, Sabine (1993) 'Karaoke: singing today without national boundaries?', paper presented at the 23rd International Ballad Conference of the Komission für Volksdichtung in Los Angeles, 23 June, published in *Ballad and Boundaries: Narrative Singing in an Intercultural Context*, ed. James Porter, Los Angeles: Department of Ethnomusicology, UCLA, pp. 307–12.

Wong, Deborah (1994) '"I want the microphone": mass mediation and agency in Asian-American popular music', *TDR* [*The Drama Review*] vol. 38, no. 2, pp. 152–65.

Yano, Christine Reiko (1995) 'Chapter VI Karaoke', in 'Shaping tears of a nation: an ethnography of emotion in Japanese popular song', PhD dissertation, University of Hawaii, pp. 193–221.

Yomiuri Shimbun (1992) 'Imadoki-no karaoke' [Present-day karaoke], *Yomiuri Shimbun* Sunday edition, 3, 10, 17, 24 and 31 May, 7, 14, 21 and 28 June on page 4 (in Japanese).

Part I

1

THE GENESIS OF KARAOKE

How the combination of technology and
music evolved

Tōru Mitsui

Karaoke

In order to give a basic description of the karaoke machine and its use,
let me begin with an extract from David Lodge. Lodge, one of my favourite
contemporary novelists, is, in any case, always a pleasure to read.

Persse McGarrigle, the protagonist in *Small World*, which has been
dubbed 'An Academic Romance', wanders into a Tokyo bar in the early
1980s (Lodge 1984: 291–3):

> In the middle of the room two Japanese men in business suits are
> singing 'Mrs Robinson' in English into a microphone, a phenome-
> non which puzzles Persse for several reasons, one of which he
> cannot instantly identify. The two men conclude their performance,
> receive friendly applause from the customers, and sit down among
> them. The chief puzzle, Persse realises, is that they managed to pro-
> duce a very credible imitation of Simon and Garfunkel's guitar-
> playing without the advantage of possessing any visible instruments.

Then Persse was encouraged or almost forced to sing a song himself:

> 'I don't wish to sing at all!' Persse protests. 'I just came in here
> for a quiet drink.'
> The Japanese beams toothily and sits down beside him. 'But
> this is *karaoke* bar,' he says. 'Everybody sings in *karaoke* bar.'
> Hesitantly, Persse repeats the word. '*Karaoke – what does that
> mean?*'
> 'Literally *karaoke* means "empty orchestra". You see, the bar-
> man provides the orchestra,' he gestures towards the bar, at the

back of which Persse now sees that there is a long shelf of music cassettes and a cassette deck, 'And you provide the voice' – he gestures to the microphone.

'Oh, I see!' says Persse laughing and slapping his thigh. The Japanese laughs too, and calls something across to his friends, who also laugh. 'So which song, please?' he says, turning back to Persse.

This might be the first description, in English, of a karaoke episode. It provides a fairly accurate picture of karaoke before the introduction of video, although some details could be corrected.

It is doubtful that 'Mrs Robinson' was found in any karaoke repertoire in the early 1980s because karaoke was then dominated by *enka* (sentimental songs in slow to medium tempo, influenced by elements of indigenous Japanese music), with an extremely limited number of songs in English. It was obviously poetic licence by Lodge to include some well-known songs by Bob Dylan and Diana Ross's 'Baby Love' in 'a long shelf of music cassettes' in the bar. Moreover, 'cassettes' were not in use if the term denotes cassette tapes as we know them, because much wider reel tapes were used for karaoke machines for reasons which will be explained later. Finally yielding to the pestering, Persse sings Dylan's songs, which he used to sing in the bath, but his performance is 'enhanced by having the original backing tracks as accompaniment'. It is very unlikely that the original tracks were used because the expense would have been prohibitive.

If a reader prefers a more objective and fuller description, here is a passage from Charles Keil's article in *Ethnomusicology* (1984: 94). Possibly the first serious discussion of karaoke in a publication is given there as one of four mediated-and-live musical scenes Keil observed in the summer of 1980, presumably not long before Lodge visited Tokyo.

> Behind the bar you find a complete cassette-tape stereo with mixer and echo effects and a library of specially recorded tapes that are missing the lead vocal parts, two to four songs per tape for quick access. On the bar itself there is a microphone and songbook-catalogues that provided lyrics and locate the song you want to sing. During the evening the microphone passes from hand to hand and every individual present can be a star in turn. People applaud after each vocal segment but they also go on with their own conversations; the music volume is not too high, so the atmosphere is relaxed, appreciative of the singer but not focused on each person's efforts. The goal of each singer seems to be a perfect replication of a specific star in a specific style, but research might uncover nuances and variations on standard star models that are valued variously in different karaoke contexts; bars are known to

be oriented toward a particular style or mix of styles, ranging from *minyo* (folk) and *enka* (urban) to U.S. blues and country, with all the European, American, and Japanese pop styles in between. Some of these contexts might prize individual interpretation more than others. Each small bar tends to have a steady clientele and regular patrons often have their name on a personal bottle of whiskey behind the bar, to be called for as needed in entertaining friends.

This sketch is also adequate, and largely applicable even to present-day karaoke bars. A 'cassette-tape stereo', 'two to four songs per tape for quick access' and 'U.S. blues and country, with all the European, American' pop styles are, however, no more than guesses.

At that time karaoke equipment centred around a music tape, although in 1982 video, laser disc and CD karaoke were introduced. It was audio tape, although not cassette tape, that was primarily responsible for the emergence of karaoke. It is true that karaoke equipment is now totally visually orientated in those parts of the world where the karaoke industry has extended its foreign market. However, video tapes and discs replaced audio tapes simply because they improved the technical functions of the original karaoke audio tape and its deck, so the contribution made by video tapes and discs to the development of karaoke is somewhat secondary.

It was in 1972 that audio tapes were first commercially exploited with some modifications as the focal part of an apparatus which soon came to be known as karaoke. There had apparently been tentative use of audio tapes before as recorded musical accompaniment to singing in night-clubs in some parts of Japan, but those tapes and decks can be called karaoke only in the rudimentary sense of equipment used to reproduce pre-recorded instrumental accompaniment to singing. Karaoke, however, is generally understood to be commercially produced and marketed equipment, with a microphone mixer, that provides prompt selection of pre-recorded instrumental accompaniment. At the same time, the term encompasses the activity of singing with this equipment, i.e. karaoke singing, as in statements such as 'Do you like karaoke?' and 'I'm taking lessons in karaoke at the downtown cultural centre.'

Pre-karaoke days

Before karaoke was invented, a non-professional singer's request for instrumental accompaniment could possibly have been granted in a night-club by its house band, but the accompaniment would not have been easily available for financial reasons. There were solo strolling musicians, called *nagashi*, before the age of karaoke, who usually frequented inexpensive

33

bars, singing standard *kayōkyoku* numbers and new hits (*kayōkyoku* is a general term for Japanese popular songs), and some of them complied with requests to accompany a customer's singing. But the accompaniment, if flexible, was limited to one or two instruments, typically the guitar and sometimes the accordion, and the number of those musicians moving from bar to bar was also limited.

The electric organ, with its variety of tones, proved itself to be moderately versatile as a one-man band in some bars and clubs to accompany the singing of customers. Yamaha's 'Electone', which was put on sale in 1959, became popular all over Japan, and I remember seeing the instrument as an accompaniment in a couple of bars in the mid-1960s. However, along with other limitations, the fees for the organ player must have been considerable.[1]

As to pre-recorded accompaniment, two types of technical equipment were readily available: phonograph discs and recorded tapes. One of the advantages of such equipment is their availability without regard to time and place provided that working machines are on hand. An obvious problem is that, unlike human accompanists, they are unable to provide instant accompaniment to the song one wants. This problem can be solved to some extent, however, by the use of a juke-box. And, in fact, some experiments with juke-boxes were conducted by different people around the same time. Juke-boxes came to Japan soon after World War II when American popular culture flooded in, although they were never as popular as in the USA. Reportedly, an early primitive experiment was to attach a microphone to a juke-box which had been left as a piece of army surplus some years after the American occupational troops withdrew from Japan (Inoue 1990). The records in the juke-box were undoubtedly regular *kayōkyoku* ones complete with vocals, along with which users were supposed to sing.

The heyday of juke-boxes in Japan seems to have been in 1968 (Inoue 1990), but shortly more advanced experiments began to be made. One of these was made by Yamachiku, a retail record store in Kanazawa, Ishikawa, which in 1967 produced 'music-minus-one' singles of *kayōkyoku*, in cooperation with Japan Victor, and sold them to clubs which were equipped with a Victor juke-box, to which Yamachiku installed a microphone. Soon National, another major manufacturer of electric appliances, cooperated with Yamachiku in releasing the same kind of singles, and the business lasted for some ten years (Kawabata 1990). Obviously, these singles of professionally performed recordings for juke-boxes co-existed for some years with regular karaoke, which emerged some years later. The disadvantage of this first attempt at karaoke, which grew increasingly acute as regular karaoke developed, was the relatively limited number of songs a juke-box contained. The typical capacity of a juke-box was 100 singles, that is, 200 songs at most. Furthermore, the machine was rather bulky, taking up a great

deal of space, and the pace of wear and tear on record grooves and needles was significantly faster than that of tapes.

Moreover, it should be noted that Columbia put on the market in May 1972 a stereo set equipped with what they called a 'voice-changer', which enabled users to delete the vocal part of a stereo recording in order to sing the song themselves. This machine, which drops down the frequency of the recorded vocal part, was in demand for three years. Then, possibly inspired by this device, Victor developed, in August 1972, a phase-reversing mechanism called 'Vocaless-function', which was installable in juke-boxes made by Victor. This contrivance turned out to be successful when it led to the manufacture of a new product called 'Bandwagon', a movable, smaller juke-box equipped with 100 singles (Ōtake 1997: 207–8).

The audio tape and deck appeared on the Japanese market in the late 1950s. One possible use for the new equipment was to record an instrumental accompaniment to one's singing or playing of another instrument, as I myself attempted in 1959, although I an uncertain how widespread the practice was. According to a karaoke manufacturer, rudimentary use of the same kind for commercial purposes seems to have developed in one way or another in different places at different times in the mid- and late-1960s (Inoue 1990). Some years after he started his club in 1964, Seiji Kawabata, a night-club owner in Takamatsu, Ishikawa, a small seaside town (Kawabata 1990), employed an elderly pianist from Nagoya, who was very useful as an accompanist to drunken singing customers. The accompanist had some 500 songs in his repertoire, most of which were probably *kayōkyoku*. Before long the night-club owner had the pianist record some of the piano accompaniments on reel-to-reel tape to eliminate his labour and to make accompaniment more easily available to the customers. As to the lyrics of the songs, customers used a volume of hit songs annually published by Zen'on, a major music publisher, and when this wore out (note that this was before the advent of Xerox), the owner attempted to photograph lyrics on slides and project them on a screen. Thus he anticipated karaoke singing with its ubiquitous written lyrics, whether printed in large letters in a collection of lyrics accompanying the karaoke machine or shown horizontally at the bottom of a TV monitor screen. The fact that accompaniments catered musically for amateur singing also anticipated the later overall tendency towards amateur-oriented arrangements in karaoke recordings. But the critical weakness of these tapes was their inefficiency in promptly supplying a singer with the desired song accompaniment. Rewinding and fast-forwarding the tape were inevitably awkward and likely to dampen the fun. Some devices were apparently experimented with but without satisfactory results.

An attempt was also made to use a tape on which music from the radio had been recorded. In 1958 a short morning radio programme began which

featured one or two popular *kayōkyoku* tunes performed by an orchestra without vocals. Actually, it had long been customary for record companies to release the instrumental versions of their hit songs. This programme, *Uta-no-nai kayōkyoku* [*kayōkyoku* without singing] at 6.30 a.m., sponsored by Sunstar, a toothpaste manufacturer, was enjoyed by early birds, presumably as background music. Some bar owners recorded the songs with a home tape recorder and played them as 'music-minus-one' for customers to listen to and also to sing along with (Inoue 1990). The customers were not very eager to sing, however, because the performance was never intended for amateur singing in its key, tempo and modulation. The key of a song was adjusted to the one in which a lead instrument can demonstrate its best quality and help create a pleasing piece of background music. Again, there was some delay in selecting tracks, and the recording and playing of radio music for commercial purposes were a violation of copyright, more blatant than playing home-recorded tapes of popular songs. It is interesting, however, that this practice among the general public stimulated Teichiku to release some instrumental versions of hit songs, by Yūjirō Ishihara, as LPs from 1971 to 1974, naming them *Let's Sing with an Orchestral Accompaniment* (Ōtake 1997: 211). The popular actor Ishihara's amateurish but pleasing delivery was generally regarded as the model one should follow when singing these songs.

Meanwhile, the 8-track stereo continuous loop cartridge, with a small deck, which was, in the USA, 'heavily promoted by the automobile industry as the ideal medium for in-car entertainment' (Schicke 1974: 152–3), was introduced to Japan possibly in the late 1960s. The popularity of the 'car stereo' can be imagined from the fact that the number of cars produced in Japan leapt from 480,000 in 1960 to 5,290,000 in 1970, that is, more than ten times, and the fact that in 1967 it exceeded that of any other country except the USA (Heibonsha 1985: vol. 6, 1,004).[2] Each 8-track stereo cartridge, which cost 'from ¥2,400 to ¥3,200' according to an entrepreneur, Hisayoshi Hiya (quoted in Asakura 1993: 35), contained sixteen songs, with four songs recorded in stereo on each pair of tracks. A marked characteristic of this loop cartridge is that it automatically stops itself when the forward reel is fully unwound (in this case, after playing four songs in succession), and that the playback head shifts automatically from one track to the next, whereas a reel-to-reel tape needed to be threaded from one reel to another.

According to the magazine *Gekkan Karaokefan* (April 1989: 32), it was in 1968 that someone first hit upon the idea of devising a new juke-box using the 8-track continuous loop cartridge. The regular juke-box with single discs was, as already mentioned, enjoying its heyday in 1968, but its size was often a problem for the typical inexpensive Japanese bar, which, like the typical Japanese home, is tiny. When Iwao Hamazaki, who was to become a karaoke manufacturer, produced the combination of

juke-box and loop cartridge, naming it a 'Mini-Juke', he also installed a microphone mixer and a coin-timer so that bar customers could pay and sing along with recordings. The amount charged for three minutes was ¥100, whereas one paid only ¥20 to play a single on a regular juke-box. The first thirty 'Mini-Jukes', dubbed 'sing-along jukes', were loaded with a dozen pre-recorded 8-track loop cartridges named 'music packs' and were rented out to bars. Encouraged by the success of this tiny tape-juke-box, Hamazaki began mass-producing in cooperation with Teikoku Dempa Co. (now Clarion, a karaoke manufacturer) in 1970. Then 'there appeared', according to him, 'other fellow-traders along with the increasing number of "singing bars" across the country'. Recorded music on the tapes was, however, not 'music-minus-one', but regular kayōkyoku hit recordings.

The prototype of karaoke

As far as I am able to ascertain, the person presumed to have recorded commercial accompaniment music for amateurs on tape for the first time was another dealer in pre-recorded 8-track loop cartridges, who was experienced in accompanying customers' requests as a house-band musician.

In early 1970, Daisuke Inoue and five other musicians (Inoue 1990; *Gekkan Karaokefan*, April 1989: 32) took over the management of Music Crescent (later Crescent) in Kōbe, Hyōgo, which leased pre-recorded music loop cartridges; according to another pioneering karaoke manufacturer (Hiya 1991: 54), one cartridge cost between ¥2,400 and ¥3,200, which roughly equalled one-tenth of the monthly salary earned by a newly recruited office worker. The Kansai region, which includes Kōbe as well as Ōsaka and Kyōto, saw a rise in the number of small bars due to the large international exhibition that year called 'Expo '70', and car-stereo decks were installed in many of these. At the time the bars were not yet linked to cable radio, which had been going since 1960 with continuous playing of hit kayōkyoku, but in the year following 'Expo '70' cable radio penetrated the area in depth and provided stiff competition to Music Crescent and other similar firms.

Inoue and others were forced to work as musicians to get money to manage their company, and often accompanied singing customers as they had done before. Kōbe, a seaport metropolis, was rather unique in the musical nightlife that was enjoyed before the diffusion of karaoke, with both bar-to-bar strolling musicians and those employed at clubs accompanying singing customers. (This was not so common in other cities and was perhaps due to the fact that the city has the largest population of *yakuza* – Japanese gangsters – who are considered to be good singers of *enka*, songs of un-requited love.) This embryonic idea of karaoke was conceived in 1971 when Inoue and his colleagues recorded the accompaniment tracks for

a couple of *kayōkyoku* on a small reel-to-reel tape for the owner of a small ironworks company. The customer was going on a recreation trip with his employees and planned to entertain them at night with his own singing. He was so pleased with the accompaniment, which was musically adapted to his way of singing, even adjusting for a couple of parts where he invariably sang off tempo, that he ordered taped accompaniment for more of his favourite songs. The commercial possibilities hinted at by these recorded tapes were reinforced when Inoue was shown the newly developed tape-juke-box with its car-stereo by the former owner of Music Crescent.

In 1972 Inoue and his colleagues recorded on 8-track tapes their own musical performances without vocals as accompaniment for amateur singers and manufactured ten tape-juke-boxes for those recorded tapes.[3] Significantly, these were the first carefully arranged commercial accompaniment tapes for amateur singers, and they were made possible by the producers' musical background. Even more important was the fact that Inoue managed to devise instantaneous song selection by modifying the 8-track loop tape for car stereos. As already described, a song was recorded on a pair of eight tracks to make it stereophonic, and each pair was about a dozen minutes long, containing four songs in succession. Inoue shortened the tape loop, cutting it to a quarter of its original length, so that each pair of tracks contained just one song; thus any of the four songs recorded on this shortened tape could be selected instantly by shifting the playback head of the deck. In other words, when a forward reel is fully unwound, that is, when one of the four songs is over, it automatically comes back to its beginning, because it is a loop. As soon as a song finishes, then, the tape is prepared to play any of the four songs from the beginning. This factor of instantaneous selection became the quintessential component of karaoke equipment, although now it is so much taken for granted that people are unconscious of its significance.

The first ten decks made by Inoue and his colleagues featured a built-in coin timer and microphone mixer with reverb echo mechanism, which has been another characteristic of karaoke ever since, and the first set of accompaniment loop tapes they produced was in twelve volumes with forty-eight songs in all. The fact that this deck and tapes, a prototype of karaoke, was named 'Crescent Juke' clearly suggests that it was regarded as a juke-box, more precisely a tape-juke-box, or an extension of a juke-box, demonstrating that karaoke, an accompaniment gadget for amateur singers in bars and clubs, is linearly descended from the juke-box. When Music Crescent leased this first machine to small bars, it also included as part of the equipment lyric sheets (handwritten and photostat-copied at that time), which were to become indispensable until they were replaced by lyrics superimposed on a screen. The sheets were inserted in a vinyl album to keep them from getting soiled by spilt liquids in bars, and even

this was a pioneering development, used by later karaoke manufacturers and eventually patented by Inoue in 1974.

In the year after the appearance of this prototype of karaoke, the Crescent people entered into cooperation with T & M, a newly formed karaoke manufacturer, and doubled the number of songs recorded on one 8-track loop tape. Instead of recording a song accompaniment in stereo, they recorded it in monaural, finding that amateur singers were not particular about the sound of accompaniment.

In the same year, 1973, more karaoke manufacturers appeared, and soon the musical accompaniments recorded on tapes became much closer to original hit records in their arrangement and orchestration with deliberate modifications for amateur singers. This made the songs easier and more pleasant to sing for customers who sought to model their singing on the original records, and this helped to conventionalize karaoke singing.

Then, in 1976 and 1977 the major record companies in Japan, including Teichiku, King, Columbia, Toshiba EMI, Victor and Polydor, almost all at once started to be involved in the karaoke business (Asakura 1993: 51). The sound quality and the orchestration, as well as the arrangement of songs, of the karaoke tapes they produced were naturally superior to those manufactured by small enterprises.

Musical-cultural context

I have not attempted in this chapter to give a full musical consideration of the genesis of karaoke, but some comments are needed to give the wider context of the musical culture within which karaoke emerged.

First, karaoke's birth might be partly explained by the theory that the Japanese have not traditionally been accustomed to sing when they are sober (see Tsuganesawa 1993: 101). Indeed, before karaoke the most common form of social singing was to sing either individually or as a group with hand-clapping accompaniment when a dinner party or a feast was in full swing. At such parties a participant was often forced to sing, however reluctantly, as is presently the case in karaoke. On the other hand, singing to a much wider public with professional accompaniment was popularized through the *Nodojiman Shirōto Ongakukai* [amateur singing contest], a live weekend show, which NHK, the Japanese equivalent of the BBC, started in January 1946, six months after the end of World War II. In retrospect, we can see that this show, in which amateur singers gleefully imitated their favourite recording artists, foreshadowed the emergence and popularity of karaoke.

Another point that should be noted, particularly as a reflection of the contemporary music scene in Japan, is the fresh impetus given by karaoke to *kayōkyoku*, the mainstream pop music. Many people who were not young enough to feel comfortable with rock- and folk-derivatives in Japan

demanded their own type of music. What filled the void was a series of hits in the early 1970s, which were labelled *enka*. The despairing sadness and self-sacrificing fatalism which permeated these songs harked back, in terms of both lyrical and musical characteristics, to the extremely popular song composed in the early 1920s – 'Sendō Ko'uta' [Boatman's song], which can be seen in retrospect as the forerunner of what we might call 'hardcore' *kayōkyoku*. This genre, newly termed *enka*, reviving an old term with the same spelling, formed the main repertoire of the karaoke bars that emerged in the early 1970s.

The definition of karaoke

Karaoke is, as the entry in Longman's English dictionary succinctly explains, 'the activity of singing to recorded music for entertainment' and also 'a machine that plays recorded music which people can sing to' (Longman 1995: 773).

This machine was described, when the word was selected for inclusion in *The Oxford Dictionary of New Words* (1991: 172), as 'A sound system with a prerecorded soundtrack of popular music from which the vocal part has been erased so as to allow an individual to sing along with it.' It is incorrect, however, to say that 'the vocal part has been erased', because in fact the vocal part never existed at all in a karaoke recording. This non-existence is the very 'kara-' of karaoke, that is, void. The ubiquitous explanation of karaoke as 'empty orchestra', an example of which we have already encountered in the passage from David Lodge, is quite misleading. This supposedly literal translation of the term has often been given by Japanese whose knowledge of English is obviously limited. The prefix 'kara-' does not imply the attribution of an undesirable 'empty' sound to an orchestra, and simply means that the orchestra on the recording is void of vocals.

Actually, the word karaoke, which preceded the advent of karaoke as we know it now and which came into use after the emergence of tape-recording, was a term used in the music industry, denoting an instrumental performance of a song recorded on reel-to-reel tape by the house orchestra of a recording company as an accompaniment to singers. They used this tape, which a recording company had recorded to reduce expenses, when rehearsing by themselves as well as when going on a national tour to promote new releases. What was called karaoke then was in essence similar to 'music-minus-one', which originated in America as a commercial phono-graph recording of an accompaniment to the performance of a specific instrument or vocals for the use of music students. This 'music-minus-one' is often regarded, mistakenly, as the beginning of karaoke, but what makes it internally different from what is now called karaoke is that karaoke is invariably intended for the public at large, with accompanying music

deliberately arranged for amateurs in its key, tempo, structural duration, and so on. In this respect, some of the devices described above that were intended as automatic accompaniment to amateur singing, but not specifically adapted to the needs of amateurs, cannot properly be called karaoke, even in retrospect.

The foremost factor which defines karaoke as a machine is, as was suggested above, a device for the instantaneous selection of a song; this is the most indispensable factor in making any kind of karaoke machine functional for commercial use, and even for home use. Other factors specifying a karaoke machine are those which enable it to be used as a piece of equipment for simultaneous singing and as playback of recordings. Thus, an input power terminal for a microphone along with an echo effecter, which has always been demanded for amateur singing, is a requirement.

The word karaoke also denotes the activity of singing using a karaoke machine. Thus, there are private enterprises called karaoke *kyōshitsu* [karaoke class], which gives vocal lessons to aspiring amateur singers in karaoke bars, as well as a book titled *Karaoke Jōtatsuhō* [How to improve your karaoke]. At the same time the word karaoke has a more comprehensive dimension. When one says, '*Kon'ban karaoke ikōka*', what is intended is a combination of 'Shall we go to a karaoke place this evening?' and 'Shall we go karaoke-ing?' The word karaoke in 'I don't like karaoke', another statement often made, connotes the activity of singing as well as a karaoke place loaded with many typical associations, including noisiness in general, obligatory hand-clapping, enforced singing and certain types of song.

Later development

Later technical developments in karaoke equipment have been diverse and often remarkable, but their functional contribution to karaoke has been basically subsidiary and no more than improvements on the innovations examined above.

In 1978, a machine which automatically rates the pitch, tempo and rhythm of a singer's performance on a 100-point scale was introduced and soon was universally adopted. Visual karaoke, including video and laser disc, as well as CDs, all appeared in 1982, gradually replacing audio tapes on the karaoke scene. In the same year, a key-shifting mechanism was invented, enabling the key of a recorded accompaniment to be automatically changed without slowing down or quickening the tempo. The year 1986 saw the introduction of the 'karaoke box', a large booth or compartment for the use of one group of people, who can now monopolize a karaoke set, rather than sharing it with other groups in a bar or club. This made karaoke easily available to both women and younger

generations, who use it not only at night but during the daytime and often without alcohol, and whose different musical tastes caused a radical change in the karaoke repertoire. In 1989 there even appeared a 'walking' karaoke, a karaoke version of Sony's Walkman, with forty song accompaniments on one small insertable card. This has apparently turned out to be unpopular.

Meanwhile, in the late 1980s karaoke manufacturers began exporting karaoke overseas, in the wake of Japanese office-workers stationed in various parts of the world who formed or expanded a social life of their own based in bars and clubs which catered for them.[4] Karaoke has thus been disseminated in Japanese societies overseas and, in turn, has penetrated the lives of the people in these countries. As an illustration I quote an excerpt, with my own abridgement, from an article which appeared in a Japanese newspaper in 1991:

> An elementary school teacher steps up to the microphone in the lounge ... As recorded music plays, a television screen projects a videotape with the lyrics of the song flashing below ... By the last verse, sensing she's on a roll, she shimmies her shoulders and sinks to her knees with one arm stretched out imploringly ... The crowd whoops with approval. Back at the table she says, beaming, 'It's like it's my song!' Ah, the chance to be a star. Everybody's secret desire. The kind of fantasy that's got people young and old, semitalented and otherwise lining up to do karaoke ... 'Once you're up there, it's good – you feel good' ... 'There's something interesting about singing – it's fun to do even if you're bad' ... 'People enjoy watching other people try to sing ... and with a sing-along tape and a professional background, even a bad singer sounds better ... At each table is a booklet listing hundreds of song titles to choose from. Pick your song, sign your name on a list, and wait to be called ... 'People who are fat, relatively ugly or bad can come to these places and really have an opportunity to express who they are, and then go back to their humdrum lives.'
> (*Yomiuri*, 20 May 1991, page unknown)

All the comments in this article, published in a newspaper in English, could describe any regular karaoke bar in Japan, but this was about a lounge in the USA; not in Los Angeles, or in New York, but in Worcester, a small town in Massachusetts. Thus thanks to the spread of video technology, karaoke has begun to be imported and widely diffused in numerous countries. The stories of the acceptance of karaoke in some of these countries are related in other chapters of this volume.

NOTES

1 Mr Seiji Kawabata, a night-club owner in Takamatsu, Ishikawa, told me that his salaried Electone player used to accompany customers who wanted to sing in his club which he started in 1964. Customers were charged ¥200 for a song, out of which ¥100 was paid to the drummer who was paid on a daily basis while the other ¥100 was counted in as a part of the club's takings (Kawabata 1990).

2 It was in 1980 that the number of cars produced in Japan (more than 10,000,000) exceeded that of the USA (Heibonsha 1985, vol. 6, 1,004).

3 One of a handful of people who claim to be the originator of karaoke, Takeo Naba'e, 'clearly recalls' that, in October 1970, a small label named Taiyō Records produced twenty-three 8-track tapes of 'kara-no-oke' under the brand name 'Gekka'. However, it is not known whether the performances were adjusted for amateurs. He also recalls that 'a bandman named Inoue who frequented the office of Taiyō tentatively leased out twenty sets'. 'Sets' obviously refers to sets of equipment, which were presumably machines to play those tapes (Naba'e 1992).

4 As early as the late 1970s, one of the first independent dealers of karaoke tapes and machines, Kisaburō Takagi, was 'peddling' them in Taiwan, Hong Kong, Singapore, Thailand and the Philippines, according to Kyōji Asakura, who interviewed Takagi (Asakura 1993: 26).

REFERENCES

Asakura, Kyōji (1993) *Karaoke-ōkoku-no tanjō* [The birth of the karaoke kingdom], Tokyo: Takarajima-sha (in Japanese).

Gekkan Karaokefan Ōsaka: Coin-journal (published since September 1985) (in Japanese).

Heibonsha (1985) *Heibonsha Daihyakkajiten* [Heibonsha Encyclopedia] 16 volumes, Tokyo: Heibonsha (in Japanese).

Hiya, Hisayoshi (1991) *Takaga karaoke, saredo karaoke* [It's only karaoke, but it's karaoke], Tokyo: Asuka-shobo (in Japanese).

Inoue, Daisuke (1990) Interview with Daisuke Inoue, then an executive of Crescent, a karaoke manufacturing company in Kōbe, Hyōgo, on 5 November 1990 (in Japanese).

Kawabata, Seiji (1990) Interview with Seiji Kawabata, then a night-club owner and an agent of karaoke equipment, in Takamatsu, Ishikawa, on 18 March 1990 (in Japanese).

Keil, Charles (1984) 'Music mediated and live in Japan', *Ethnomusicology* vol. 28, no. 1, pp. 91–6. Reprinted in Charles Keil and Stephen Feld (eds) (1994) *Music Grooves*, Chicago: University of Chicago Press, pp. 247–56.

Keil, Charles and Feld, Stephen (1994) *Music Grooves*, Chicago: University of Chicago Press.

Lodge, David (1984) *Small World*, London: Secker and Warburg.

Longman (1995) *Longman Dictionary of Contemporary English*, third edition, London: Longman.

Naba'e, Takeo (1992) privately printed leaflets (in Japanese).

Ōtake, Akiko (1997) *Karaoke Umi o Wataru* [Karaoke crosses over the sea], Tokyo: Chikuma Shobō (in Japanese).

Oxford Dictionary of New Words (1991) Oxford: Oxford University Press.

Schicke, C.A. (1974) *A Revolution in Sound: A Biography of the Recording Industry*, New York: Little, Brown.

Tsuganesawa, Toshihiro (1993) 'Taishū-bunka-toshiteno karaoke', in Takeshi Satō (ed.) *Gendai-no Esprit* (L'esprit d'aujourd'hui), July, Tokyo, pp. 96–106.

Uta, newsletter of the Crescent Company, Kōbe: Crescent (in Japanese).

Yomiuri: The Daily Yomiuri (one of several daily newspapers in English published in Japan), Tokyo.

2

THE EFFECTS OF KARAOKE ON MUSIC IN JAPAN

Hiroshi Ogawa

In Japan karaoke is still very popular, and has a big influence on the Japanese popular music scene. Karaoke has fundamentally changed the Japanese popular music scene. In this chapter, I would like to show how karaoke changed the Japanese popular music scene, first in the early karaoke stage, then in the karaoke box stage. Then I would like to examine its position in the history of Japanese popular music, first from the standpoint of hit-making, then from the standpoint of the flow and stock of popular songs. Finally I would like to consider the globalization of karaoke.

The early karaoke scene

When karaoke was introduced, there were three typical karaoke scenes. First, clubs or bars where professional musicians used to perform. Karaoke was substituted for live performance. Second, bars where music was played through loudspeakers. The soundscape of bars had already been filled with loudspeaker music in the 1960s. There were strolling musicians with guitars in some bars, who sang customers' requests. As well as these, cable radio was remarkable in the 1960s. Cable radio stations provided some kinds of music programmes for bars. The manager of the bar would phone the radio station to request the songs which his customers wanted. Karaoke was substituted for this system. Juke-boxes were another means of providing music in bars. In the case both of the juke-box and of karaoke customers had to pay a charge for each performance of the machine, for listening in the former and for singing in the latter.

In the first and second kinds of karaoke, there are several groups in a club or a bar. So usually the manager ensures that each customer's opportunities to sing are equal. Each group sings in turn.

Finally, there was a dinner party, 'en-kai' or 'utage' in Japanese. 'Utage' includes 'uta' which means 'song'. In traditional Japanese culture, alcohol

45

and songs were necessary for parties. Even in these modern times people normally have parties on special occasions, in companies as well as in informal groups – for example a New Year's party, a farewell party, a welcome party, a cherry blossom viewing party, a year-end party, and so on. Usually the guests at the party would be expected to do some party tricks such as singing, dancing, magic, and so on. They were expected to show another side of their characters than usual to make the party go well. Karaoke was introduced in such situations and it was welcomed as something easier to do than performing a magic trick.

In this way, in the early stage of karaoke, it was tied to drinking places. Then most of the users of karaoke were men or, exceptionally, women who served at bars. The repertoire sung with karaoke was limited to '*enka*' songs which were liked by middle-aged and elderly people. *Enka* songs are slow to medium tempo ballads heavily influenced by indigenous Japanese music.

The early karaoke users were born in the years from the 1930s to the early 1940s. They were brought up surrounded by songs for schoolchildren, war songs and popular songs with a military atmosphere. Their pre-war education in music was extremely limited. As they could not read music and had not mastered any instrument except perhaps a mouth organ, they felt inadequate with regards to music and performing.

After the war they had to work hard doing their part to reconstruct and develop the Japanese economy. In the 1970s most of these people held managerial positions in their companies. They had no way to express themselves through music, although younger people did start to play the guitar and sing during the Beatles boom. It was at that time that karaoke was introduced. It was a perfect way for the older generation to express themselves. With karaoke equipment, people could sing even if they could not read music, and the use of an echo changer made them feel just like professionals.

On the one hand, karaoke can reinforce the sense of belonging within a group. With its wall of music, karaoke encloses a 'karaoke space'. People within it are thought to be friends. There a singer has to show a different face from normal. And singing in the presence of others in spite of shyness is thought to be trustworthy. Both sharing 'a karaoke space' and singing in the presence of others reinforce group consciousness. On the other hand, people can express themselves by their selection of songs and their performance. Usually there are two microphones in a karaoke space. People can sing solos or duets and the rest watch how the singer sings. In short, karaoke is a hybrid form between group consciousness and individualism.

The karaoke scene follows ritual behaviour patterns. Even now, in karaoke time at a bar or party, there seem to be 'hidden' rules:

1 People must not sing two songs in succession.
2 People must not sing the same songs that others have sung.

3 When others are singing, people must applaud between verses and at the end of the song.

Unless people break these rules, everything goes well. The first rule guarantees that many people will have an opportunity to sing. The second rule prevents the audience from being bored and prevents competition between different singers. In the case of a company party, people must take care not to sing their boss's speciality song. The third rule means that, as long as people don't break it, they can talk with others, watch the TV monitor, or page through a list of songs in order to select the next one. In other words, they don't have to listen seriously to the others' singing. If they show respect to the singer by clapping or applause at the appropriate moment, karaoke decorum is maintained.

The karaoke box stage

The technological development of karaoke equipment was remarkable. During the 1970s lyric sheets covered with plastic were required but after visual karaoke was developed, lyrics came to be displayed on TV monitors. Software has changed a great deal in twenty years, from 8-track tapes, compact tapes, compact discs, video tapes to video discs. And in the 1990s wired information systems emerged. Now each system possesses a repertoire of more than 10,000 songs.

The small enclosed space known as a karaoke box became very popular from the end of the 1980s to the beginning of the 1990s and they came to have a major effect on music in Japan. A karaoke box is a small room for singing equipped with karaoke equipment. At first boxes were converted truck containers and were set up along main roads in the suburbs, but they gradually came to be set up in buildings in the amusement areas of cities. The size of the room varies, from a room which can hold two people to one that contains thirty people. The standard size is for seven or eight people.

Manners and styles of karaoke in boxes are different from those in bars or at parties in various ways. Here I would like to point out three differences. First, the range and numbers of karaoke users have expanded. In karaoke boxes the relationship between karaoke and drinking is not as strong as in the case of bars or parties. At bars, drinking comes first; singing, second. In contrast, in boxes singing is the main purpose. So young people, female office workers, housewives, old people and children come to use karaoke boxes. Karaoke came to be one of the most significant Japanese leisure activities.

According to the *Leisure White Paper '96*, 55.4 per cent of Japanese over the age of 15 experienced karaoke in 1995. People who used karaoke systems did so an average of 10.5 times per year (Yoka Kaihatsu Center 1996).

Table 2.1 Karaoke singing, by age and gender*

	Male	Female
15–19	61.9	87.9
	(N=138)	(N=130)
20–29	73.5	76.4
	(N=303)	(N=305)
30–39	59.3	59.7
	(N=288)	(N=305)
40–49	61.3	54.2
	(N=348)	(N=355)
50–59	55.6	45.8
	(N=300)	(N=314)
60+	33.5	24.2
	(N=335)	(N=347)
Total	56.7	54.1
	(N=1,712)	(N=1,756)

Note: *Percentage of those who have sung with karaoke once or more in 1995
Source: Yoka Kaihatsu Center 1996

Second, as users increased, the repertoire for karaoke singing became full of variety. Third, behaviour on the karaoke scene changed. Young people in particular began to use karaoke in a different way from before. In karaoke boxes, the ritual interactions such as clapping and applause faded. Often people sing one after another without waiting for the end of each song.

Satō called such a style of interaction in the karaoke box 'media-reflected communication' (Satō 1992). People watch the monitor which shows some visual image and lyrics, so each member of the group seems to be connected through it. There is little direct interaction among them. We can find a new relationship between body and medium in it.

The difference between the karaoke scene at a party and that of the karaoke box is as follows. In the case of a party, participants gather because they work in the same office. Usually they differ in age, values and taste. There it is expected that heterogeneous people know one another and feel that they belong to the same group. In contrast, people of the same generation who get on well go to the karaoke box. Their main purpose is not to strengthen the cohesiveness of the group, but to share the pleasure of singing. In karaoke boxes pleasure in small groups is pursued. There, in general, conversation among participants does not exist. In other words, it is avoided naturally. The relationship may be very superficial, but there exists a human relationship which can be constructed only by sharing the pleasure of singing.

The users of karaoke boxes not only receive audio, visual, and literal information but also sing by themselves. This experience is one that nobody

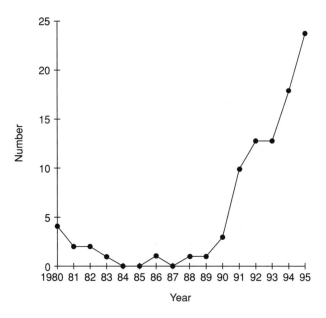

Figure 2.1 Million-sellers of singles, 1980–95

had ever had before. Such a style of communication is the forerunner of that of the 'multimedia' era. In the case of the wired communication system in particular, there exists an interactive relationship between the centre of the karaoke system and the users.

Power over the pop charts

At the start of the 1980s only a few recorded singles had registered a million sales in any given year. But since 1991 there have been more than ten million-sellers of CD singles each year, and more than twenty in the mid-1990s (see Figure 2.1).[1] The reason for this increase is karaoke. How does karaoke contribute to these mega-hits?

It is precisely that karaoke boxes contribute to hit-making. The songs often sung in karaoke boxes occupy the top 40. Now those who make the top 40 are not just passive listeners but the users of karaoke. This means that one of the important elements for hit songs changed from 'good to listen to' to 'good to sing'.

Recording companies have responded to this situation by adding a karaoke accompaniment version to the original version sung by a singer. Now most CD singles include a karaoke accompaniment version for the purchasers to practise the song at home. Songs good to sing have come to be selected for CD singles. Tetsuya Komuro, a singer–songwriter and producer, realized that young people in cities go to karaoke boxes after

discos, and produced the songs sung in karaoke boxes after dancing. His songs have become extremely popular. As duets for two female singers are very popular in karaoke boxes, several songs for this style have been produced.

TV music programmes have also changed. After the mid-1980s, the lyrics came to be superimposed on the screen. They are not the original lyrics of foreign songs nor the translated lyrics of original foreign songs, but the lyrics sung in Japanese. Now it is quite difficult to find music programmes without superimposed lyrics.

Music programmes based on karaoke culture are very popular. *The Yoru mo Hippare* (The Hit Parade at Night), which is broadcast at 10 p.m. every Saturday, is a typical music programme. It is a kind of count-down show and its characteristic is that professional singers do not sing their own songs. They sing hit songs originally recorded by other singers. The audience can thus enjoy a performance which is different from the original one. For example, an *enka* singer who usually appears in a tradi-tional kimono will sing dance music in modern dress. Middle-aged and older people can also enjoy the singers who were popular in their younger days trying to sing the latest hit songs. The singers sitting and waiting for their turn applaud the others between verses and at the end of the songs. In fact, this programme is a huge karaoke party by professional singers relayed from the studio.

Before the karaoke boom people thought each song was the exclusive property of the singer who had recorded it originally. The bond between a song and a singer was very strong. A professional singer seldom sang songs from the repertoire of other singers in public. But as the singers from the early days of Japanese popular music passed away one after another, the singers of the younger generation gradually began to sing their songs on TV. *The Yoru mo Hippare* is the very programme that continues this tradition.

Karaoke singing is not isolated from other behaviour in the music life of the young. According to our research on urban youth culture in contem-porary Japan conducted in 1992/93,[2] 'singing with karaoke more than once per month' was significantly related to 'driving while listening to music', 'using a CD rental shop more than once per month', 'taping favourite songs'. Here we can find a series of actions, renting CDs, taping them, practising at home or in a car, and singing with karaoke. Furthermore, we found an interesting tendency. While men often go to karaoke in a group of four or five, women go there with one friend (see Figure 2.2). Women tend to practise singing intensively to show their performance in the pres-ence of more friends including men (Takahashi *et al.* 1995).

Now most hit songs are the theme songs of TV dramas or image songs for TV advertisements.[3] They are produced with tie-up deals with TV dramas and TV commercials. While a variety of music is listened to, songs

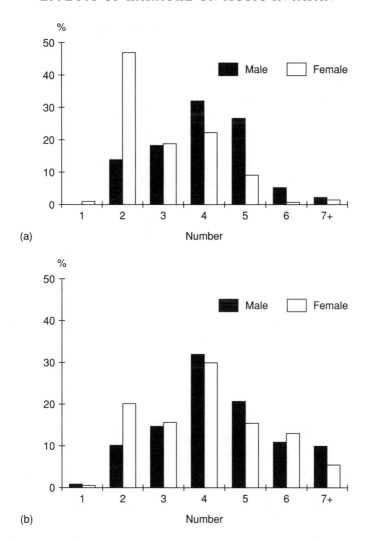

Figure 2.2 Numbers of karaoke singers, who form a group as customers, in Tokyo (a) and Kōbe (b) by gender, 1992–3
Source: Takahashi *et al.* 1995

known in common among friends are selected for karaoke singing and thus the repertoire tends to be chosen from the charts. But this is only one side of this phenomenon. Users often check what songs will be used as theme songs or image songs in advance in order to practise singing these particular songs.

Flow and stock of popular songs

How can I characterize the 1980s and 1990s when karaoke came to have such a big effect on popular music in Japan in terms of the history of Japanese popular music?

First, I would like to mention that those who are concerned with 'the flow' of popular music, the latest hit songs, are limited to the youngsters. Other generations are familiar with the songs which were popular in their youth.

Over sixty years have passed since the record industry began in Japan, so Japanese society now holds the 'stock' of popular songs of a lifetime. Karaoke made it possible for people to sing *natsumero*, their old popular stock songs. Before the karaoke boom people thought that old popular songs just reminded them of the good old days. After karaoke appeared, however, they came to recognize that these songs could be sung and they lived long in their hearts. At the same time, the repertoire of karaoke users was clarified over time as it became obvious that certain songs were being frequently requested while others were not. The popular songs were grouped together in a category which could be labelled 'standard Japanese numbers'. 'The Selected Fifty', which is bought by the beginners of karaoke equipment for home use, contains this range of 'standard Japanese numbers'.

Second, I must point out that Japanese pop songs are more popular than the Western ones in Japan at the present time. Of course music from the West is often broadcast on FM stations and Western albums sell well. But when it comes to CD singles' sales, the domestic songs are superior. For instance, FM802, one of the most popular FM stations among young people in Ōsaka, had to start its second countdown programme in 1995. *Osakan Hot 100*, the first countdown programme, reflects the station's frequency of play, which is based on the DJs' selections and listeners' requests through the week. There were more Western songs than Japanese songs. *J-Hits Top 20*, the second countdown programme of the station, plays the charts of only Japanese pop songs. The ranking is decided based on the data of the leading rental CD chain store in Ōsaka and the listeners' requests. Considering the strong connection between rental CD and karaoke, this chart reflects the popularity of songs sung in karaoke.

It is reasonable to think that the Americanization of Japanese popular music started in the mid-1960s and almost finished in the 1990s. While the sound of the music is Americanized, lyrics are written in the native Japanese. It is easy to sing a song written in Japanese.

Since the 1970s sound has been stressed at the expense of words. Two bands which made their debuts in 1978 represent this tendency. One band, the Southern All Stars, wrote lyrics which were easy to sing to the rhythm of rock music. They do not always make sense, but they consist of

'Japanglish' in which Japanese and English words were mixed together. On the other hand, the Yellow Magic Orchestra became popular as leading musicians who made the most of computers and synthesizers, and succeeded in having some pieces make the charts. Their pieces were instrumental music with few lyrics, a combination which was rarely heard in Japanese popular music.

As has been noted, sound-oriented music has been superior these twenty years, but lyrics written in Japanese have not always been ignored. Japanese society in the 1980s was characterized as a consumer society. It was no longer at the stage of mass production and mass consumption, but was a society where each individual consumed goods as signs. In this way, they set out to make their own story, they pursue 'My Own Story'. Bigger stories such as 'Westernization' or 'Urbanization' are no longer necessary. The cover versions of rock'n'roll or rockabilly sung in Japanese from the late 1950s to the early 1960s were representative music of the story of 'Westernization'. Songs of homesickness which were popular in the late 1950s were representative music of the story of 'Urbanization'. Japanese pop music corresponds to 'My Own Story'.

When people plan and experience 'Their Own Stories', the fact that the lyrics are written in their native language is important. They quote part of the lyrics and read them in terms of their stories. It is difficult to quote from English songs, because each story has delicate shades of meaning which are difficult to match up with imperfectly understood English lyrics. Image songs in the 1980s were not only music for advertisements but also background music for the consumer society.

In the 1980s most popular songs in Japan were sound-oriented, however, at the same time, they were written in Japanese. Japanese pop songs matured. Karaoke boxes were introduced at that time. This coincidence changed the popular music scene in Japan. Karaoke stimulated singing Japanese pop songs, and their popularity stimulated karaoke singing.

Is karaoke part of global culture?

Currently karaoke is spreading all over the world. What is common to all is the use of the karaoke device, but how and where people sing with it varies. The device itself has various technical advance stages, so the type of karaoke device selected depends on each economic situation and cultural context.

When I did research on karaoke in Liverpool in 1991, it was just becoming popular. Many pubs there had karaoke nights once or twice a week. After the emcee set the example and got the ball rolling, the customers would sing one after another. Some pubs even offered awards of goods or cash. In Britain karaoke was one of a pub's attractions, just as live bands were on other nights. Customers, paying only for their drinks,

could join in or just sit back and listen. Karaoke in Japan is thus very different to the variety found in Britain.

'Karaoke is not a Japanese cultural export', insisted one of my friends who lives in Liverpool. 'It is a part of English culture. People have been singing together in pubs for ages.' In fact, the repertoire of karaoke depends on the locality. Japan cannot export songs for karaoke. The technology of karaoke is global, but karaoke will sink its roots into each local culture and grow differently.

Notes

1 This chart is based on the data of *Original Confidence*, a trade journal of music in Japan.
2 This survey was conducted on 16–29-year-old youths in Tokyo and Kōbe in 1992–3: 45.2 per cent of young people in Tokyo (N=526) answered, 'I sing with karaoke more than once per month', and 47.2 per cent in Kōbe (N=575) answered similarly (see Figure 2.2). This collaborated research has been supported by Grant-in-Aid for Co-operative Research (The Japanese Ministry of Education, Science and Culture).
3 An image song means a song which is used in advertisements on TV or radio, providing some image for the companies or the goods, and at the same time is recorded and sold as a disc. An image song is the method of advertisement which was developed in the mid-1970s by cosmetic companies and advertisement agencies. In 1996 about 30 per cent of the top 40 singles were image songs and about 50 per cent of them were used for TV programmes.

References

Baudrillard, Jean (1970) *La Société de Consommation: ses mythes, ses structures*, Paris: Gallimard.

Hayashi, Susumu, Ogawa, Hiroshi and Yoshii, Atsuko (1984) *Shōhishakai no Kōkoku to Ongaku* [Advertisement and music in the consumer society], Tokyo: Yūhikaku.

Satō, Takumi (1992) 'Social history of karaoke boxes as media', in the editors of *Monthly Across* (eds) *Pop Communication Zensho* [All about pop communication in Japan], Tokyo: PARCO Shuppan.

Satō, Takeshi (ed.) (1993) *Jōhōka to Taishu Bunka* [Information and mass culture: video game and karaoke], *Gendai-no Esprit* (L'esprit d'aujourd'hui, July).

Takahashi, Yuetsu, Kawasaki, Kenichi, Haga, Manabu and Ogawa, Hiroshi (eds) (1995) *Toshi Seinen no Ishiki to Kōdō* [Consciousness and behaviour of urban youth], Tokyo: Kōseisha-Kōseikaku.

Yoka Kaihatsu Center (1996) *Leisure Hakusho '96* [Leisure White Paper '96], Tokyo: Yoka Kaihatsu Center.

3

KARAOKE AND MIDDLE-AGED AND OLDER WOMEN

Shinobu Oku

Introduction

Karaoke is one of the most popular leisure activities in Japan in the 1990s: even some taxis are equipped with karaoke screens and machines. According to the drivers, customers in a group on their way home after a party continue singing in turn, and women in particular sing more than men in taxis. In rural Japan, some families have elaborate karaoke sets and enjoy karaoke singing with their family and neighbours after supper or on holidays. In these cases, housewives are generally in charge of the home karaoke party. Karaoke singing plays an important role in maintaining good relationships in rural districts with decreasing populations.

In remote islands such as Okinawa and Amami, where people preserve a somewhat different culture from the Japanese mainland, many popular songs with a local musical flavour have been composed and sung in karaoke. Their main themes are historical stories, or legendary love stories. Songs of this type are most sung in karaoke parties in these districts. Singing, I believe, is one way to confirm their cultural identity. The above examples show the variety of functions of karaoke in present-day Japan. The function mainly depends on the time, the place and the participants.

Karaoke culture has been discussed mainly as the culture of two different groups, middle-aged and older men and young people of both sexes. It is difficult to get a clear picture of karaoke for middle-aged and older women from statistical investigations. Women and karaoke have not been the focus of any research and the following may be some reasons for this negligence:

1 In the 1970s, karaoke was first introduced in bars and other drinking places.
2 In the 1970s, few female office workers visited such places in the evening.

55

3 Middle-aged and older women were not socially well-organized, and therefore were ignored.
4 Despite the popularity of karaoke boxes in the late 1980s, they were aimed at attracting young people.
5 More generally, middle-aged and older women were thought to spend less money on hobbies, compared to men and young people.

Nevertheless, the situation today has changed; women of all ages are karaoke fans and some of them are so enthusiastic that they sing even in a taxi.

Generally speaking, statistical and psychological research has often shown that there are differences between the sexes with regard to musical ability and behaviour; that females are generally better at music than males. In school, boys tend to be more active in sports and girls in music. Boys sometimes refuse to sing and often disturb the music classroom. Many girls are fond of singing and, even if not, they try to sing well. In many schools in Japan, there are girls-only choirs due to the lack of boys' participation.

We can find this trend also in the genre of karaoke. There are many female karaoke fans. For example, in the 1995 karaoke championship, organized by the journal *Gekkan Karaokefan* [Monthly Karaoke Fan], 26 of the 46 finalists were female (*Gekkan Karaokefan*, August 1996, pp. 27–33). Another example: a TV programme on the air every Monday morning has a section of housewives singing karaoke. In the programme, each tells her personal history of many problems with smiles and tears, and then sings the song with karaoke which reminds her most of these experiences. Most of them sing remarkably well and make a deep impression on the audience in the studio. Their singing is the result of many hours of preparation.

Prior to my description of 'middle-aged and older women and karaoke', I would like to quote the results of marketing research by the Zenkoku Karaoke Jigyōsha Kyōkai [All Japan Association of Karaoke Entrepreneurs, ZKJK] in 1996 as background material. The ZKJK divides the dealers' market into three groups: first, pub/bar; second, karaoke box, and finally hotels and inns. Figures 3.1, 3.2 and 3.3 show customers of each market in 1995 according to the results of the research. These figures suggest that the place and time for karaoke vary according to age and kind of group.

The characteristic differences according to age can be briefly summarized as follows:

1 High school students sing karaoke in karaoke boxes. They visit karaoke boxes after school events and/or school examinations. Wherever they live, it is easy to visit karaoke boxes as many boxes are located along

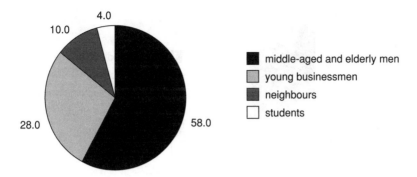

Figure 3.1 Customers of karaoke pubs and snack bars, 1995 (%)

main roads. Managers of karaoke boxes often set special reduced prices for them because they come in the afternoon. Students show their ID cards at the entrance, they choose their favourite songs and sing them in turn without any break. Therefore, they get full value for their money. Their singing is sometimes accompanied with hand, arm, and body movement and they become excited as a group.

2 University students often go to a karaoke box/room in the evening after their meeting and/or party. The reduced price is usually applied to them, too. They also sing in turn without any breaks and even cut interludes. While their colleagues are singing, they chat to each other and choose songs, but, nevertheless, pay attention to others' singing.

3 Salaried workers living in cities visit karaoke pubs/snack bars with their colleagues in the evening. They drink alcohol and sing songs with karaoke. They seem to get rid of their stress there. In pubs and snack bars, there are usually other groups of customers, but they do not always listen to the singing of other groups. They seldom make contact with other groups through karaoke.

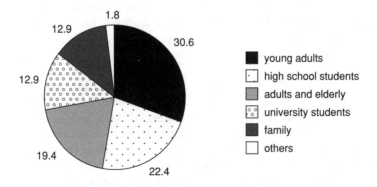

Figure 3.2 Customers of karaoke boxes, 1995 (%)

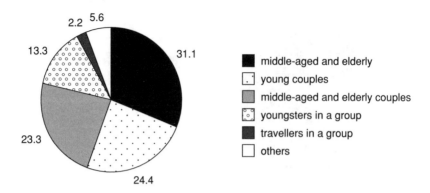

Figure 3.3 Customers of hotels, inns and other places, 1995 (%)

4 With regard to karaoke in hotels at sightseeing places, differences of generation or gender do not apply. In a group tour, karaoke usually plays a very important role at dinner parties and after.

In urban areas of Japan, quite a number of middle-aged and older women stay at home as housewives. From the above description, one cannot find karaoke places suitable for them. How and where do they enjoy karaoke? As a matter of fact, some pubs and snack bars are open as karaoke coffee shops in the daytime. Housewives often enjoy karaoke in such karaoke coffee shops. Young mothers sometimes go to a karaoke coffee shop near the kindergarten where their children go, and use the waiting time for singing before they pick up their children. After their children begin primary school, they visit karaoke coffee shops after finishing their house-work.

A karaoke coffee shop in the afternoon

To the south of the old capital, Kyōto, there is a famous karaoke area. The district originally developed rapidly and rather formlessly after the 1960s, Japan's rapid economic development era. We can find many karaoke pubs/snack bars in the midst of the houses. I would like to describe a scene there.

At the entrance, there is a thick door on the outside and, inside it, another thick soundproof door. The small dark room is the typical size of a coffee shop with twenty seats consisting of three booths and several seats along the counter. Three karaoke screens are placed in different locations so that customers can watch the display wherever they sit. The customers are mostly female, in their thirties up to their sixties. Many of them come with a friend, but almost all of them know each other. They sing in turn when they are called by name by the proprietress.

Incidentally, housewives are called by name in a hospital and city hall, but almost everywhere else they are called merely '*Okusan*' [Madam]. They are identified as someone's wife or someone's mother and seldom identified as a person with her own individuality. A karaoke coffee shop is an exceptional space where they are personally identified.

Each customer keeps a thick bundle of song request cards beside her coffee cup on the table. The bundles are 2–3 centimetres thick. Each bundle is a repertoire of more than fifty songs, with no duplicates. The customers choose the next song from among their own bundle or ask for another card in order to write the name of a new song of their repertoire on it.

Suddenly the entrance door opened and a woman peeped in. After some hesitation, she came in, found a vacant seat and sat down there. She looked a little uneasy and as if she might be a newcomer. The proprietress served her a glass of cold water, a request card and a copy of the song menu in which more than 2,000 songs were listed. Drinking a glass of water, she looked a bit more relaxed, looked at the menu and wrote a song name. At one corner of the room there is a little stage 10 centimetres high where each customer sings the request song in turn. When the newcomer was called, she went to the stage and sang a song there. Others listened to her song and discussed their impressions during the orchestral interludes. They applauded frantically when she finished. During the break, some of them looked as if they were singing mentally, and others commented on her singing to their friends. As soon as she came back to her seat, her neighbour praised her beautiful voice and asked her whether it was her first time there and why she chose that song. Another brought a new request card and asked her the name of the second song she wanted to sing on behalf of the proprietress. Before her second turn, she had completely relaxed and felt at home.

Males are not excluded from karaoke coffee shops. Pensioners and owners of small shops sometimes visit and sing with females. However, karaoke coffee shops are open only in the daytime and therefore the customers are mostly middle-aged and older women. Compared with other karaoke environments, singing in karaoke coffee shops has the following features:

- People can go to karaoke coffee shops alone.
- People can soon make friends in karaoke coffee shops.
- People can enjoy karaoke singing without alcohol.
- People can stay for up to 4 hours in the afternoon for only the cheap price of a cup of coffee and some extra fee.
- People listen to other people's singing in karaoke coffee shops.
- People can practise a particular song repeatedly if they want.
- People can ask others to criticize their own singing if they want.
- People can get information on new songs.

With these characteristics, women in this district are eager to visit karaoke coffee shops. For them, singing in karaoke coffee shops has the following merits:

1 It does not require a lot of money.
2 It promotes a healthy mind and body.
3 It can be enjoyed almost any time one is free.
4 It is a way to make new friends.
5 Karaoke shops are a good place to show off and test the results of everyday practice.

An old woman said that her family was quite happy and satisfied with her hobby because her happiness means her family's happiness and karaoke was the key to good relations in her family. What she said is a great compliment for karaoke.

Characteristics of middle-aged and older women who like karaoke

Besides karaoke, choir singing is another popular hobby among middle-aged and older women in Japan. Most of these choir women belong to a type of choir group called '*Mamasan Kōrus*' [Mothers' choir] which is very active in competitions, conventions and voluntary performances. Even though women in both karaoke and choir groups are fond of singing, their views on music are quite different.

Figure 3.4 shows the result of my comparative research in 1992. The subjects were a group of women who took part in choir activity and another group of women who often sang karaoke in karaoke coffee shops (Oku 1997). The subjects were asked the degree of preference for singing alone in front of people at four stages in their life, namely, when they were in the lower grades of primary school, in the higher grades there, in junior high school and at the time of research. In the choir group, more than 40 per cent of those questioned had been fond of singing alone in front of people during their school years but then the rate dropped significantly. By contrast, about one quarter of the karaoke women had disliked singing alone in front of people while in school, but dislike had changed to a considerable liking.

It is remarkable that few women who sing in a choir sing karaoke, and vice versa. There is a clear boundary between choir and karaoke. I can suggest two reasons for this: school music education and social position.

With regard to the first point, women who value school music education highly are likely to be in choir groups and women who are negative about school music are more commonly found in karaoke groups. The basic repertoire of '*Mamasan* choirs' consists of school singing material

60

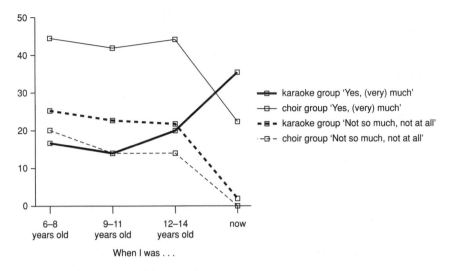

Figure 3.4 Replies to the questions: 'Did you like singing alone in front of people?' and 'Do you like singing alone in front of people?'

which is sung with Westernized voice production and expression. One of the objectives of school music education has been to sing in a choir. In this respect, '*Mamasan* choir' is a developed form of school music education. Norioka did field research on the choir activity of amateur groups in the Kansai district (Norioka 1995:17) and found that most members got high marks in the subject 'music' during their schooldays. Table 3.1 shows how they remembered their grades in 'music' in their schooldays.

To my knowledge, no research has been done so far with regard to such grades by karaoke women in their schooldays, but we can guess from Figure 3.4 that their results were not as good as choir women's. Moreover, most of the repertoire of karaoke singing is *enka* which preserves many elements of Japanese traditional music. Differences between the two types of music, concerning styles, voice range, voice production, way of expression,

Table 3.1 Marks in 'music' attained by amateur choir members in their schooldays (evaluated on a relative scale)

Remarks	Lower grades in primary	Higher grades in primary	Junior high school
very good	43.8	50.2	52.6
good	33.1	30.5	31.0
ordinary	19.9	16.5	14.2
bad	2.0	2.1	1.5
very bad	1.1	0.7	0.7

Table 3.2 Amount of schooling received by choir members

Age	Senior high	Junior high	College and technical colleges	University and more	Others
under 30	0	7.1	25.1	67.3	0.5
in 30s	0	16.9	16.9	65.6	0.7
in 40s	2.3	44.1	24.0	29.3	0.4
in 50s	4.2	48.5	17.3	29.2	0.8
in 60s	8.7	44.9	31.9	13.8	0.7
in 70s	17.4	50.0	15.2	15.2	2.2
total	3.5	34.3	22.2	39.4	0.7

etc. are the main determinants of choir members' positive evaluation of school music education and their negative attitude to karaoke.

The research by Norioka is also suggestive of the latter point. As is shown in Table 3.2 and Figure 3.5, choir members had more school education than average Japanese people. Most choir women came from rather rich families and attained higher marks in school. From their viewpoint, karaoke tends to be thought of as a popular, low, or even vulgar hobby.

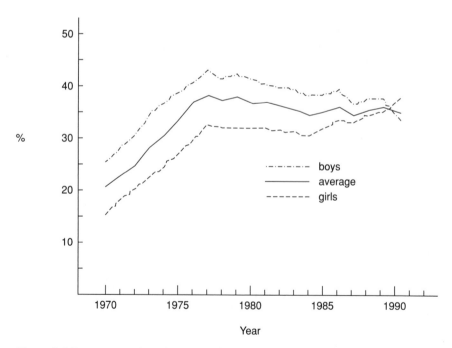

Figure 3.5 Percentage of students at universities and taking short courses at universities, 1970–90
Source: Oku 1994: 10

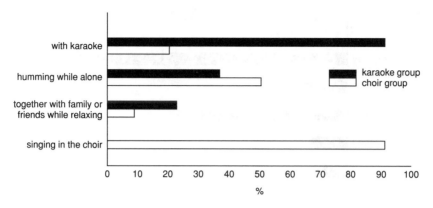

Figure 3.6 When do you sing?

Given these conditions, the places for singing by choir women and karaoke women are almost completely different even though some choir women have experienced singing with karaoke (see Figure 3.6). The majority of karaoke women sing with karaoke so often that karaoke greatly encourages their singing behaviour (Figure 3.7).

In fact, karaoke women are eager to practise singing karaoke (Figures 3.8 and 3.9). They sometimes go to a karaoke class where a karaoke teacher teaches them how to sing a song individually or in a group. They often buy CDs and tapes for practice. As they practise singing by imitating the melody lines and expression of the original singing, karaoke singing is said to be nothing but a copy of the original. Some women even use music scores for practice.

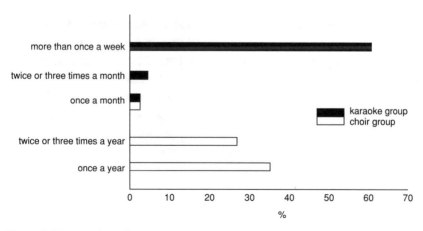

Figure 3.7 How often did you sing karaoke last year?

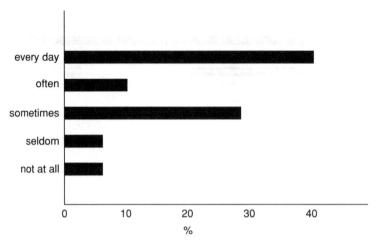

Figure 3.8 How often do you practise karaoke singing?

One-third of the karaoke women replied that one of the attractions of karaoke singing was because of the accompaniment (Figure 3.10). It can be said that a relationship exists between karaoke singing and Japanese traditional vocal music. Vocal music in Japanese traditional music has almost always been accompanied by the same melody lines of instruments. Even though karaoke accompaniments are arranged in functional harmonic style, the melody lines are sounded together with harmonized rhythmic accompaniments. Such accompaniments encourage people to sing well and people therefore feel the joy of singing. The first part of *enka*

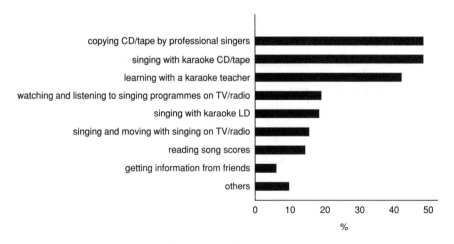

Figure 3.9 How do you practise karaoke singing?

64

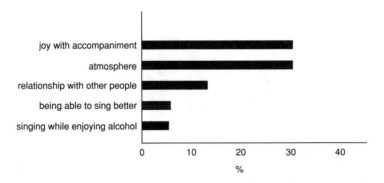

Figure 3.10 Why does karaoke appeal to you?

songs usually sounds like a parole-part in chansons which is rather monotonous, following the intonation and accents of the words, and then comes a climax called '*sabi*'. Accompaniments play an important role for people to express the dynamic change of the *enka* songs.

One-third of the karaoke women also enjoy the atmosphere. The familiar atmosphere which was described above and the strong interest in singing which the customers share influence their responses. One-quarter of the women also pointed out good relationships as an attraction of karaoke. As described before, women are identified by their own names and have contact with each other as individuals in a karaoke coffee shop. They can sing and behave as they like. I think this point has an important meaning from the viewpoint of gender in Japanese society.

Many traditional music elements remain in *enka*, as mentioned before. The monthly journal *Karaokefan* carries brief data of song request rankings in karaoke markets every month. The data make clear that middle-aged and older women singing in a karaoke coffee shop especially favour *enka*, as shown in Table 3.3. The songs given in bold are *enka* and those underlined were originally sung in English. The singers' names given in italics are males and the others are females.

As shown in Table 3.3, songs sung in karaoke coffee shops are largely limited to *enka*. Favourite songs for singing there are mostly *enka* songs sung by Japanese female professional singers. Even though women in karaoke coffee shops like to listen to *enka* songs sung by male singers, those by female singers are easier to sing because of their voice range. I believe that the lyrics of *enka* also affect their responses greatly.

Gender in *enka* lyrics sung by women

A famous *enka* composer, Masao Koga said that the master of the *enka* is lyrics and its wife is music (Koga 1977: 201). I presume that few Japanese

Table 3.3 Songs requested in order of frequency in the karaoke markets

Rank	Karaoke circle and coffee shops		Karaoke pubs and bars		Karaoke boxes	
	Song name	Singer's name	Song name	Singer's name	Song name	Singer's name
1	**On'na no Shigure**	*Hosokawa, T.*	**Amagi-goe**	Ishikawa, S.	Kore ga Watashi no Ikiru Michi	Puffy
2	**Beni**	*Fuji, A.*	**Kita-kūkō**	*Hama, K.* and Kei, U.	SWEET 19 BLUES	Amuro, N.
3	**Naruto-kaikyō**	Godai, N.	**Izakaya**	*Itsuki, H.* and Kinomi, N.	Ajia no Jun'shin	Puffy
4	**Otoko ichidai**	*Kitajima, S.*	Ajia no Jun'shin	Puffy	Save your dream	Kahara, T.
5	**Hana-shizuko**	Ōtsuki, M.	**Toki no Nagare ni Mi wo Makase**	Teresa, Ten	BELOVED	*GLAY*
6	**Echigo-jōwa**	Kobayashi, S.	**Sake yo**	*Yoshi, I.*	**Koi-gokoro**	Aikawa, N.
7	**Tsugaru-koinin'gyō**	Nonaka, S.	**Koi-gokoro**	Aikawa, N.	Swallowtail Butterfly	YEN TOWN Band
8	**Ujigawa-aika**	Kōzai, K.	**Tsugunai**	Teresa, Ten	Another Orion	*Fujii, F.*
9	**Sanbashi**	Ishihara, J.	**Ginza no Koi no Monogatari**	*Ishihara, Y.* and Matsumura, J.	Aoi Inazuma	*SMAP*
10	**Kazemakura**	*Atsumi, J.*	**Roman**	*N.* and J. Yamamoto	Den'en	*Tamaki, K.*
11	**Yorisoi-bana**	Mizumori, K.	**Kita no Koibito**	*Ishihara, Y.*	I'm Proud	Kabara, T.
12	**Chindo monogatari**	Tendoh, Y.	**Chindo monogatari**	Tendoh, Y.	Cherry	*Spitz*
13	**Jinsei sokosoko 70 ten**	Nakamura, M.	SWEET 19 BLUES	Amuro, N.	BODY AND SOUL	SPEED
14	**On'na no Ryōka**	Kadokura, Y.	**Suterarete**	Nagayama, Y.	Nagisa	*Spitz*
15	**Hōrō-ki**	Tagawa, S.	**Wakare no Yokan**	Teresa, Ten	BREAK OUT	Aikawa, N.
16	**Sado-jōwa**	Yonekura, M.	**Tsugaru-kaikyō/ Fuyugeshiki**	Ishikawa, S.	Anata ni Aitakute	Matsuda, S.
17	**Yume-Jōwa**	*Miyaji, O.*	Save your dream	Kabara, T.	SPARK	The Yellow Monkey
18	**Echigo-zesshō**	Ichikawa, Y.	Gomen'ne	Takahashi, M.	By myself	hitomi
19	**Oshidori-funauta**	Mizusawa, A.	BELOVED	GLAY	Iiwake	*Aha-ran-Q*
20	**Ame no sho-kyōto**	Kōda, S.	**Kon'ya wa Hanasanai**	*Hashi, Y.*	Yellow Yellow Happy	*Pocket Biscuits*

Source: Gekkan Karaokefan, January 1997, p. 38
Note: Titles in bold are enka, and singers in italic are female.

would disagree with this opinion. Speaking generally, one may have one's favourite/never-forgotten songs because the lyrics have struck one's heart so deeply. Traditionally in Japan, the lyrics have been the core of the music and singers have put great emphasis on the lyrics.

Enka is one of the typical music genres characterized by this traditional tendency. Therefore, karaoke customers also put emphasis on the lyrics. They often choose a song particularly because its lyrics attract them very much. I would like to analyse the lyrics which are popular among female karaoke customers.

Enka songs can be divided into two groups: one called *On'na-uta* are sung by female singers and express female feelings, and the other called *Otoko-uta* are sung by male singers and express male feelings. Christine Reiko Yano points out that *enka* songs written from a female point of view outnumber those from a male viewpoint (Yano 1995: 209). In all events, the concept of human life and the role of both sexes, sung in these two groups, is almost the same; these two are both sides of the same coin. Karaoke women seldom sing the latter but male karaoke customers sometimes enjoy singing *On'na-uta* to play the other's role.

Contents of *enka* lyrics are mostly divided into three key areas: illicit love; regrets for lost love; and nostalgia. These are connected with each other in a typical plot such as the following: a man from a rural village, working in the city, gets married, but then he meets a gentle woman in a pub, they fall in love, and are now on one last trip before parting. The background for such a plot is a place of meeting such as an inn, a harbour or a train station. Tears, rain, snow, seasonal flowers such as hydrangeas, and insects such as fireflies, these sorts of things also appear in the stage setting, suggestive of parting. Men sing such songs from males' viewpoint in *Otoko-uta*; women sing the same contents from females' viewpoint and moan their misfortune.

Relationships between males and females in these types of *enka* songs can be summarized as follows:

1 A man goes out to work and a woman stays at home and awaits his return.
2 A woman is attracted to a tough guy.
3 A woman often falls in love, even illicitly.
4 A woman accepts her misfortune with regret when her lover leaves her to go back to his wife.
5 The lover was attractive to her because of emotional and sexual appeal rather than rational discussion.
6 A traditional and simple lifestyle is worthwhile when it comes to home, food, drinks, etc.
7 Beauty and youth in a woman are good weapons, but her sincerity is the most important feature.

Table 3.4 'On'na no Ryōka' [Woman's fishing song]

Lyrics	Notes
When the sea billows, seagulls make noises,	theme 1
Women wait at the seaside for the fishing boats,	theme 1
while keeping red fires on the rocks	theme 1
broken with wave and snowstorm	theme 1
hyurr hyurrr hyurr	onomatopoeia of the strong wind
The wind blows hard	
Donto Donto in the midst of waves	onomatopoeia of the wave sounds
Donto Donto Come back as soon as possible,	
Boarding on the first boat	an image of a tough guy
I am your seagull throughout my life.	theme 7
Ah, I love you.	theme 2
With a flag of a good haul men sing out a boat song,	atmosphere of a traditional party after good fishing and theme 8
a woman pours sake into her lover's glass	
With a white cloth round his waist,	traditional costume for fishermen
Suntanned arms must be wild tonight	theme 5
hyurr hyurrr hyurr	onomatopoeia of the strong wind
The wind blows hard	
Donto Donto in a dream	onomatopoeia of the wave sounds
Boarding on the first boat	an image of a tough guy
I am your seagull throughout my life.	theme 7
Ah, I love you.	theme 2

Note: Lyrics by Toyohisa Araki, music by Keisuke Hama, sung by Yuki Kadokura, on sale 24 July 1996

8 A woman's role is to heal a man who works hard at his job and the man appreciates her sincere care.

I would like to cite two examples showing these points from among recent popular *enka* songs. Table 3.4 shows 'On'na no Ryōka' [Woman's fishing song] and includes the above themes 1, 2, 5, 7 and 8. In this song's lyrics, the life of a woman who is a fisherman's wife is positively and frankly described.

The second example, Table 3.5, 'On'na no Shigure' [I, a woman, am in a hot spa town on a cold, drizzling evening] describes points 3, 4 and 5 of *enka*. The woman, working in the spa, has fallen into an illicit love affair. Cold and drizzly rain is a typical scene in which illicit love takes place. Compared with the first example, the woman is in the shadow and she has a complicated feeling about her sexual relationship. The atmosphere is wet and dark.

Table 3.5 'On'na no Shigure' [I, a woman, am in a hot spa town on a cold, drizzling evening]

Lyrics	Notes
Am I weeping because it's raining?	
or because of forbidden love?	theme 3
I am loved as if I were killed,	
My black hair is untied and dishevelled and	theme 5
I, a woman, am in a hot spa town on a cold, drizzling evening.	theme 4
An instant bloom in a secret spa	
becomes a paper flower after one night	theme 3
I did not want to have any memory,	theme 3
but have been dyed thoroughly in one female colour	theme 5
it is really hard for me to say goodbye to you as a stranger	
this morning.	theme 4
There is a love which floats and flows away.	theme 3
There is also a love which bleeds if cut off.	theme 5
Without asking when you will come again	theme 3
I put up an umbrella for you	theme 4
I, a woman, am in a hot spa town on a cold, drizzling evening.	theme 4

Note: Lyrics by Takashi Taka, music by Tetsuya Tsuru, sung by Takashi Hosokawa, on sale 21 August 1996

Incidentally, this song was originally sung by a famous male singer. Both male and female karaoke customers often sing this song. The phenomenon of male singers and male customers often singing a song describing a female feeling might be considered a kind of sexual perversion; however, this consideration is misleading. For men, the ideal woman is sometimes one who devotedly takes care of him even though ill-treated by him. The men who sing such songs with emotion seem to express their own wishes.

When middle-aged and older women were in their teens and twenties, only a small number of the girls continued their studies in senior high schools and universities. Some women got married immediately after they finished school and have been housewives ever since. The images of women in *enka* songs describe the social condition of their life.

By singing *enka*, some women find their unhappy lives copied in the song, others compare their relative good fortune with the misfortune described in the song. As I mentioned before, karaoke women are mostly wives of blue-collar workers and they have been poorer than choir women. Choir women, receiving a higher education, seldom sympathize with the world of *enka*.

In the past twenty years, Japanese society has been changing. The number of girls who go to university is increasing, and the number of women who work is also increasing. In this situation, *enka* is playing a smaller role in the karaoke market. For example, one quarter of all new

songs put on sale every month are *enka* songs, the others are so-called pop songs. Women in *enka* have almost always been a victim of a male's illicit love, and such an image of women is unacceptable to younger people.

Most of the lyrics of pop songs describe love for the younger generation without any background of gender. A man/woman may be lonely, fall in love, arouse jealousy, or lose love equally. I predict the number of *enka* whose lyrics describe such situations will increase gradually because of changes in Japanese women's lifestyle in the next decade.

Moreover, I can indicate one new trend: internationalization, especially Asian-oriented. Recently, Korean culture has made some impact on Japan. In the genre of *enka*, some singers from Korea sing *enka* songs in Japanese and their way of expression has inspired the *enka* world. They have a strong voice and their feelings are expressed more directly. As a result, the lyrics of Japanese *enka* songs have become more direct and positive. The following lyrics of 'Chindo Monogatari' [Story of Chindo] are based on Korean environment and culture. Even though the names of the islands, a special natural phenomenon of the sea, a traditional event and the key word *Kamusahamunida* (meaning 'I appreciate you') are unfamiliar to us, this song, which was composed for and sung by a Japanese (regretfully not a Korean) famous singer became one of the most popular songs for women in 1996. This song may be the first *enka* which celebrates eternal love under the guise of internationalization in present-day Japan.

'Chindo Monogatari' [Story of Chindo], lyrics and music by Daizaburō Nakayama, sung by Yoshimi Tendō, on sale 21 February 1996 (the words in italics are Korean).

> The sea will be divided and a road will appear.
> Two islands will be joined together
> From here, *Chindo*, to the other side, *Modori*
> Bless the God of the sea! *Kamusahamunida*
> We wish in lives in *Yondon Sari* only that
> our separate family will meet again
> Hi, I am praying here that
> we would love again.
>
> I am living warmheartedly here
> even though far from you, I believe you.
> Yes, I am sure we will meet again in the future.
> Bless the God of the sea! *Kamusahamunida*
> The joined road between two islands
> leads to the far north.
> Hi, I love you, I love you with all my life.
> We love together forever.

Nowadays, new *enka* songs are composed continuously, their scores are printed in song books and karaoke journals and their recorded tapes are sold for practice. With this trend promoting consumption, most customers in karaoke coffee shops are keenly interested in new songs. For them, to sing a new song is fashionable, so that almost all the songs listed in the coffee shop column in Table 3.3 were put on sale in 1996. The karaoke computer information system begun in 1995 is also contributing to this trend. Customers in karaoke pubs/bars, on the contrary, do not have as strong an interest in new songs. As shown in the pub/bar column of Table 3.3, new songs are not in the majority, and some songs keep their places in the list for several years.

Middle-aged and older karaoke women receive their information on new songs by means of TV and radio, record them on tape, practise singing at home and then perform on the 'stage' of karaoke coffee shops. If someone sings a new song, then most listeners are interested in it and they will practise it immediately.

Young customers in karaoke boxes are also very eager to learn new songs. They also get their information both by cable and ordinary broadcasting. They listen to music programmes such as BGM everywhere: while studying, working in a store or a fast food shop, driving a car, etc. If a song on the air is attractive, it will be added to their repertoire of songs.

Musical characteristics of karaoke *enka*

The profit-making strategy of *enka* production pays great attention to karaoke. In fact, the release of a new song is often accompanied by the announcement of a karaoke contest of that song. Singability for karaoke fans is thought to be a necessary condition to make a popular song a good seller, but it should not be too simple. Takashi Hosokawa, the singer of 'On'na no Shigure' tells the readers of a karaoke magazine that he sings the song delicately, taking into consideration the recent rapid advance of karaoke fans' ability (Hosokawa 1996: 152).

Because of the strategy of matching the songs to fans' singing ability, new singing techniques and unfamiliar musical elements are generally risky and unwelcome. Therefore, many traditional musical elements have remained in *enka*. *Enka* songs are composed on the basis of traditional music structure, have strong links with traditional music feelings and their lyrics are based on the traditional view of gender. The three songs mentioned above are good examples of this characteristic.

In the 1970s, Fumio Koizumi researched Japanese popular songs He suggested seven aspects for musical analysis of *enka*. Table 3.6 shows these seven aspects, their characteristics, and how the three *enka* songs satisfy these points. Koizumi also wrote that *enka* songs seldom had all of these

Table 3.6 *Enka* aspects and characteristics, and three examples of contemporary *enka*

Aspects	Characteristics	Degree of satisfaction		
		'On'na no Shigure'	'On'na no Ryōka'	'Chindo Monogatari'
1 rhythm	a) most of them are in 2 and 4 time	○	○	○
	b) evenness of pulses	△	○	○
2 scale	a strong relationship with traditional scales	○	○	×
3 melody	linkage with prominence of lyrics putting special emphasis on the beginning of the lines	○	△	○
4 dynamics	pay little attention, generally flat delicate change of dynamics on *kobushi* on each syllable	○	○	△
5 ornamentation	*Kobushi*, melisma, vibration	○	△	×
6 voice production	a variety of voice colour	○	○	○
7 lyrics	Koizumi did not mention anything here because lyrics were not his professional area	described in pp. 72–8		

Notes: ○: thoroughly/basically satisfied △: partly satisfied ×: unsatisfied
Source: Koizumi 1984: 169

characteristics at once and most of them were made of a combination of several characteristics (Koizumi 1984: 169).

As shown in Table 3.6, the characteristics of *enka* have remained basically unchanged, or rather, more points tend to be satisfied nowadays than in the past. For example, 'On'na no Shigure' thoroughly satisfies all these points. The other two songs also generally satisfy the points even though several new elements have been included. I will analyse these three in more detail.

'On'na no Shigure'

1 Rhythm The rhythm is 4/4. The melody is supported by regular pulses but the principle of phrasing is based on a traditional folk song rhythm style, named 'Oiwake style' of free rhythm. Koizumi pointed out three components for this style: first a logogenic component related to the pronunciation of lyrics; second, a component for keeping tension to produce a constant pitch, and finally, a melisma-forming component. According to him, they are constructed in the way shown in Figure 3.12.

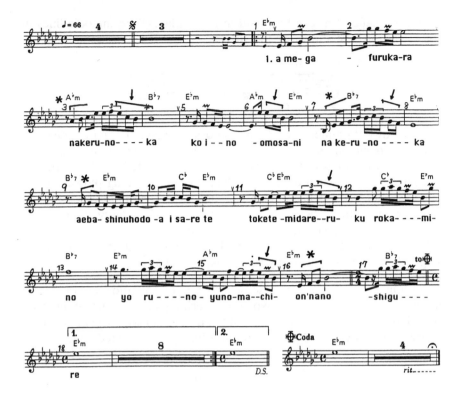

Figure 3.11 'On'na no Shigure'

Of all the phrases in 'On'na no Shigure', phrases of bars 3–4, 7–8, 11–12, 16–17 are typical examples of the construction, but others also are formed on the same principle.

2 Scale Minor key lacking in the seventh as shown below. A traditional

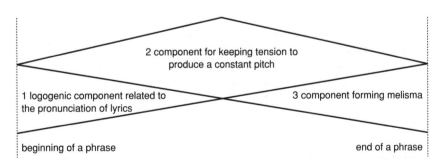

Figure 3.12 Construction of three rhythmic components of 'Oiwake style' by F. Koizumi

tetrachord called 'In' can be found in many places. The melodic lines in 'In' tetrachord are shown by the sign ↓.

3 Melody Prominence of the lyrics does not match the lyrics generally but every beginning of the lyrics line matches the melody line as seen in traditional folk songs of the 'Oiwake style'. These notes are shown by *.

4 Dynamics Clear difference of dynamic range among phrases is not intended, but more delicate dynamic nuances in each phrase is desired.

5 Ornamentation 'Kobushi' and melisma are frequently used. Moreover, vibration is necessary for every long note.

6 Voice production A slightly nasal voice in the high range for a male singer. (This refers specifically to Hosokawa Takashi.)

Thus, 'On'na no Shigure' is a song with a strong relation to traditional musical feeling and singing expression techniques. As such it may be considered a contemporary version of the traditional style *kiyomoto* which appeals earnestly in high range and in a highly ornamented style.

'On'na no Ryōka'

1 Rhythm The rhythm is 4/4. This song is based on an even pulse. This rhythmic treatment is common in *warabeuta* (children's play songs). The places are shown by ↓.

2 Scale Minor key lacking the seventh (example 2). Almost all phrases finish with a traditional cadence. The places are shown by *.

3 Melody Melody lines generally follow the prominence of lyrics.

4 Dynamics The first part of the song (bars 1–12) is contrasted with the second part (bars 13–22).

5 Ornamentation Ornamentation is suppressed and focused only on a place of 'sabi' (climax). *Kobushi* cannot be used because of the fast pronunciation of each note. With regard to long notes, vibration is not used, so that the singer can express the simple and rough feelings of a fisherman's wife effectively. Melisma is used in the *sabi* in bar 17.

6 Voice production This song is sung in a throaty natural voice.

Thus, traditional Japanese elements such as rhythm, scale, melody are used in the framework. Western influence, however, is found in the dynamics and ornamentation. Such a style of composition is very common among contemporary *enka* songs.

Figure 3.13 'On'na no Ryōka'

'Chindo Monogatari'

1 Rhythm The rhythm is 4/4. This song is based entirely on an even pulse. All phrases finish with a long note on the last syllable of each line. This method is often used by Japanese composers.

2 Scale Minor key with leading note (*) which goes up to the tonic with semitone.

3 Melody Prominence of the lyrics are given emphasis as shown in Figure 3.15.

4 Dynamics Dynamic range increases like a wave repeated up and down the '*sabi*' (bars 23–24)

5 Ornamentation *Kobushi* and melisma are not used definitely. Using vibration on long notes is acceptable.

6 Voice production Natural voice with rich resonance.

Figure 3.14 'Chindo Monogatari'

'Chindo Monogatari' is a song which has the fewest traditional elements among *enka* songs. All phrases consist of four bars, chords proceed according to basic functional harmony and the melody lines of two parts finish on the tonic note via the leading note. Such a music style, together with the lyrics, expresses an international feeling. Nevertheless, 'Chindo Monogatari' belongs to the genre of *enka*. I would, therefore, like to compare it with the pop songs sung by young people in karaoke boxes.

The biggest difference between them lies in tempo. The tempo of 'Chindo

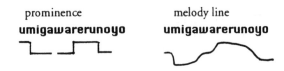

Figure 3.15 Prominence of lyrics

76

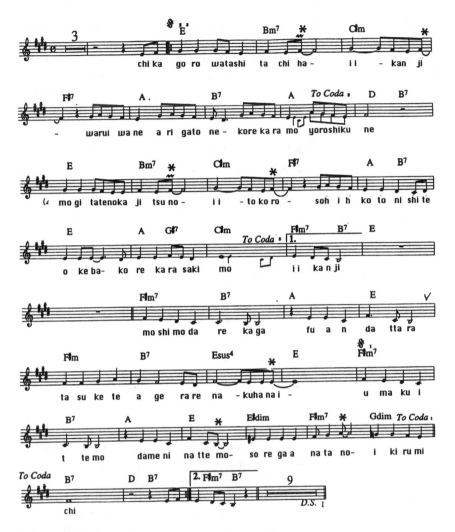

Figure 3.16 'Kore ga Watashi no Ikiru Michi'

Monogatari' is ♪ =96, that is one syllable is sung for half of ♪ =96. This is very slow, when compared with pop songs for young people. For example, one syllable in 'Kore ga Watashi no Ikiru Michi' (Figure 3.16), which is listed in the karaoke box section of Table 3.3, is sung for half of ♪ =135.

A second difference lies in the treatment of the lyrics' rhythm. In pop songs which are based on an even pulse according to the rhythm of the lyrics, syncopation is used in many places and the last syllable of each line is seldom put on the pulses as shown by *. However, in 'Chindo Monogatari' such rhythmic treatment is very rare.

A third difference lies in the beat of the accompaniment. For pop songs, strong regular beats are necessary because the attractiveness of pop songs is partly in their syncopated sung rhythm contrasted with regular beats. However, the melody of 'Chindo Monogatari' is more traditional than many pop songs for young people. In many ways, 'Chindo Monogatari' is an exceptional *enka* song as it is composed completely in Western style.

How to sing *enka* songs and express the lyrics

If an *enka* song appeals to a woman who enjoys karaoke, she will start practising it. In most karaoke song books instructions on how to sing the song and express the lyrics are included. I will quote the instructions for 'On'na no Ryōka' as an example. This song is evaluated in a karaoke song book as follows:

Table 3.7 Evaluation of 'On'na no Ryōka'

Points	Degree
difficulty	★★★★★
passionate appeal	★★★
sex appeal	★★★
freshness	★★★
joy of singing well	★★★★

Source: Tsukahara 1996: 154

The general instructions are as follows:

- A lively and fashionable song. Do sing it comfortably. Don't be misled by its image and don't think that the song is very difficult. Once you check and practise every phrase carefully, you will sing it well. Please express the song dynamically: sing the first part emotionally, in the middle part, control your voice and expression, and then let yourself go at the last part. Anyway, sing in a comfortable voice. This is the basic principle (Tsukahara 1996: 154).
- Sing dynamically as a whole. Make a clear distinction between a gentle part and a powerful part ('One bit of advice': *Gekkan Karaokefan* August 1996a: 167).

More details of how to sing are indicated on the next page. For the first chorus of 'On'na no Ryōka' see Table 3.8.

To sing well and comfortably while following these directions, many hours of practice are necessary. Most female karaoke fans do such practice of new songs in the privacy of their own homes and then enjoy singing in karaoke coffee shops.

Table 3.8 Notes on how to sing the chorus of 'On'na no Ryōka'

Lyrics	Notes
Umi ga arerya (*When the sea billows*)	powerfully
Hama no onago wa (*Women at the seaside*)	
Fubuki majiri no (*in the snowstorm*)	gently
Akai takibi no (*red fires*)	dynamic
Hyururu Hyururu Hyururu (*hyurr hyurrr hyurr*)	delicately
Kaze ga nakukarasa (*The wind blows hard*)	climax
<< <<<<<	
Donto Donto (*Donto Donto*)	powerfully
<< <<	
Donto Donto (*Donto Donto*)	powerfully
<<	
Ichiban-bune de yo . . . (*Boarding on the first boat*)	dynamic
Watasha isshō (*I am throughout my life*)	dynamic
<< < <<<	
Anta no kamome (*your seagull*)	
Suki da yo. . . . (*I love you!*)	
Ah . . . (*Ah!*)	dynamic

While female karaoke fans are practising singing *enka* songs of illicit and/or lost love and enjoying singing in karaoke coffee shops, their husbands are working in an office or a factory and their children are at school. Female karaoke fans seldom forget this. They say, 'See you again!' to each other at the door of the karaoke coffee shop at 5 p.m. when the shop is closed for one hour to prepare for its opening as a karaoke bar/pub. They return home feeling cool, calm, and collected: one woman buys a radish in a grocery store, puts it into a basket and rides her bicycle, another woman buys a quart of milk, holds it under her arm and walks with hurried steps. They are thinking of their families and dinner at home.

Were the lyrics sung just before in the karaoke coffee shop her fantasy or her wish? Do the women remember their own past by singing such songs? It has been said that singing a song is acting a three-minute drama, and so they have lived as many lives as the number of songs they have sung. Several female karaoke fans told me that singing was their joy and made their lives worthwhile. Their lives seem to me quite distinct from the unfortunate lives of the heroines in *enka* songs.

References

Gekkan Karaokefan (1996a) '95 Zennippon Ōza Ketteisen Kaisai', *Gekkan Karaokefan* [Monthly Karaoke Fan], August 1996.

Gekkan Karaokefan (1996b) 'Hit Hit Melody', *Gekkan Karaokefan* [Monthly Karaoke Fan], December 1996.

Hosokawa, Takashi (1996) 'Hosokawa Takashi', *Oto no Ōkoku* [Magic Notes], Dec.–Jan. 1996–97.

Koga, Masao (1977) *Uta wa Waga-Tomo Waga-Kokoro* [Song is my friend, my soul], Tokyo: Ushio Shuppan.

Koizumi, Fumio (1984) *Nihon Dentō Ongaku no Kenkyū* [A study of Japanese traditional music], vol. 2 Rhythm, Tokyo: Ongaku-no-Tomo-sha.

Norioka, Yoshiko (1995) *Seijin no Amatsua Ongaku Katsudoh to Gakkou Ongakuka Kyohiku tono Kanren ni Kansuru Kenkyuh* [On the relation between adults' amateur music activity and their school music education: Report for grant-in-aid by Japan Ministry of Education], Ōtsu: Shiga.

Oku, Shinobu (1994) *Music Education in Japan*, Nara, Nara: Neiraku Art Studies Centre.

Oku, Shinobu (1997) 'Chūkōnen Josei to karaoke', *Ongaku Kyōikugaku Kenkyū*, vol. 5, Wakayama: Wakayama University Press (forthcoming).

Tsukahara, Minoru (1996) 'On'na no Ryōka', *Kayō-enka Karaoke Kōryakubon '97* [How to sing *enka* songs '97], Magazine Land.

Yano, Christine Reiko (1995) 'Shaping tears of a nation: an ethnography of emotion in Japanese popular song', PhD Dissertation, University of Hawaii.

Zenkoku Karaoke Jigyōsha Kyōkai [All Japan Association of Karaoke Entrepreneurs] (1996) *Karaoke Hakusho* [White Paper on karaoke], Tokyo: Zenkoku Karaoke Jigyōsha Kyōkai.

Part II

THE ADAPTABILITY OF KARAOKE IN THE UNITED KINGDOM

William H. Kelly

Introduction

This chapter examines karaoke singing in the United Kingdom. A phenomenon which has become virtually institutionalized in its country of origin, Japan, and the wider East and South-East Asian realms, efforts by makers and distributors of karaoke to market the activity further afield – in Australia, New Zealand, Europe, North America and South America for example – have met with variable lasting success and although the internationalization of karaoke is still on the agenda of the karaoke industry in Japan, it is now widely accepted that the most stable and lucrative markets as well as those which promise the greatest potential for future growth are still in East and South-East Asia. One reason for this may be the more complicated logistics of developing and distributing specialized karaoke systems and software for culturally and linguistically diverse markets far from home, such as in Europe for example, but 'cultural' and historical factors are also significant in assessing the adaptability of karaoke within a particular society or social context.

Two phases in the karaoke phenomenon's history in the United Kingdom can be identified. During the first, karaoke was confined to night-clubs and restaurants catering specifically, sometimes exclusively, to the Japanese expatriate community. The second and, for the purposes of this discussion, more significant phase involved the transmission of karaoke from these Japanese expatriate enclaves into the wider, indigenous population. The focus of this discussion is on this second phase and is specifically concerned with assessing karaoke's adaptability in the United Kingdom, in light of both historical and musical precursors, elements of which are reflected in contemporary performances of karaoke.

In the United Kingdom, the performance of karaoke – usually pronounced 'kariokee' – echoes a history of public singing which dates back

centuries, but was, along with most other forms of modern recreation in the nation, consolidated and institutionalized (or re-institutionalized) during the last century, largely in response to demographic and social changes associated with industrialization. This reorganization corresponded with what the historian E.P. Thompson termed the making of the working class, during which 'most English working people came to feel an identity of interests as between themselves and as against their rulers and employers . . . the working-class presence was, in 1832, the most significant factor in British political life' (Thompson 1963: 10).

During the transitional years between the nineteenth and twentieth centuries, 'the characteristic syndrome of working-class culture took shape' (Hobsbawm 1987: 288). This 'identity of interests' encompassed many aspects of lifestyle – food, clothing, speech and, of course, leisure and recreation. It is within the context of this historical development of a working class and working-class culture that the adaptability of karaoke in contemporary society may be, at least in part, understood. After briefly outlining the recent state of karaoke in the United Kingdom, the phenomenon is examined with respect to a tradition of public singing which thrived in at least three institutions during this period – the pub, the Victorian music hall and working men's clubs. It is hoped that this approach to the subject may elucidate karaoke's adaptability in the United Kingdom and also suggest implications for the question of karaoke's 'invention' which, as in Japan, is not without ambiguity.[1] Finally, karaoke's linguistic adaptability as a metaphor in popular discourse is briefly considered, followed by a few concluding remarks.

Karaoke in the United Kingdom

Between late 1989 and 1992, the karaoke boom took place in the United Kingdom. Seemingly overnight, karaoke began to appear in pubs around the country, usually featured on otherwise slow nights, perhaps weekly or several times a month. Karaoke was also featured in clubs and winebars in London, in community centres, at charity fund-raising events, at private parties and, eventually, in enterprises established specifically as karaoke venues such as a combination Chinese restaurant/karaoke bar in central Oxford.

The phenomenon has also manifested itself on British television, most spectacularly in a short-lived programme called *Kazuko's Karaoke Club*, a talk show in which prominent people were interviewed and asked to sing a favourite song. The programme's presenter, Kazuko Hohki, is also a founding member of the Japanese female duo 'Frank Chickens' whose cabaret-style variety shows in London night-clubs (and beyond) incorporated karaoke, serving to popularize the phenomenon to British audiences before it had become commonplace. Karaoke's television credits include

cameo roles in episodes of long-running situation comedies and weekly dramas. Broadcast at the beginning of what the Queen referred to as her *annus horribilis* was 'Pallas', a spoof of the royal family featuring the Duchess of York, Sarah Ferguson as a compere at a karaoke contest in Switzerland (*Northern Echo*, 31 December 1991). A recent and most striking example of the infiltration of karaoke into both popular parlance and popular culture came in the spring of 1996 with the broadcasting of television playwright Dennis Potter's four-part drama *Karaoke*,[2] discussed briefly at the end of this chapter.

Karaoke first appeared on the market in the United Kingdom in the early and mid-1980s, although the concept may date from as early as 1975 when, according to a long-time promoter who claims to have first introduced the concept to Britain, a crude version of the modern karaoke machine was 'invented' by combining tape player, speakers and microphone into one portable unit as a substitute for a live organist unable to play at a pub sing-along. Although karaoke appeared, if only fleetingly, in a diversity of contexts throughout the United Kingdom during the height of its expansion, the phenomenon was first established in the industrial north of England and it is here, in the midst of a general decline nationally, that it continues to thrive.

Performance

Within these contexts, karaoke has become most closely associated with the public house in the form of the 'karaoke night', evenings when the activity is featured as the pub's main attraction. Publicans have the option of either buying or leasing the karaoke machine and may also hire a compere or KJ (karaoke jockey) whose role in establishing and maintaining a convivial atmosphere is a characteristic feature of the karaoke night and one which distinguishes this venue from its counterparts in Japan. According to Andy, a 'karaoke disco roadshow' presenter in the Manchester area, the first objective of the presenter is to 'get the party going'. This is achieved by encouraging members of the 'audience'[3] to overcome their aversions and inhibitions to singing and, if necessary, by cajoling the first singers on to the stage: 'There's a young chap who's going to sing for us. His name's Martin and he's the first one up so I hope you'll give him a big hand' (*Oxford Times*, 17 May 1991, p. 15). Once the ice has been broken and the singing begun, it is the presenter's responsibility to prevent the pace from slackening. This is accomplished by arranging song requests into a sequence which is musically balanced – mixing old classics, upbeat modern hits and romantic ballads for example – but also by filtering out songs with a proven tendency to dampen the mood. One karaoke jockey cited 'Stairway to Heaven' as an example. Another strategy, used by radio and disco DJs, involves filling the void between songs with

snappy commentary seasoned with encouragement to both performer and the audience. Comments made by one karaoke jockey in the course of hosting a karaoke night at a pub in central Oxford are typical: 'If you listen to the original song, that was not far from it' following a particularly good rendition of 'Holding Back the Years' (Simply Red); 'You know the song, now sing along with it', interjected in the midst of a performance of Frank Sinatra's 'My Way' ; 'Can we have a show of appreciation?' after 'Kiss You All Over' (Rod Stewart).

As the mood of the evening reaches its climax, singing typically becomes more communal, spirited, boisterous and drunken and subsequently less dependent on the karaoke machine and the karaoke format for its structure. At this stage, the individualized karaoke performance may be subsumed by a wave of collective participation with the entire gathering joining together in song – perhaps only during a popular and well-known chorus, but just as likely through the entire song, thus eclipsing the person with the microphone. This may culminate in the singing of well-known songs which may be outside of karaoke's scope. As one article, entitled 'Carry on at the karaoke' (an allusion to the long-running series of popular comedy films made during the 1960s and 1970s) described, 'By the end of the night, they were chanting football songs ferociously and "We're Top, You're Not" was not even on the karaoke machine' (*Northern Echo*, 2 April 1991).

As I hope this brief sketch has suggested, karaoke in the United Kingdom, as manifested in the pub karaoke night, incorporates solo, duet, chorus, and raucous communal forms of singing as the mood and pitch of the evening increase, with the entire event co-ordinated by the karaoke presenter.

Music

The songs which form the mainstay of karaoke's music are drawn from the top of the charts which span most of the post-war period, as the song sequence in Table 4.1 from a karaoke competition at the Oxford pub already mentioned, serves to illustrate.

The list suggests the important distinction between songs that have been short-lived hits and those which have endured, becoming 'classics' which, although associated with one particular era or generation, may span several, becoming firmly established in the society's musical history. These are often songs which have been recorded repeatedly by singers of different eras, as evidenced by a karaoke disc catalogue in which one column was headed, 'Version made popular by . . .'. Although both types can be found in karaoke in the United Kingdom, it is not the five-minute wonders, but the old classics which prevail, perhaps because these songs strike an emotional chord with a wider sector of the population or of a given karaoke

Table 4.1 Song sequence from an Oxford pub

Number	Song	Made famous by
1	Poison Ivy	The Coasters
2	Woman in Love	Barbra Streisand
3	Oh Boy (All My Lovin)	Buddy Holly
4	Holding Back the Years	Simply Red
5	My Way	Frank Sinatra
6	Kiss You All Over	Exile
7	All By Myself	Eric Carmen
8	Crazy	Patsy Cline
9	No More Tears	Barbra Streisand
10	Wonderful You	Elvis Presley
11	He Ain't Heavy He's My Brother	Hollies

audience, and therefore more effectively embody a sense of community and shared experience. Songs like 'You'll Never Walk Alone',[4] which has now become a karaoke standard, perhaps best express this sense of *communitas*. Described by one karaoke presenter as a favourite finale at pub closing, it has been suggested that this song is to the pub-goer what the national anthem is to the late-night television viewer – a final expression of collective solidarity, although at a more local and intimate level in the former case, before retreating into the private realm (*Northern Echo*, 29 February 1993).

Within this range of possibility, the selection of songs is quite broad – 1,000 songs or more is common for a particular maker's line of software – as a few examples of karaoke discs from one producer's catalogue illustrate:

Disc 1
Like a Virgin
Can't Buy Me Love
Bennie and the Jets
Teenager in Love
The Rose

Disc 2
Don't be Cruel
Yesterday
New York, New York
Mack the Knife
My Boyfriend's Back

Disc 25
Mona Lisa
Some Enchanted Evening
Moon River
Smoke Gets in Your Eyes
Blueberry Hill

Disc 30
California Dreaming
House of the Rising Sun
Kansas City
Bad Moon Rising
I Fought the Law

Songs may be grouped either according to a common 'theme', period or musical genre or, as seems to be the case on 'Disc 1', as a medley of

enduring hits spanning several genres and musical eras. In one 'backtrack catalogue' issued by a karaoke promoter in the Manchester area, headings for thematically based song groupings included '50s' Hits', '60s' Hits', '70s' Hits', 'No 1 Hits of the 80s'', 'Party Favourites' ('Hokey Cokey', 'Obla Di Obla Da'), 'Country Favourites', 'Various Hits', 'Instrumental' (a curious category for a collection of karaoke songs!), 'Male Standards', 'Musicals', 'Pub Songs'/'Sing-along Pub Favourites', 'Duet Hits', 'Female Hits' and several collections bearing the name of the singer or group – 'Beatles', 'Barry Manilow', 'Neil Diamond', 'Roy Orbison/Gene Pitney', 'Elvis', 'Madonna', 'Buddy Holly' and 'Cliff', referring to Cliff Richard who has had a string of hit songs in Britain during a career which has spanned several decades. In addition to the software series containing these various groupings, several specialist series were also listed such as 'Christmas Series', 'Irish Emerald Series' ('Danny Boy', 'When Irish Eyes are Smiling', 'My Wild Irish Rose') and a 'Welsh Series' which included Welsh lyrics. Regardless of how songs are categorized, the selection seems to ensure that there will be something for everybody and, perhaps more importantly, a high degree of familiarity with most songs among most participants. Despite this variety, more than one informant noted that many songs in demand – the music of Dusty Springfield was cited as an example – are not yet available on karaoke in the United Kingdom, a situation resulting from the fact that most of the music used is recorded in the United States under Japanese licence, primarily for a US market. Although I have little information on the music in question, unlikely to be included are songs by UK artists which did not fare as well on US music charts as they did at home.

In the United Kingdom, as in Japan, one repercussion of the karaoke phenomenon has been its effect on perceptions and evaluations of popular music. Whereas such aesthetic judgements were, before karaoke, primarily based on aural criteria – that is to say, on musical qualities from the perspective of the listener, karaoke adds the additional parameter of assessment from the perspective of the performer. Of course, the two criteria often overlap so that a song which has been popular in discos, for example, may enjoy a similar popularity in karaoke. However, there are at least two factors which distinguish musical evaluations within the context of karaoke. One, from the perspective of the performer, is what might be termed the song's 'singability' or, in other words, its compatibility with the average range and abilities of the amateur singer. The other is related to a song's suitability in the context of public performance. This is a somewhat vague notion, encompassing such factors as the song's general appeal in society – measured in part by its popularity over time, the sense of nostalgia or history which the song conjures up for its audience and, related to this, its effectiveness as a representation of a particular time or generation. More important in the context of karaoke, however, is what might be termed a song's 'appropriateness'. As several

so-called karaoke jockeys pointed out, while some songs are well suited to the karaoke forum, contributing to the pace and sense of fun which are the requirements of a successful karaoke evening, others, as already noted, seem to have the opposite effect.

It is perhaps not surprising, given these processes of 'selection', that some songs have been dubbed karaoke classics. This is reflected in the production of both karaoke software, where one common category of songs is 'karaoke classics', and karaoke cassette tapes and CDs, which appeared in British record stores from about 1990 and include titles such as 'Karaoke Number One' or 'Karaoke Favourites' amongst the many other collections of songs available (Country, 60s', 70s' or 80s' Hits, Xmas Karaoke Sing-along). More striking, however, are references to karaoke classics in the print media. One reviewer, writing about a Stevie Wonder concert in London, noted that the singer's repertoire included 'karaoke classic, "I Just Called to Say I Love You"' (*The Times*, 24 May 1995), while another review of a newly released Diana Ross album (*Take Me Higher*) claimed, 'Among inclusions will be her version of the karaoke classic "I Will Survive"' (*Sunday Times*, 8 December 1991). As this suggests, not only has karaoke success become a measure by which songs can be assessed, but such evaluations, based on the identification between a song and its popularity in karaoke, have become incorporated into musical discourses in contexts which bear no direct relation to karaoke itself – concert and album reviews in the examples cited here.

Another aspect of karaoke's influence on perceptions of music results from the appropriation of popular songs from the exclusive realm of the professional singer by karaoke amateurs who make them their own, thus closing the gap between amateur and professional. This represents a shift from a close identification between professional singer and song to a disproportionate emphasis on the song itself which has been reinvented for the karaoke format and the amateur singer. As one article explained,

> so flawlessly does karaoke fulfil the participative longings inspired by rock that it might be said to render rock stars redundant. They become like catwalk models, showing off songs instead of clothes. The real thrill comes when ... we steal the song and make it as much our own as the lycra mini or the Paul Smith suit.
>
> (*The Times*, 8 December 1991)

Precursors

The pub

It is not surprising that karaoke has found its principal niche in the pub, an institution which has historically been if not the main, at least a central

focus of British community life. Long a centre for gaming, gambling, singing, drinking and socializing in general, its role has not been limited to the realm of leisure and recreation. It has served as a venue for meetings of a political, communal, or work-related nature, the headquarters of athletic organizations – in 1865, eleven of thirteen Sheffield football clubs listed in the local directory had pub addresses – and even as a clinic where local doctors could examine patients. However, providing recreation has been the pub's primary function and as one writer on its role in early nineteenth-century life put it, 'the public house probably provided a more popular recreational culture than all other institutions combined'.[5]

Both *Punch* magazine and the game of cricket are said to have been conceived in pubs, the former in a Fleet Street tavern now bearing the same name and the latter in the 'Bat and Ball' in Hampshire. The pub's role as a 'breeding ground for new activities' owes much to the publican. Always in search of new and lucrative ways to attract and entertain his or her customers, the publican has been a formidable force in the generation of new forms of leisure and entertainment.

In addition to propagating new forms of leisure, the public house has also served as a bastion of tradition where old pastimes are maintained. Among the oldest of these is the pub sing-song (or sing-along), which one investigator claims has existed since 'the Anglo-Saxons "wassailed" in their alehouses' (Jackson 1976: 131). The tradition of pub singing flourished in the mid-nineteenth century with the creation of separate rooms specially designated for entertainment, particularly singing. Known as the free-and-easy, music room, supper room, or, in its more specialized form, the singing saloon, these were popular stops during an evening out on the town. The atmosphere was informal and interactive, with entertainment most often provided by amateurs either hired locally by the proprietor or drawn from those in attendance who were encouraged to 'get up off the floor and provide their own entertainment by singing or reciting' (ibid.).

By the mid-nineteenth century, a singing tradition incorporating elements of both the amateur solo and group sing-song styles was well established. The singing saloon and similar institutions flourished following an 'enormous increase in the numbers of pubs becoming licensed for entertainment between 1820 and 1850' (Summerfield 1981: 213) and enjoyed something of a heyday between the 1820s and 1850s. Although largely commercial ventures for their owners, these institutions were not simply the creation of ambitious publicans, but 'were called into being by the working classes, and the working classes asserted a remarkable degree of popular control over them' (Baily 1987: 42). Similarly, entertainment was not simply provided by the publican for the people, but reflected the will of the people themselves, 'The Singing Saloons, or Singing Halls, are the best guarantee for recreation, and approach nearer to the inclinations and customs of the working classes than any other institution of the present

age' (ibid.: 44). From the point of view of many in positions of authority, this was precisely the problem. As gathering places for working-class citizens and forums for collective expression which was often drunken, raucous and antagonistic towards authority in general, they came to be seen as a particular threat to the smooth and ordered functioning of a newly industrialized society. Without excessively exaggerating the polarization between the working classes and the government and industry – between 'us' and 'them' – as the situation was infinitely more complex, suffice it to say that prevailing circumstances – political, economic (industry's dependence on reliable, rational labour), and social (temperance movements, Chartist activity, Methodism) – converged, resulting in legislation which had the effect, by the closing decade of the nineteenth century, of displacing the singing saloon and producing, in its stead, the music hall which, by the end of the 1880s, 'was becoming the dominant form, not through a linear development caused by changes in popular taste from pubs, through saloons, to music halls, but through a process of selection' (Summerfield 1981: 216).

The music hall

> In England, you will find a few thousands of perfectly cultivated people, but you will find the mass of people singing songs of the music hall.
>
> William Butler Yeats[6]

The development of the music hall represents the transformation of singing and musical entertainment into a form of mass leisure. The larger music halls in London included theatres with enough seating for hundreds, in some cases thousands, of patrons. Although chorus singing continued to be a feature of an evening's entertainment and songs with verses well suited to sing-alongs remained popular, amateur performances yielded to the growing numbers of professional entertainers who were made by and made their living in (in some cases, a very good living) the music hall. Although this process of professionalization had already begun in the context of the song saloons, the proprietors of many such establishments paying 'the more talented amateurs among clientele to perform regularly' (Summerfield 1981: 212), it was the music halls which were the real makers of musical stars and, in fact, it is within this context that this usage of the word 'star' was coined. Whereas amateur entertainment and audience participation were characteristic features of the song saloons 'so that the distinction between performer and audience was ... blurred' (ibid.), a combination of legislation delimiting and defining the acceptable bounds for music hall entertainments and logistics – audiences of several thousand were not uncommon in the largest establishments – resulted in a greater

separation between audience and performer, thus hindering the establishment of an easy and intimate rapport between the two: 'The proximity of artist and audience, on which the improper gesture and scurrilous remark depended, was destroyed. One artist described his experience of performing there as "barking into a chasm"' (ibid.: 227). As the professionalization of entertainment intensified and legislation enacted to regulate the participatory inclinations of music hall patrons began to take effect, 'the "audience" once taking it in turns to do and act, came to be "sedated" in fixed seating and more of a spectorate' (ibid.: 236). The music halls themselves were operated on an increasingly mass scale, in some cases as chains owned by a single interest – an enterprising individual or brewery for example – which competed fiercely to attract the top acts. Not only were music halls 'star makers', but also hit makers, serving as the breeding grounds for popular songs, some of which continued to be sung in working men's clubs and at pub sing-songs for decades after the decline of music halls in the early part of this century. In the context of the history of public singing, the music hall is significant in that it largely displaced forums for public singing which were centred on amateur performance and audience involvement, staging instead 'professional' entertainment for larger and comparatively passive audiences. The development of music halls also ushered in the beginnings of an entertainment industry which operated on a mass scale and as a business whose operations were increasingly standardized, thus providing entertainment as a commodity for a consuming public.

Working men's clubs

The working men's clubs provide the least ambiguous example of a 'populist' singing tradition. Originally conceived as self-improvement societies by their founders – many of whom were clergymen – the first clubs were established as an alternative to the public house and to counter the 'bad effect of the music saloons' (Taylor 1972: 31). Organizers sought to promote educational pursuits and wholesome entertainments, but activities forced up from below – musical performances and singing, for example – conflicted with those imposed from above such as readings and lectures, with members overwhelmingly favouring the former which generally prevailed if the club was to survive.

Clubs were sustained by members' fees and as non-commercial ventures were free from the restrictive legislation that affected their more profitable counterparts – thus the entertainment of working men's clubs was relatively 'grass roots'. In this sense, the institution is perhaps the most appropriate one for assessing the adaptability of karaoke within the working class: 'In the working-men's clubs, customers have not yet been exploited to support the profitable mythological figure of the good-

fellow-working-man-with-his-warm-common-sense-and-honest-pint' (Hoggart 1992: 151). Although, as Taylor suggests, club entertainment came to rely increasingly on professionals, in part due to the influence of music halls, amateur performances by club members themselves have always played a central role in club entertainment.

According to Hoggart (1957), although entertainments in the working men's club varied in scope 'with "bills" which suggest a variety theatre' with 'comedians and occasionally a ventriloquist', the 'emphasis is on singing, both by individuals and by the company as a whole' (1957: 153). Performers are mostly amateur or semi-professional and most clubs 'have among their number one or two known to have good voices and to be willing to "oblige"' (ibid.). These clubs commonly feature a pianist who 'plays by ear, and rarely falters for want of a good tune of the right kind ... Occasionally someone will rise and move to the piano, probably urged on by friends.' After 'firm cries of Order Please! ... the company become still and the singer delivers his contribution'. Singing is described as 'open', emulative of 'the style used by working-class entertainers giving *individual* performances in the great public places' (ibid.: 154). This emphasis on the solo performance as orchestrated by a chairman is also described in Taylor's account of a working man's club in Newport:

> Adopting very much the same approach as that in the Music Halls, the chairman for the night would take a seat on the stage with his beer and a small brass bell on a table before him, cast his eyes around the hall, and write in his notebook the names of probable performers: there were always plenty ... 'For our first turn tonight, I would like to call on our old friend ...': The summoned singer would take a last swig of his beer and amble towards the stage for a whispered discussion with the pianist. This was often an unnecessary ritual as most of the singers had their well-known favourites which were trotted out week after week. This in no way detracted from the enjoyment given: there was a kind of reassurance in this repetition. To my knowledge, Jack Price – a regular 'opener' – sang the same song every Sunday night for the six years I was a member of the club.
>
> (Taylor 1972: i)

The history of working men's clubs is complex, as the institution has undergone numerous transformations during its formation and subsequent development. Nevertheless, several defining characteristics of entertainments within these contexts can be summarized. For one, despite a general trend towards the greater professionalization of club acts, the prevailing emphasis has been on performances by either the members themselves or by local, 'semi-professional' talents. Although club entertainments cannot

always be easily conceived of in terms of a dichotomy between amateur and professional as many fall somewhere in between (see Finnegan 1989), the relatively sharp divide between amateur and professional which is characteristic of the music halls is, in the working mens' clubs, somewhat blurred, with the overwhelming emphasis on amateur acts which are consistent with the intimate and interactive nature of these contexts.

Historical continuity

Several elements of karaoke performance in the United Kingdom are well documented in historical accounts of community singing within the three institutions mentioned. One example is the role of the presenter, well established in the so-called 'free-and-easies'[7] or singing saloons of the mid-nineteenth century where entertainment was mediated by 'the chairman' – sometimes the publican himself, sometimes a hired professional, or even a member of the audience:

> One of the regulars took the chair, receiving food, drink, and tobacco for his services: wearing the 'official club cocked hat', turns were often boisterous and hilarious: either a song, a speech, poising a tobacco pipe or coal scuttle; an imitation of cat, dog, or fowl, posturing or the more classic feat of quaffing to the dregs the pewter Amystis of some potent compound.
>
> (Summerfield 1981: 211)

The existence of both solo and chorus singing (with emphasis on the latter) which distinguishes the performance of karaoke in the United Kingdom from that in Japan (where solo singing and duets are the dominant forms), is also well documented. Hoggart, in his description of entertainment in working men's clubs in the first half of this century notes, 'the emphasis is on singing, both by individuals and by the company as a whole', adding that 'when the choruses come along ... the company are likely to join in less self-consciously than in other forms of community singing today' (1992: 155).

Similarly, the solo performance in which individuals were encouraged to 'get up off the floor and provide their own entertainment by singing or reciting' was also characteristic of entertainment in the free-and-easies, but as has been noted with respect to this context, 'the special feature of the evening was chorus singing' (Summerfield 1981: 212), during which time the audience 'came to its own' (Baily 1987: 43):

> At the end of every verse the audience takes up the chorus with a zest and vigour which speaks volumes – they sing, they roar, they yell, they scream, they get on their legs and waving dirty

hands and ragged hats bellow again till their voices crack. When
the song is ended and the singer withdraws, they encore him with
a peal that seems enough to bring the rotting roof on their heads.

(Baily 1987: 44)

There are numerous other features in historical accounts of singing,
primarily among the labouring classes, which suggest a compatibility with
karaoke. Baily mentions mid-nineteenth-century singing halls where,
'programme books as thick as a magazine [are] laid upon the tables for
our acceptance, and as the song is announced by the chairman, he refers
you to the number and volume, beneath which you may find the words'
(ibid.: 44). Although technological advances have now rendered such aids
obsolete, they were once a common feature of karaoke bars in Japan.

Hoggart mentions that the use of the echo chamber had become a
popular feature of singing in working men's clubs, 'since it suggests both
something out of this world and the resonance of that singing in the bath
which makes us all feel that we have fine voices' (1992: 165). The echo
function which is a defining feature of karaoke technology seems to serve
much the same purpose.

Finally, there is almost certainly a degree of musical continuity between
karaoke and its historical precursors. Accounts of singing in the context
of the working men's club confirm a breadth of music not uncharacteristic
of that available on contemporary karaoke menus. As Taylor notes in his
account of the first club he joined in Newport,

The old favourites ... were leavened with the new. Young
members of the club added their own versions of the popular
songs of the day; the programme content for the evening span-
ning some hundred years and embracing the hey-day of the music
hall and the early signs of Rock-and-Roll.

(Taylor 1972: i)

Although 'new songs' predominate in both karaoke and working men's
clubs, there are none the less certain criteria, some of which have already
been alluded to, which determine which songs are successfully taken up,
perhaps becoming karaoke classics in the former context or simply classics
in the latter. As Hoggart observes with respect to singing in the working
men's clubs, 'though new songs are almost everywhere in the majority,
each one, if it is to be taken up, must meet certain general requirements
of melody and sentiment' (1992: 159). It is the songs which adhere firmly
to these 'general requirements' which provide the most striking evidence
of musical continuity over time and across singing contexts. Although this
cannot be explored further here, it is at least suggested by the song 'You'll
Never Walk Alone', which Hoggart mentions as an example of a 'successful

sentimental song' in the post-war working mens' clubs and which, as has already been noted, remains a popular last number on pub karaoke nights.

These few examples are isolated from their broader and more detailed accounts as a way of hinting at a historical basis for the adaptation of karaoke – primarily within working-class contexts – in the United Kingdom. However, the implications of this argument extend beyond the adaptation of karaoke to the question of its origins. There are several self-proclaimed inventors of karaoke in Japan[8] and at least one in England.[9] Although sociologist Hiroshi Ogawa has confirmed (personal communication) that the first karaoke machine to appear in Japan pre-dated the Manchester claim (see note 9), the potential for the 'invention' of a karaoke machine existed *in both societies*. In Japan and the United Kingdom, there exist performance traditions which the karaoke machine could not only be adapted into, but from which it could be generated once the necessary technological level had been achieved. Given the existence of a sufficient social context – one in which what might be termed a pre-karaoke performance tradition exists – there is no logical or sociological reason why something like karaoke technology would not eventually emerge, as, indeed, it did several times independently in Japan and possibly at least once in England.

In conclusion, although it may be possible to speak of the development or 'invention' of karaoke technology, it is perhaps more appropriate to speak of the evolution of karaoke as a sociological phenomenon. In the United Kingdom, as in Japan, it is the technology and not the tradition which has been 'invented'. 'The most striking feature of popular culture was its resilience and immutability of various forms of entertainment. What changes took place ... simply reflected technological advances in the craft of the showman' (Walton and Walvin 1983: 27). In this sense, karaoke in the United Kingdom may represent the rejuvenation of traditions of community singing and performance which, though long established in institutions such as the pub and working men's clubs, may have become comparatively dormant in recent decades. As one report on the decline of singing in Britain put it, 'Maybe karaoke will help to ... reverse the passivity of so much modern mass entertainment' (*The Times*, 29 June 1992).

Metaphorical karaoke

Having provided some account of the adaptability of karaoke as an activity in Britain, something must be said about the adoption of the word into the English language – on karaoke's linguistic adaptability. Beginning at the onset of the karaoke boom in 1989, the term began to appear regularly in both the press and in common parlance. Media coverage of the phenomenon's spread was extensive. Referred to only sparingly before

1990, it was mentioned in fifty-four articles (six headlines) in *The Times* during 1991 and in sixty-nine articles (five headlines) in 1992. More than just a reference to the singing phenomenon, the term 'karaoke' has infiltrated the language in contexts as diverse as horse racing, where 'Karaoke King' was reported the winner at Greenmantle in a field which included 'Double Echo' (*The Times*, 3 December 1992) and in political discourse where it has served as a metaphor for both compliment[10] and insult.[11] More recent political metaphors include 'karaoke democracy' in reference to Japanese politics,[12] 'karaoke diplomacy' to describe the diplomatic style of Britain's Governor of Hong Kong[13] and 'karaoke Conservatism', as a label for the 'New' Labour Party's articulation of policies which have long been associated with the Conservative Party.[14]

In the television drama *Karaoke*, which is the most prominent example of karaoke's metaphorical use, playwright Dennis Potter employs the term as a grand metaphor for the artificiality and mediocrity of modern life. One of Potter's two final works which were completed shortly before his death, *Karaoke* is a semi-autobiographical account of a middle-aged (and terminally ill) playwright who in the course of his daily activities over-hears snatches of dialogue in the conversations of strangers and people passing by which are identical to those in his play, *'Karaoke'* (the play within a play). 'They are speaking my lines', exclaims a bewildered Daniel Feeld, the protagonist/playwright in Potter's play.

As in his previous works, Potter uses the unusual dramatic device, which has become his trademark, of having characters mouth or 'lip-synch' the words of popular songs, but in the context of this play conflating the 'authentic' and karaoke versions. This juxtaposition between authentic/ 'real' and scripted experience (and the underlying question of how to distinguish one from the other) is set up in the opening sequence depicting two amorous teenagers in a chrome-plated 1950s' car while the original version of 'A Teenager in Love' (Dion and the Belmonts) plays in the background. As the camera pulls back, revealing the song's lyrics along the bottom of the frame, and simultaneously, as the original song merges into an ear-splitting rendition delivered in a heavy London accent, it becomes clear that what we have been viewing is the screen of a television monitor on which are displayed the video images which accompany the song's karaoke version. We are in fact in the London karaoke bar which is the setting for several scenes of Potter's drama and although karaoke figures in the play – there are several singing sequences – its purpose is primarily metaphorical. As Potter explains,

> Although there's a little bit set in the karaoke clubs, obviously karaoke is a metaphor: there's the music, and you have your little line, you can sing it, and everything is written for you and that is the way life feels to a lot of people. For some, you haven't got

much space, and even the space you've got, although you use your own voice, the words are written for you.[15]

This central theme reverberates throughout Potter's play, articulated by Daniel Feeld who claims of his play (the play within a play), 'I called it Karaoke because – oh, you know the song or the story of our lives is sort of already made up for us' (Potter 1996: 95), and Linda, a character in Potter's play who is cast to play the female lead in the play within, who comments, 'All I know is . . . people keep trying to put words in my mouth' (ibid.: 157).

Potter's metaphorical use of 'karaoke' is intertwined with his use of popular songs. Noting what Noel Coward once referred to as the potency of popular music, Potter explains:

> I knew there was energy in that sort of music, and I knew there must be a way of being able to use it in the way that I perceived people used it themselves, for example the way that they would say, 'Oh, listen, they're playing our song.' I was interested in the feeling that people have sometimes when they listen to music of the past, the way songs wrap themselves around whatever emotion you happened to be carrying when you first heard them, the way a song can infiltrate the mood for a group of people.[16]

Having his characters lip-synch popular songs is both a way of harnessing their emotional potency and of getting 'the music straight bang up in front'.[17] Potter distinguishes this device, which he once referred to as 'pre-karaoke',[18] from singing in musicals, noting that, 'A musical has a different grammar: the action builds to a song and then a song caps it and then it moves on. The song has a different function in musicals.'[19] By contrast, in Potter's serials, 'characters do not burst into song, but into a lip-synched rendition of songs whose lyrics and melodies usher in or echo a character's emotions.'[20]

Potter's *Karaoke* not only demonstrates the degree to which the word has infiltrated both the English language and popular parlance in Britain, but also confirms the potency of karaoke as a metaphor, in Potter's case for the scripted and predictable nature of life, but, as illustrated in the mainstream press, also for that which is inauthentic, artificial or copied.

Conclusions

Karaoke in the United Kingdom has been a much more faddish and passing phenomenon than has been the case either in Japan where it first began more than two decades ago or throughout South-East Asia where karaoke singing continues to enjoy widespread and enthusiastic popularity. Despite karaoke's general decline, it remains viable in various parts of

the United Kingdom – primarily in the North of England, Scotland, Wales and in pockets throughout the rest of the United Kingdom – where patterns of public, amateur singing have been historically strongest. In considering karoake's adaptability, it is also possible to speak of its linguistic adaptability, for although the practice may be in decline, the term has entered the language as a versatile metaphor in a variety of contexts and discourses.

Finally, it has been suggested that the adaptability of karaoke singing in the United Kingdom is, at least in part, linked to class. Although other factors may also have influenced the degree to which karaoke has been taken up – regional or sub-cultural variation, for example – it is hoped that this discussion has demonstrated at least a degree of continuity between the contemporary uses of the karaoke machine and forms of recreational singing and entertainment which have been associated primarily with the working or labouring classes in Britain since at least the middle of the last century. As one newspaper article, about the Royal Pigeon Racing Association's (RPRA) annual meeting in Blackpool[21] succinctly put it, 'We don't have to lay on any special entertainment because it is already here. They used to head for the working men's clubs and bars. Now they seem to prefer karaoke clubs and discos' (*The Times*, 18 January 1992).

Notes

1 W. Kelly, unpublished MPhil thesis, Oxford University, 1991.
2 Best known for his works *Pennies from Heaven* (also made into a Hollywood film), *The Singing Detective* and *Lipstick on Your Collar*, Potter was considered by many to be Britain's most eminent television writer. Diagnosed as terminally ill with cancer in 1994, Potter vowed to complete his two final works, *Karaoke* and *Cold Lazarus*, before his death, requesting that they be produced and broadcast jointly by two of Britain's largest television stations, BBC 1 and Channel 4.
3 The word is in quotations since, in this case, the audience is composed of both spectators and potential amateur performers.
4 Originally from the popular musical *Carousel*, the song has been re-recorded many times. According to musicologist David Horn (personal communication) and another anonymous source, it was taken up by Liverpool football fans in 1963 or 1964 after a successful recording by local Merseyside (Liverpool) group, Gerry (Marsden) and the Pacemakers, becoming a vehicle for the expression of team support and solidarity. The piece was recorded again by Marsden with the help of other stars to raise money for the victims of the Bradford City football fire in April 1985. A popular drinking song due to the possibilities it provides for improvisation and one parodied by 'hooligan' elements at many football grounds ('You'll Never Walk Again' was one version) it remains significant as an expression of communal or collective identity in both Liverpool and other areas in the North of England.
5 Allan Redfern, 'Crewe, leisure in a railway town' (Walton and Walvin 1983: 120).
6 From a speech given in New York, 1904 (Ellman 1987: 116).

7 Defined in the *Oxford English Dictionary* as 'A convivial gathering for singing, at which one may drink, smoke, etc.', the free-and-easy served as a forum, often within the public house, where entertainment was provided for by members of the gathering in what constituted a blurring of amateur and professional, performer and audience.

8 As discussed by sociologist Hiroshi Ogawa and by this author elsewhere (unpublished MPhil thesis, University of Oxford).

9 As reported in two regional newspapers in the Manchester area, *The Express Advertiser* (18 November 1992) and *Today*, where the headline read, 'I plead guilty: I invented karaoke (and the Japanese nicked it)' (19 November 1992).

10 As when Member of Parliament Tony Andrew, in paying tribute to his colleague's (MP Alf Morris) highly regarded Disability Allowance Bill, commented, 'For me to follow Mr Morris on a matter of this kind ... is a bit like a barfly in a karaoke pub following Michael Jackson' (*The Times*, 17 December 1990).

11 On the eve of a general election, Scottish Secretary Ian Laing said of opposition leader Neil Kinnock, 'The leader of the Labour Party is Karaoke Kinnock. He'll sing any song you want him to. Just press the button and out comes the line to take, inspired not by guiding principles, but by the fleeting fads of the moment' (*Financial Times*, 24 March 1992). Similarly, during the US presidential campaign in 1992, then President Bush dismissed Bill Clinton's claim to be the comeback kid, proclaiming, 'We're running against the karaoke kids, willing to follow any tune, like customers at a singalong bar, to help them get elected' (*Financial Times*, 19 August 1992).

12 'In little more than a year, Japan has moved from stable, one party rule that lasted almost four decades to a kind of karaoke democracy, where almost anybody is invited to stand up and sing' (*The Times*, 7 August 1994).

13 'When he performed the karaoke at the wedding of Deng Xiao Ping's great-granddaughter, it was seen that he had achieved a dramatic breakthrough in Anglo-Chinese relations' (*The Times*, 29 December 1994).

14 'Mr Blair's device is to sing Tory tunes using Tory rhetoric about the need for wholesale reform of the welfare state. Why should the electorate prefer karaoke Conservatism to the real thing?' (*The Times*, 23 August 1995).

15 *An Interview With Dennis Potter*, Channel 4 Television, broadcast on 5 April 1994.

16 See *Potter on Potter* (Fuller 1993: 84–5).

17 From the edited transcript, *An Interview with Dennis Potter*, Channel 4 television, broadcast on 5 April 1994: 16.

18 ibid.: 17

19 ibid.: 16

20 *Potter on Potter* (Fuller 1993: 80).

21 A popular seaside resort on the northwest coast of England since the middle of the nineteenth century, it was recently described by one commentator in these terms: 'If the Church of England was the Tory Party at prayer, Blackpool was and remains the working classes at play ... to ridicule its attractions would be to ridicule an entire culture' (*The Times*, 7 March 1993).

References

Baily, Peter (1987) *Leisure and Class in Victorian England*, London: Methuen.
Channel 4 Television (1994) *An Interview With Dennis Potter*, edited transcript of television interview broadcast 5 April 1994.

Disraeli, Benjamin (1985) *Sybil or the Two Nations*, Harmondsworth: Penguin.

Ellman, Richard (1987) *Yeats: The Man and the Masks*, London: Penguin Books.

Finnegan, Ruth (1989) *The Hidden Musicians: Making Music in an English Town*, Cambridge: Cambridge University Press.

Fuller, Graham (ed.) (1993) *Potter on Potter*, London: Faber and Faber.

Golby, J.M. and Purdue, A.W. (1984) *The Civilisation and the Crowd: Popular Culture in England 1750–1900*, London: Batsford Academic and Educational.

Hobsbawm, Eric (1987) 'Mass-producing traditions: Europe, 1870–1914', in Eric Hobsbawm, and T. Ranger (eds) *The Invention of Tradition*, Cambridge: Cambridge University Press, pp. 263–307.

Hoggart, Richard (1957) *The Uses of Literacy*, Harmondsworth: Penguin.

Jackson, M. (1976) *The English Pub*, London: Collins.

Lum, Casey Man Kong (1996) *In Search of a Voice: Karaoke and the Construction of Identity in Chinese America*, Mahwah, New Jersey: Lawrence Erlbaum Associates.

Potter, Dennis (1996) *Karaoke and Cold Lazarus*, London: Faber and Faber.

Summerfield, Penelope (1981) 'The Effingham Arms and the Empire: Deliberate selection in the evolution of the music hall in London', in E. Yeo and S. Yeo (eds) *Popular Culture and Class Conflict*, Brighton: Harvester Press.

Taylor, John (1972) *From Self Help to Glamour: The Working Man's Club, 1860–1972*, Oxford: History Workshop Pamphlets, no. 7 (Ruskin College).

The Times, editions as quoted.

Thompson, E.P. (1963) *The Making of the English Working Class*, New York: Vintage.

Walton, J.K. and Walvin, J. (eds) (1983) *Leisure in Britain 1780–1939*, Manchester: Manchester University Press.

Winter, Jay (ed.) (1983) *The Working Class in Modern British History: Essays in Honour of Henry Pelling*, Cambridge: Cambridge University Press.

Yeo, E. and Yeo, S. (eds) (1981) *Popular Culture and Class Conflict 1590–1914: Explorations in the History of Labour and Leisure*, Brighton: Harvester Press.

5

FROM TV TO HOLIDAYS

Karaoke in Italy

Paolo Prato

Prologue

Summer 1995: two weeks in the sunlight of southern Italy. A holiday camp near Crotone, in Calabria, the town where the Greek philosopher Pythagoras founded his celebrated school. There, as in many other resorts scattered along the Ionian and Tyrrhenian coasts, you can experience a Club Med-style vacation on a lower budget. Leisure activities are the highlight of Ionian Village (the name of the multi-purpose hotel), with the aim of giving people a good time (this type of vacation is modelled upon the drives of the archaic feast: more stimuli and contacts of an aesthetic nature are compressed in a restricted space for a limited span of time). Monday night is theatre, Tuesday is quiz night, Wednesday is 'Calabrian night', Thursday karaoke. Folklore, with its cooking, dressing and singing traditions, survives side by side with TV culture – national traditions shaped on American forms – and the newest fad imported from Japan, karaoke. If you are a 'highbrow' tourist and you go south in the search of those objects of desire narrated in two centuries of travel literature, you would be disappointed. The sun and the sea are still there, though the latter not as clean as it used to be when people did the Grand Tour. Many local products are still available, unfortunately for a higher price than if bought in supermarkets: after all, this is still the land *'wo die Zitronen blumen'*, as Goethe put it. But, apart from these and a few more 'signs of authenticity', the average tourist who takes a holiday in a *'villaggio-vacanze'* wants to find what he/she already knows, and wants to experience what he/she has read about in trendy magazines. In such 'pseudo-places' (Paul Fussell 1980) that all look the same, you have the opportunity to brush up your skills, knowledge, even beliefs, as you are constantly under the gracious (and often invasive) attention of the G.O.s (*gentils organisateurs*: the boys and girls organizing the leisure time, that is, *all* the time at your disposal except when you are sleeping . . .).

Music and games have often gone together in modern Italy, as we will see later. This may be one of the reasons why karaoke has caught on very quickly with the older generation also. In Club Med resorts and the like, karaoke has become a much requested extra alongside dancing, table-tennis, a swimming pool, colour TV and games of all kinds. A highlight of what we call *'animazione'*, i.e. socializing activities led by a team of *'animatori'*, karaoke favours the exchange of stereotyped musical expressions by means of which complete strangers get to know each other in a more active way than sitting in front of a TV set or a chess deck or on a tennis court.

Let's go back to Thursday night. A TV set is brought to the swimming pool around 10 o'clock, while a group of tourists occupy the seats and the available armchairs all around the pool. A DJ makes an announcement: the karaoke night is about to begin, everybody is invited to join in. Who wants to break the ice? A chubby, short woman, pushed by her husband, goes to the little area in front of the spectators and grabs the mike. She is clearly embarrassed, but the blush on her face suddenly disappears when she starts to sing a song by Massimo Ranieri, 'Rose rosse'. The audience sing along, so they help her, but they are also having fun. It looks like a secular mass, with the officiant leading the choir to the sublime peaks of praise to God. Only, there is no God to praise. Just us, our faces, our shared musical memories. No contest is going on: the mike circulates among those who stand up and want to try that particular song, while the rest continue to sing along, in a lower tone.

Summer 1996: my wife and I have chosen another camp on the Tyrrhenian coast of Calabria. Its very name betrayed its promises: Shangri-la, a paradise for another two weeks . . . , located at Marina di Fuscaldo. Inevitable, this time on Friday, was the karaoke night. This one was a little different, however: first, there was a real stage; second, the event was organized as a contest. Some ten people had already registered in the afternoon as participants. The rest stayed seated, as the audience, ready to vote for their favourite singer at the MC's signal. No sing-along this time for a technologically frustrated karaoke: no TV set was available, displaying the words of the song. The contestants sang along with the instrumental part recorded on a tape, while reading the words on a piece of paper. Not a 'real' karaoke, therefore, but a 'blind' version of it. Never mind . . . it was a new experience for many and lots of fun for everybody. Rather than a visceral and more informal happening like the first one in Crotone, where the public was always part of the game, this one appeared to be a more spectacular type of event. If the first recalled a secular mass, the second was a copy of a TV variety show.

Karaoke in Italy fluctuates between these two poles: the long tradition of singing along in thousands of situations and the extraordinary popularity achieved by a TV show launched in 1992 by Fiorello. In other words, the

Italian form of karaoke is a new type of singing together made popular by TV and then assimilated into our traditions. As it is a technologically more advanced way to do – and do better, with all the right words instead of the many holes in our memory – what generations of Italians have been doing for ages, karaoke will probably last longer than a mere fad.

A rock concert where you are the star: the introduction of karaoke in Italy

The first attention the popular press devoted to the phenomenon dates back to 1988, covering some pioneering karaoke singing held at Gilda, Rome's top jet-set club.[1] Four years later, the first karaoke bar (Bella: lì) is opened in Milan. There you can make a copy of the video cassette recorded during your performance.[2] Two more years and the fad spreads all over the country thanks to a TV show that started on 28 September 1992 with very little fuss, but takes off, in a few months becoming a veritable 'mania': it bears the obvious title *Karaoke* and creates a new popular hero, the good-looking Fiorello as Master of Ceremonies. Born in Augusta (Sicily) in 1960, Rosario Fiorello had long worked in holiday camps as an *'animatore'*, developing a natural aptitude as an entertainer. Vocally gifted, he often sings along with competitors, especially if someone goes out of tune, or misses the beat. Adored by teenagers for the ponytail that has become his look, Fiorello introduces a different programme every night, with different songs, audiences and competitors, in different cities and villages throughout Italy. His *Karaoke* focuses the TV camera on hundreds of squares which function again like 'music centres' for the community. In every town the potential competitors have to audition to be selected for the show, so that the final quality of the performance is never too bad: they are all amateurs, but often with some experience (e.g., club singers, local DJs, music students). Sometimes, though, they are chosen at the very last minute, just for their face.

The show starts at 8 p.m. and stops at 8.30, from Monday to Friday, actually lasting less than thirty minutes because of many commercials. It is broadcast by Italia 1, the third of the Mediaset channels – Fininvest (Berlusconi's) TV holding, which also runs Canale 5 and Rete 4. Italia 1 specializes in programmes, films and entertainment shows for the young. At that peak time, the most popular of the TV day, Fiorello's show had to face competition from such top-rated shows as *TG Uno* (the news on RAI Uno, the first public channel) and *TG 5* (Canale 5 news), plus the other programmes broadcast by RAI Due (the second part of *TG 2* news), RAI Tre (*Blob*, a cult TV trash programme) and Rete 4 (usually a political talk show). Notwithstanding all these long-standing 'giants' of Italian TV, the second series of *Karaoke* (1993–94) took a 20 per cent share, with 5.5 million viewers.

The competition is entirely decided by the crowd's cheering, by a machine that automatically records its intensity. The winner (one each night) receives a radio or a TV set as a prize but, more importantly, he/she achieves three minutes of glory in front or their friends/parents/acquaintances and his/her status will grow in importance. Some will get more pay if employed in a local club. To make the show more spectacular, its producers (Fabrizio Castelletti and Massimo Dorati) have decreed that each song must be sung by three competitors, one at a time.

Karaoke has caught on especially in the provinces, where life is more subject to routine than in the big cities and the seductive aura of being a TV hero is more appealing. In the first series (1992–93) the show visited ninety towns with a total distance travelled of 40,000 kilometres (equal to the earth's circumference), reaching an average of 3 million viewers per night. In the second series, major cities like Genoa and Milan were also visited, and the final show took place in Rome with the participation of such famous guests as the city mayor, professional singers, actors and journalists engaged in a furious, exhilarating 'singing battle' in squads. *Karaoke* has had a promotional effect on the small towns which it has visited, by showing another Italy to the rest of the country. If the squares looked very different from each other, the public, however, all looked the same: same screams, same excitement, same songs, same desire to show off. As well as the many professional karaoke sets bought for bars and discos, another industry which has benefited from the karaoke effect has been publishing: Fabbri and De Agostini, the two leading publishers in the kiosk market,[3] launched *Cantautore* and *Canto anch'io*, two partworks products based on 'blind karaoke'. Both consist of a cassette containing between six to eight famous songs available also in the 'minus one' (the voice) version, so as to make purchasers – provided with written lyrics – practise on their own. Sold very cheaply, these products are the first self-taught popular singing courses in Italy.

Karaoke's success has opened up a flourish of polemic and debate, the typical consequence of the spread of a new technology/fad/collective behaviour. In Italy such issues often take on a political dimension, and karaoke is no exception.[4] The country was all of a sudden divided between karaoke fans and karaoke critics: the former were seen as superficial, hedonistic, therefore right-wing. The latter were critical, snobbish and left-wing. Probably because of its association with TV and, especially, Berlusconi's TV, which is regarded as reactionary and consolatory, karaoke has had a right-wing reputation in Italy since its beginning. Almost every significant commentator has declared his/her antipathy towards the new fad. Psychoanalysts were the first to destroy karaoke: 'It's food for the stupid ... It relies on people's inferiority complex. I'm sure that, among the participants, you would not find any individuals gifted with psychological richness' (Aldo Carotenuto quoted in Marina Cavallieri 1994). 'I

don't see any psychological implications. It's just a collective fad, bound to fade away,' said Emilio Servadio (quoted in Marina Cavallieri 1994). 'Once we had the yo-yo, now you have karaoke.' The realm of the banal is enriched by sociologists:

> It makes me think of two great historical phenomena related to improvisation: the *commedia dell'arte*, based on absolute improvisation, and the numerous trills that the sopranos of 1700 featured. Mass society has levelled us, but this way of standing out against anonymity does nothing but confirm the levelling itself.
> (Franco Ferrarotti, quoted in Marina Cavallieri, 1994)

Music critics and journalists share these viewpoints, fluctuating between paternalism (youths just want to have fun) and negative criticism.

But karaoke also has supporters such as Vera Slepoj, president of the Italian Psychology Association: 'Italians love to show off, they love to be the focus of attention. Karaoke is good, maybe even necessary. It's a form of communal feeling certainly less harmful than soccer fanaticism, which often ends in violence.'[5] Rarer are its distinguished fans, such as the Bishop of Pescara, one of the cities visited by Fiorello where turmoil, caused by an indisciplined audience, disturbed the show (like a rock concert with no stars) who said: 'I should have liked to go, it certainly was a good opportunity to meet the young. Their desire to be together is enormous'.[6]

A singing country: the making of a national passion

Singing is present in virtually every documented culture of the present and the past, neither more nor less than arts and crafts, dance, food or religion. To a certain extent every person is educated in singing by the community, and has lots of chances to practise this skill from childhood to adulthood. However, when you compile a list of national features, maybe not everyone would put 'singing' as a leading national passion. However, Italians would. There is a great deal of stereotyping in this, and stereotypes help to make the distinctions clearer between oneself and the Other. However, there is a long history to prove that a lot of this is true – as with most stereotypes.[7] I will start in Naples, the cradle of our singing tradition which began around 1200. One of our most ancient songs is 'Il canto delle lavandaie del Vomero', which was sung by the young washerwomen while washing linen by the brooks on Naples' hill. Work songs are the first form of collective singing in Italy, and they are present through the centuries (although they are a dying genre), from Sicilian fishermen to Abruzzo's shepherds, from Piedmont's cobblers to Padana Plain's rice-weeders. The other ancient form of collective singing, the ritual chant, is tied to the religious calendar (Christmas, Easter, wedding, spring rites, etc.).[8] Work and festivals, the two

major aspects of community life in a pre-industrial society, have always represented an important background for singing. With the growing secularization of *mores* and the arts, a third pole emerged: leisure time. In what we call 'free time' (*tempo libero*), people do not sing to alleviate any fatigue (as in the work songs) nor do they sing to celebrate any event (as in the ritual chant): they sing for pleasure. For the pleasure of being together, passing some pleasant hours having fun – with drinking and eating as secondary but much appreciated ingredients. A question arises, at this point: what did Italians sing when they gathered for secular, non-productive reasons? Certainly not the work songs nor the ritual chants, for these repertoires were strictly tied to their occasions (only in the last few decades have most work songs ceased to serve their function and be considered aesthetic artefacts, and thus added to the traditional songbook as a sort of 'nostalgia-reminder'). Italians sang new songs composed by authors who were no longer anonymous, but recognizable, with their names known to all, and their lyrics were concerned with daily life (above all love). Historians date the beginning of Italian song to the first half of the nineteenth century,[9] the time in which industrialization and urbanization take over, and situate its artistic maturity towards the end of the century, with the extraordinary flourishing of Neapolitan song.

Neapolitan is the first language of Italian song, long before a truly 'national' songbook was formed in the age of Fascism. For half a century Neapolitan songs were heard throughout Italy and the states that, before 1861 (the date of the constitution of Italy), were to merge their territories into the new state. This heritage brought together various ingredients of Italian music, from the eighteenth-century *Opera buffa* to nineteenth-century melodrama; from the ancient folk modes (an Arabian legacy) to the sophisticated harmonies of art song.[10] At the same time, however, another songbook was being written by the many soldiers who defended their country. From the *Risorgimento* to the First World War, which represented the climax of creativity, hundreds of songs were composed – mostly by amateur musicians and poets – or appropriated from regional traditions and transformed into Italian songs to be sung collectively. Although many of them kept their original dialects (especially those of the mountain regions such as Veneto and Friuli, where most of the battles took place), the military war chants became Italy's first songbook. None of these songs were written for artistic reasons: they were made to be sung at the front, far from home and one's family and loved ones. Their diffusion among the troops promoted the adoption of Italian as a national language at a time when it was spoken only by the upper classes, while the rest of the population spoke only forms of dialect. This gave birth to the two other oral repertoires of the present century: that of the *mondariso* (the female rice-weeders, who experienced a sort of feminine military life, in their being almost segregated far from home) and that of *canti della Resistenza*

(songs of the Resistance, sung by the partisan movement during the Liberation war from 1943 to 1945, then extensively adopted by all Italians).[11]All these songbooks originated in the country and were kept alive by the lower classes, circulating as folk songs at a time when word of mouth was no longer the dominant form of communication. Urban culture, on the other hand, developed its own songbooks in theatres and clubs. At the turn of the century, Naples was the capital city of urban song, with its flourishing music industry (authors, publishers, performers) and its 'musical' people (many of its most appreciated composers were illiterate and did the poorest jobs). Moreover, Naples' proliferating *cafés-chantants* and music halls established the sociological foundations of what is now singing behaviour in the 'society of the spectacle'. In those places people came in not only to listen and watch, but also to participate in the artistic event by singing along and accompanying the acts on stage by making a noise, whistling, handclapping, foot-tapping.[12] However, the *café-chantant* culture, then developing in the music hall and which eventually reached the established theatres, was relegated to certain cities and certain publics. Only radio could mould a national culture featuring popular music which had an unprecedented success during the years of the regime.

Radio, TV and open-air contests in post-war Italy

Inaugurated in 1924, Italian public radio (first EIAR, then RAI from 1946 on) soon revolutionized popular music production in the country. It favoured the establishment of a homogeneous national songbook that little by little took over the regional folk repertoires in dialect. Neapolitan lyricists, for example, began to write in Italian to serve the new and anonymous public – which marked the end of classical Neapolitan song. In doing so, radio was strictly controlled by the Fascist regime, which built a large following thanks to its programmes, speakers and singers.[13] The state required disciplined participation in the collective rituals held on Saturdays (the 'Fascist Saturday' involving the young *Balillas* – youths in Fascist uniform – working out and singing), by imposing its utilitarian hymns and chants which were of scant artistic value, but were very functional in directing emotions. By these official occasions, the state promoted the use of popular music as a way of escaping from daily life. It was this 'secular' music, not the political hymnody, that was kept alive. Radio became a sounding box for the extraordinary will to sing that caught on in the 1950s, after the Sanremo Festival was launched in 1951. This radio event (from 1953 also on TV) had an incredible impact on Italians' habits: for a few years (until the early 1960s with the same intensity) every little village, town or city from the Alps to Sicily, organized a song festival no matter whether it had renowned singers or unknown amateurs. It was like a mass craze, equalled only by the cinema craze (mass auditions for a walk-on

with Visconti or Fellini . . .). Talent scouting was the primary aim of those festivals, which, however, also played a strategic role in attracting tourists: most of the festivals were dedicated to new songs in Italian, but many were devoted to specific dialects and topics such as the Venetian landscape, religious songs, the mountain song, the seaside song, the camping song (!) – sponsored by the Associazione Campeggiatori Turistici d'Italia (Camping Tourists Association of Italy). The sporting character of such events can be recalled by such titles as the Olimpiadi della canzone di Roma (the Song's Olympics of Rome). There were hundreds of these festivals, held all year long, for almost a decade. Some of them were also exported, such as the Festival della Canzone Italiana hosted in Paris (1954) by Maurice Chevalier, followed by similar occasions in Zagreb, Zurich, Madrid, and so on. Others have survived to the present and still supply young talent to the music industry. But the real selection took place on radio, where fewer contests always hit the target by discovering the professional talent who would then become famous. Nevertheless, what is more important in this context, the myriad festivals legitimated a national passion by transforming it in a potential utopia: everyone could take a chance and make of his/her 'natural' voice an instrument of fame and money.[14] From here to karaoke is a short step: one could say that karaoke is a disenchanted festival-mania, in that it does not offer any utopia, but just fun. In this respect, karaoke is more akin to the juke-box ('two minutes of happiness', wrote Jean Baudrillard in 1974). It is a secular approach to singing whereas festivals displayed a sacred aura as a passport to eternity. To do so, i.e. to take it more seriously, organizers accepted only new songs, and thus festivals were highly respected by composers and publishers too. Karaoke, by its very nature, cannot accept any new songs: a song must be known and famous to enter its world. It would make no sense to present a new song through karaoke, because karaoke is a container of what has been assimilated for a long time. It is one of the last links in the record industry chain – not even 'secondary exploitation', as much as 'tertiary' or 'quaternary'.

If the roots of karaoke singing can be found in the making of a national songbook promoted almost exclusively by radio, the rules of its functioning must be traced back, in Italy, to television and to the 'quiz mania' that boomed in the early 1960s. Some of the most popular quiz shows were centred on music. The most famous was *Il musichiere*, which was revived in 1996, 36 years after its start, and has always been a feature of domestic parties. TV is certainly mother to the Italian form of karaoke in so far as another programme such as *La corrida* can be considered the real forerunner of the karaoke competition made famous by Fiorello. With the subtitle of *dilettanti allo sbaraglio* (amateurs taking a chance), the show consists of anonymous, ordinary people striving for a prize by dancing, imitating animal sounds, impersonating actors and singers, whistling, playing music

(odd instruments, such as your mouth deformed by the hands, so as to produce weird sounds, are welcomed) and, of course, singing.

La corrida is one of the longest-running shows in Italian media history. Begun as a radio programme in the mid-1960s, it moved to TV (Canale 5, Berlusconi's 'flagship' channel) in the 1980s exploiting, for more than three decades, the Italians' masochistic drive to show off. Together with the internationally renowned Sanremo Festival and the Saturday night variety show of RAI Uno, *La corrida* is the most representative symbol of popular national culture,[15] focusing, as it does, on the 'protagonism mania which pushes *dilettanti* from all around Italy to show off'. This is shown to be one of the basic ingredients of the Italian temperament.[16]

Karaoke as highly ritualized *loisir*: some theoretical hypotheses

Singing competitions are an ancient phenomenon that ethnomusicologists have observed in various cultures, from the Eskimo to Tuscany. Mostly, the winner is he/she who finds the best and most appropriate words (insults, provocative lines) to beat his/her rival, so therefore it is neither the power of the voice nor its beauty which counts.

Karaoke is a secularization of these traditions: there are no words to invent (it would take too long, the competition must be held within 'showbiz' time rules, therefore it must be fast), so the match is centred on the level of expression instead of the content. No one pays attention to what the competitor sings, because it is well known. Everyone focuses on the quality of the voice, and the degree to which it approximates the Urtext, i.e. the original record of the song. The 'liberating' function that singing has in many oral cultures,[17] here applies only to the signifiers, thus stressing the expressive and aesthetic function at the expense of the communicative function featured in traditional cultures.

Karbusicky speaks of a 'hedonistic function' of music that should be somehow 'pre-aesthetic': 'Der ganze Effekt der hedonistischen Funktion ist z.B. lediglich eine Erwärmung der Empfangs-apparatur, ihre innere Exzitation, die diese selbst als etwas Angenehmes empfindet.'[18] Music for pleasure, therefore, to quote a famous promotional slogan coined by the record industry. For 'pleasure' is the meaning of the Greek word *hedone*, and pleasure is precisely the object of those 'trivial pursuits' taking place during the metropolitan nights populated by singing youths, and after-noons spent by the swimming pool by elderly couples reliving their youth around a microphone … These two faces of karaoke – city bars and summer camps – witness a different use of singing: it is not for aesthetic purposes (if you want that, you go to opera), nor is it for mere distraction (if so, you go to a cocktail bar). Karaoke brings forth music which deserves absolute attention – a primary listening – but is aware of the fact

that there is a simulation going on – more probably, a parody of what one has learned from living in a society where singing is a professional matter, dealt with by experts. It can switch from parody to serious reception only when the artistic results are satisfying: then applause takes over from laughter. A karaoke audience gathered in a holiday camp or in a downtown club is relaxed enough to apply mild criteria of judgement, which are, naturally, very different from those applied in a serious context (e.g. opera): you don't boo if a note is off. You are more likely to ignore it, grin or just smile, for a sort of complicity has been established between the stage (often a table, in the middle of others) and the audience: there are no stars, no great differences in the artistic rendition, therefore everybody shares the same feelings (from stage fright to the self-awareness of one's limits . . .). Moreover, you neither boo nor even critically comment by humming – which is typical of opera fans – because there is no ticket to be paid for. Karaoke is free (at most it costs you the same as a jukebox) and this lowers the level of critical judgement.

In English, French and German, performing music and playing games share the same verb: to play, *jouer*, *spielen*. Karaoke seems to me a good example of this lexical and conceptual encounter. I see karaoke as *loisir*, similar to other practices that stand between intellectual games and sport. It involves the mind (culture, memory), the machine (a technical apparatus) and the body (singing, shouting). Like many leisure activities, karaoke features competition and laughing, the two poles that make a party and, generally speaking, a convivial situation successful. *Loisir* can tend to *style* – what Paul Rambali calls 'international leisure style', including such fashionable activities as playing frisby, windsurfing, beach volley-ball and the like – and it can tend to *emotion* – where the 'self' is also involved. The first type of leisure does not require the display of 'real' emotion in public: it is mostly played at an individual level, or calls for two people at maximum. It does not have a spectacular dimension. The second type, on the contrary, needs a collectivity to be effective. And a collectivity, notwithstanding its temporary existence, is aroused by human elements, not by mere representation.

I would thus argue that karaoke is a good example of leisure activity, combining:

- competition;
- emotion;
- mask;
- laughter.

If we combine these ingredients with Caillois' theory of games, we can see that karaoke shares at least three of the four features indicated by the French scholar as constitutive of games:[19]

1 Competition is what Caillois calls *agon* – the mere sporting element.
2 Emotion is what he calls *ilinx* (vertigo), only with a weaker connotation – panic, stage fright.[20]
3 Mask is what he calls 'mimicry' – *'le plaisir d'être autre ou de se faire passer pour un autre'*.

Only *alea*, that is 'chance', is absent from karaoke: everyone knows what he/she is going to sing. Instead of *alea* we have 'laughter', which is its opposite: if *alea* is lack of information, laughter occurs in the redundancy of meaning.

I would like to suggest that karaoke singing stands somewhere between games, music, simulation and a community rite. It shows characteristics that belong to all four, but does not coincide too much with any of these. All but music – tied as it is to the local culture (Anglo-American pop is scarcely represented in comparison to Italian pop, as we will see later) – are universal behavioural modes, or 'frames', to use an interactionist terminology. These frames, which predetermine people's rules of interaction and the meanings that are produced during its display, are easy to find in everyone's experience. We are often required to behave as if we were playing a game, or taking part in a contest (both at work and in private). We often have to play roles or pretend to be other than ourselves. We often find ourselves in the middle of rituals that reinforce our community ties. All these frames, centred on a more particular, cultural element (music), make up a karaoke event: the game frame is what makes karaoke different from an ordinary situation (a party, a bus trip) where people sing to a guitar or similar instrument. It establishes a hierarchy within tacitly accepted rules (aesthetic, sociological). The simulation frame is the skill of role-playing (theatrical, TV roles) and reveals one's knowledge of the shared culture. The ritual frame establishes the success or failure of the event – sanctioned by applause or laughter. Finally, the music frame involves both the physical quality of the voice and the degree in which a certain repertoire has been correctly assimilated. It is precisely this frame that makes the difference. 'In rituals, the central event is acoustic', wrote Marius Schneider.[21] The rituality embodied by singing [22] doubles the rituality already predetermined by the 'community rite' frame. The result is a highly ritualized leisure activity, which is my succinct definition of karaoke. In a unique mix of universal (anthropological) and particular (cultural) factors (frames), I see its appeal and its remarkable spread from Japan.

Domestic vs. foreign songs: an analysis of karaoke playlists

In choosing for the most part a domestic repertoire (due to the ease of reproducing it, as well as the fact that it is often known by heart), Fiorello's

Karaoke takes up an old and never-abandoned debate: Italian song versus foreign song. The roots of this debate can be traced back to the early decades of the nineteenth century when Italian music was representative of a Mediterranean, southern way of music, as opposed to the northern, represented by French, then English and, above all, German music. The debate originated with the *querelle des bouffons* in the eighteenth century – French vs. Italian opera – and culminated in the second half of the last century in the battle between fans of Wagner and Verdi. A commentator on our national history, Giuseppe Mazzini (a republican theorist and a politician), wrote that 'Italian music has been melodic at the highest degree, since Palestrina translated Christianity in notes.' Writing in exile (France), he accentuated the nostalgic elements by outlining the characteristics of Italian music: 'Lyrical up to delirium, passionate up to rapture, volcanic as the ground where it was born, sparkling as the sun that shines on that land.'[23] Marco Santucci, *Kapellmeister* in Lucca from 1790 onwards, wrote that foreign melodies are 'over-refined, difficult to play instead of *cantabili*, bizarre, harsh and sometimes barbarian'. He counterposed the 'plain, easy, natural and expressive sing-songs' of our *maestri*.[24]

For the most part, however, the predominant role that Italian songs have in *Karaoke* – and in the many karaoke bars which have appeared in almost every city of Italy – has to do with language, not with music. First, English as a foreign language is not as extensive in Italy as in other European countries. Second, Anglo-American pop shares half of the record sales with domestic pop, whereas in most other countries of Europe it largely predominates over domestic repertoires (with the exception of France). It might be interesting to take a look at the songs that made up Fiorello's show for an entire year. They will not only shed light on what is more *cantabile* but also on the penetration of international pop into mass tastes.

The data I quote refer to a scrutiny of the show's second and most popular series (1993–94), after which Fiorello moved to other TV shows and his *Karaoke* was taken up by his younger brother Fiorellino ('little Fiorello'). Both moves, however, were unsuccessful and the show was finally dropped in 1995.

That 'magic' series lasted 239 nights, with almost 1,200 'karaoked' songs. Many of them were sung again and again over the months, depending on their appeal, so that the total number of songs did not exceed 360. The first data refer to the national vs. foreign split: Italian songs take 82 per cent of the whole repertoire and 84 per cent of the entries, i.e. the number of times each song is performed. The second group of data refer to the historical distribution of the songs: most are contemporary, that is, belong to the 1990s (33 per cent of the entries) and the 1980s (28 per cent). Considering that the 1990s were only four years old at the time of the show (1993–94), we could say that *Karaoke* was a hyper-contemporary

113

show promoting the songs of the day for exactly one-third of its total. The 1970s take 23 per cent, the 1960s 14 per cent and a few oldies the remaining 2 per cent. Talking about foreign songs, however, the 1980s are more represented (42 per cent of the whole foreign repertoire) than any other decade. In this respect, *Karaoke* must have acted in tune with the record business (consciously or not, for there are no data to prove it). But its patron was first of all the audience, and the choice of the songs to be performed each night was often dependent on the success obtained not only by the winner, but also by the appreciation accorded to the other songs presented. This is something which can be measured especially by the degree of collective participation in singing along.

1 'Non ho più la mia città' (launched in 1993 at the Sanremo Festival by Geraldina Trovato, a young representative of Italian new pop) with 13 entries.
2 'Nord sud ovest est' (by 883, a pop–dance group, best-sellers in the 1990s).
3 'Battito animale' (by Raf, a pop singer–songwriter), with 12 entries.
4 'Ragazzo fortunato' (by Jovanotti, a star-rapper).
5 'Il gatto e la volpe' (a hit from the 1970s, in the rock'n'roll style).
6 'La canzone del sole' (the best-loved song by Lucio Battisti).
7 'Terra promessa' (the first big hit for Eros Ramazzotti), with 11 entries.
8 'Azzurro' (the most internationally known hit of Adriano Celentano, first 1960s entry).
9 'C'era un ragazzo' (a protest song of the late 1960s also covered by Joan Baez).
10 'La solitudine' (Laura Pausini's first hit), with 10 entries.

The first three hit songs were all contemporary. Most performed among foreign songs were Whitney Houston's 'I Wanna Dance with Somebody' and Madonna's 'La Isla Bonita', with 8 entries, followed by 'All That She Wants' (Ace of Base), 'What's Up' (4 Non Blondes), 'I Will Always Love You' (Whitney Houston), 'Material Girl' (Madonna) and 'We are the Champions' (Queen).

The more we scan through the remaining titles, the more we come across a repertoire of 'singable' songs that make up most of what phenomenologists would call 'shared knowledge' in the field of music. Or, to put it better, in the sub-field of the 'shareable', 'socializable', 'exportable' music. No wonder, therefore, that the majority of songs are Italian: singing (unlike listening, which, being passive, is open to experiences which are more distant for the individual) is an activity close to chatting, and people like to chat in their own language. No wonder that the majority of the songs are contemporary: *Karaoke* is a (private) TV show, tied as such to a market-oriented mass medium where the nostalgia appeal (very strong in

non-TV contexts) must be handled with care. Oldies, folk and regional songs, for example, are virtually absent from this list, whereas they always come up in every singing party. But since they don't have any commercial potential, they do not belong on *Karaoke*. The 360 songs performed all year in Fiorello's show represent a good starting point to map out Italians' popular tastes, although they might resemble what the record industry would like to think of them rather than what they really are.

Conclusion

The Fiorello show has contributed to Italian culture by homogenizing and institutionalizing a vast repertoire of songs that are commonly sung in informal meetings such as private parties, school trips, parish meetings,[25] after-dinner parties, and so on. For centuries, generations of Italians have been singing songs while riding trains and driving cars, at the bar and in the tavern, at the oratory and the picnic: some are contemporary, others belong to one's parents' or even grandparents' time. Fiorello has selected songs from this enormous container which nobody has ever traced the limits of (nor have its formation and changes through the decades ever been studied) and has given it a form. TV has legitimated an oral knowledge – pop songs, once appropriated by an anonymous public, become an oral form of communication like folk songs – by transforming it into a formalized culture. For many TV fans, a Fiorello hit like 'Io, vagabondo', a famous 1970s song launched by the group Nomadi, will never be the same again when sung together on the beach or – more appropriately – in a karaoke bar. Not the song itself, taken in its 'originality' (i.e. the Nomadi record), but the way it can be rendered by people like you in an informal context, has lost it its 'virginity': it is now clear that if you want to sing 'Io vagabondo', you refer – consciously or unconsciously – to the anonymous, yet spectacularized versions performed on Fiorello's show.

NOTES

1 See e.g. Paolo Scarpellini (1988).
2 Paolo Scarpellini (1992).
3 This market, with its more than 30,000 kiosks, is the leader in multimedia products. On kiosk publishing in Italy see Paolo Prato (1994).
4 As a witness of karaoke's popularity, one of the best-selling pamphlets in the political and cultural debate has been *La sinistra nell'era del Karaoke* (The Left in the Karaoke Age), written by internationally known intellectuals such as Norberto Bobbio and Gianni Vattimo and published by Reset in 1995. The book, however, has no reference to karaoke in itself: it just refers to it as a meaningful symbol of our times.
5 Quotations are taken from Marina Cavallieri (1994).
6 Quoted by Gabriele Ferraris (1994).

7 Stereotypes are employed to create a mood, to mould a mentality, to prepare a behavioural attitude (Anton C. Zijderveld, 1979: 18).
8 On Italian folk song see Roberto Leydi (1973).
9 For a history of Italian song see G. Borgna (1992); G. Baldazzi (1986); Paolo Prato (1986).
10 On Neapolitan song see Paolo Prato (1995) and Vittorio Paliotti (1992).
11 On these topics see Antonio V. Savona and Michele L. Straniero (1981) and *Montanara* (1987).
12 On *café-chantant* in Italy see Rodolfo de Angelis (1984); Mario Mangini (1967); and Stefano de Matteis, Martina Lombardi and Marilea Somaré (eds) (1980).
13 On the history of Italian radio see *La Radio, storia di sessant'anni: 1924/1984*, ERI, To, 1984; Franco Monteleone (1992).
14 On the festival phenomenon see Enzo Giannelli (1990).
15 This term must be taken in the sense given by Antonio Gramsci: i.e. a culture based on national values, conveyed by traditional, folk forms of spectacle.
16 Aldo Grasso (1992: 462).
17 See, for example, Alan Merriam (1964).
18 Vladimir Karbusicky (1973).
19 Roger Caillois (1967).
20 On stage fright see Stanford Lyman and Marvin B. Scott (1970).
21 Marius Schneider (1980: 20).
22 Singing is a peculiar means of communication. Its high degree of formalization 'ends up with conferring a particular ritual character to this cultural product', according to anthropologist Clara Gallini with regard to archaic societies that tend to communicate through singing and rhythmic formulae instead of prose (1975: 199).
23 Giuseppe Mazzini (1977: 51–2).
24 Marco Santucci (1981: 95).
25 The role of the parish as a socialization agency is most important in Italy: among its 'secular' activities, which regularly alternate with the sacred ones, singing is highly valued. During the long afternoons and Sundays spent on parish premises, young people become acquainted not only with the religious repertoire of hymns and anthems, but also with the popular songs of the present and the past. Pop songs – better if available with guitar accompaniment – represent an innocent contribution by the 'laymen society' which can help social and religious life to grow.

REFERENCES

Angelis, Rodolfo de (1984) *Café-chantant*, Florence: La Casa Usher.
Baldazzi, G. (1986) *La canzone italiana del novecento*, Rome: Newton Compton.
Baudrillard, Jean (1974) *La Société de consommation* translated as *La società dei consumi*, Bologna: Il Mulino.
Bobbio, Norberto and Vottimo, Gianni (1995) *La sinistra nell'era del Karaoke* [The Left in the karaoke age], Rome: Reset.
Borgna, G. (1992) *Storia della canzone italiana*, Milan: Mondadori.
Caillois, Roger (1967) *Les jeux et les hommes*, Paris: Gallimard.
Cavallieri, Marina (1994) 'Karaoke per cretini' [Karaoke for idiots] *La Repubblica*, 29 April.
Ferraris, Gabriele (1994) 'Karaoke, gioco esplosivo', *La Stampa*, 15 January.
Fussell, Paul (1980) *Abroad: British Literary Travelling Between the Wars*, London, Oxford University Press.

Gallini, Clara (1975) 'Dinamiche di produzione, trasmissione, fruizione del canto sardo', in Diego Carpitella (ed.) *L'etnomusicologia in Italia*, Padua: Flaccovio.

Giannelli, Enzo (1990) 'Un paese a forma di festival', in Gino Castaldo (ed.) *Il Dizionario della Canzone Italiana*, Rome: Curcio.

Grasso, Aldo (1992) *Storia della televisione italiana*, Milan: Garzanti.

Karbusicky, Vladimir (1973) 'Das "Verstehen der Musik" in der soziologisch-Aesthetischen Empire', in P. Faltin and H.P. Reinecke (eds) *Musik und Verstehen*, Cologne: Arno Volk Verlag.

La Radio, storia di sessant'anni: 1924/1984 (1984), Turin: ERI.

Leydi, Roberto (1973) *I canti popolari italiani*, Milan: Mondadori.

Lyman, Stanford and Scott, Marvin B. (1970) 'Stage fright and the problem of identity', in *A Sociology of the Absurd*, Pacific Palisades, CA: Goodyear Publishing Co.

Mangini, Mario (1967) *Il café-chantant*, Naples: Greco.

Matteis, Stefano de, Lombardi, Martina and Somaré, Marilea (eds) (1980) *Follie del varietà*, Milan: Feltrinelli.

Mazzini, Giuseppe (1977) *Filosofia della musica*, Florence: Guaraldi (original edition Paris 1836).

Merriam, Alan (1964) *The Anthropology of Music*, Evanston, IL: Northwestern University Press.

Montanara (1987), Milan: Mandadori.

Monteleone, Franco (1992) *Storia della radio in Italia*, Venice: Marsilio.

Paliotti, Vittorio (1992) *Storia della canzone napoletana*, Rome: Newton Compton.

Prato, Paolo (1986) 'Tradition, exoticism and cosmopolitanism in Italian popular music', *Differentia*, vol. 2.

Prato, Paolo (1994) 'Assalto all'edicola', *Musica e Dischi*, vol. 568, pp. 32–6.

Prato, Paolo (1995) *Cantanapoli*, Milan: Bramante.

Santucci, Marco (1998) 'Sull'armonia, sulla melodia e sul metro', in Antonio V. Savona and Michele L. Straniero *Canti della grande guerra*, Milan: Garzanti. (Original edition, Lucca, 1828.)

Scarpellini, Paolo (1988) 'Karaokami una canzone', *Panorama*, 24 April.

Scarpellini, Paolo (1992) 'Cantio anch'io . . .', *Panorama*, 2 February.

Schneider, Marius (1980) *Pietre che cantano*, Milan: Guanda. (Original edition, Singende Steine, 1972.)

Zijderveld, Anton C. (1979) *On Clichés: The Supersedure of Meaning by Function in Modernity*, London: Routledge.

117

6

FILLING VOIDS ALONG THE BYWAY

Identification and interpretation in the Swedish forms of karaoke

Johan Fornäs

As implied by its Japanese etymology, karaoke opens up a void in its combined pictorial and musical orchestration. There is a gaping hole in a karaoke video right where the vocalist's visual presence and aural voice are expected to be. This empty space is to be filled with the karaoke performer's own voice, body and soul. The interactive media phenomenon of karaoke thereby points out how playful and communicative uses – creations and interpretations – of meaningful symbolic forms are engaged in identity reconstructions. This music/video genre and practice form offer excellent opportunities to study how music, lyrics and videos are used in reception not only to shape experiences and meaning, but also to produce new musical statements. The way karaoke has been appropriated and reworked in the West sheds further light on certain differences in subject construction that might derive from contrasting ethnic identity patterns and forms of socialization.[1]

Interactivity

All media are to some extent interactive, in that they invite their users to participate, in the form of choices (of commodities, channels, programmes, genres, texts, occasions, localities and modes of reception) and of production (of insights, meaning, experiences, social relations but also new cultural expressions in their own words, gestures, images or musical sounds). All mediated texts can be modified by the use of technological tools controlling parameters like volume, timbre or balance, and each 'recipient' has to take an active part in the re-creation of those webs of meaning that are the primary goal of communication and cultural practices in general.

All media further offer imagined spaces or virtual realities to enter, as they carry symbolic structures that as meaningful symbols refer to spaces beyond themselves and construct imaginary worlds to be inhabited temporarily. These are truly inter-subjective – simultaneously inner and outer, emotive and cognitive. Hermeneutic reception studies have developed useful theories on how readers, listeners and viewers by 'disappearing acts' (Modleski) enter textual works to fill their open voids (Iser) and within 'interpretive communities' (Fish, Radway) (re-)create more or less discursive webs of meaning.

Recent discussions of interactive media and virtual reality have thematized new digital, audiovisual and electronic techniques that radically enhance this interactivity by explicitly focusing on the active co-activity of the recipients in the very formation of media texts. Each book or record is given a specific interpretation by each reader/listener in each particular situation, but these texts are none the less mostly experienced as relatively closed, 'given' entities, whose reception is understood as a more or less faithful reconstruction of their meaning–content than as the creative co-production it actually is. But for computer games, or television programmes where viewers are asked to participate in the show by telephone calls, the audience is expressly an integrated actor in the immediate production of the material text itself.

Such intensified interactivity is not new. The creative activity of the user is needed to complete an old-fashioned paint-book not only as a web of meaning (which is true for all texts) but also as a material work. Recent electronic media developments have only offered some enhanced and more debated techniques for this (cf. Landow 1992 and Turkle 1995/1996). In music, karaoke is a typical example of such an interactive digital media form. It also has many predecessors: contexts in which prefabricated structures are combined with personal 'performances'. Playing music or singing according to notes; singing along with recorded music at parties; young girls 'playback' miming to pop music; 'minus one'- records, where one instrumental part is missing, to be filled in by training musicians; and sophisticated musical collages by means of digital sampling are but a few examples from the realm of music.

Even in the silent movie era there were animated films where the lyrics of popular songs rolled up across the screen and the audience could sing along with the help of a little ball that bounced from syllable to syllable through the lyrics, perhaps to the accompaniment of a cinema orchestra, piano or organ. Max Fleischer is said to have invented this 'bouncing ball' technique in 1924, but other types of sing-along films existed even earlier (Maltin 1980; Crafton 1982). Similar animated films with soundtracks were later produced by Disney, and during the 1950s and 1960s television audiences were also encouraged to sing along to musical films with bouncing figures indicating which lyrics to sing. Thus, prototypes of karaoke as a

type of music video made for interactive use have been around for a long time, but karaoke heralds the future expansion and refinement of the interaction between living subjects, the machine hardware of different media and the textual software of various genres.

A mixed and polystratic genre

Karaoke hardware represents a medium or technological apparatus. As software, karaoke videos represent a separate music video genre, a sub-class of all music videos, but at the same time a super- or metagenre that itself contains a diversity of musical genres and sub-genres, which are related to different styles of pop music and television genres. It is not a definite musical genre unto itself, but consists of special versions of pop hits and other types of songs in video (laser disc) recordings without the lead vocalist's melodic line, but with the lyrics instead displayed on the video screen, together with various background images. As a medium and metagenre, embracing a diversity of musical genres, karaoke has grown up in an already complex and multi-layered field of other media forms and metagenres, with which it continues to interact.

Inevitably, it is the use and functional context of the genre that define its possible forms and contents, and these are as polystratic as are its external interrelations to other genres and media forms. The main layers in the karaoke video 'text' are three: written lyrics, musical sounds and pictorial images. They each have several different functions for different subjects (singer, listener, presenter) in different contexts (pubs or parties, public arenas or private homes). And they are in actual use completed by the adding of the vocal and bodily performance of the karaoke singer, with the background of the audience and the whole local and contextual setting of the venue in question.

In most 'ordinary' music videos, the singing fuses the lyrics into the music, thus forming an inseparable auditive flow of combined words and tones, where the tonal quality of the sung words enters the musical web while the musical forms and sounds contribute to how the verbal expressions function. In karaoke videos, the lyrics are instead visually presented, only to be transformed into song in their performative use. The video soundtrack is then purely non-verbal (some videos may contain vague lyric fragments of sung background choruses), the lyrics purely visual, and the music only auditive. Contrary to most music videos, karaoke ones seldom have images of musicians playing instruments or artists singing. Maybe famous artists would be reluctant to lend their personae to karaoke videos? In any case, it would be functionally strange to see a vocalist but not hear his or her voice on the track, or to see accompanying musicians, but not the lead singer. Furthermore, the amateur singer is probably not too eager to see and 'be seen by' the idol he or she attempts to imitate.

Such mechanisms cast some light on the interplay between forms and functions.

Besides the visual lyrics and the auditive music, the third, pictorial level is purely visual and rarely has any immediate counterpart on the sound-track, since no sound effects or the like are usually related to the film sequences. The pictorial scenes are mostly regarded as much less important to the (use and exchange) value of the videos than is the text line. Therefore, they often seem very hastily made – which does not imply that it would be irrelevant to ask why they have been put together in precisely this way, and what the semantic effects are supposed to be

Different elements of the karaoke 'text' have different functions for different subjects in different contexts. For the performer, the video images are most probably extraneous: it is the written lyrics that are focused on, and the video images should interfere as little as possible. But for those who are listening, an attractive flow of images may provide a welcome alternative to watching the performer.

There are often clear connections between the video images, the lyrics and the musical sounds of karaoke songs. This is a way to prevent the images from disturbing the performance, and also a way to make the pictorial composition easier without having to invent some other formal principle and making it work together with the structure of the lyrics and the music. However, the often much less elaborate production of these karaoke videos in comparison to those shown on TV channels like MTV leads to more mismatched elements: instances where the visuals do not fit the music at all, where cuts seem random and the images have no apparent connection to the content of the lyrics. Far more than in other film, TV or music videos, the karaoke images are pretty much downplayed and strictly subordinate to the visual lyrics and the sound track. One rarely sees the daring, rhythmical and agile complexity in time, space and style that characterize many pop videos, partly because aesthetic subtleties would be wasted in the often apparently hasty and low-budget karaoke productions, partly not to restrict the singer's associations too much when acting out individual identity-experiments in the perfor-mance. The pictorial sequences mainly function as a background. Instead of the often unconsciously perceived soundtrack behind the visual flow of a classical Hollywood movie, one can here talk about a quasi-neutralized 'image track' behind the rolling text strip and the instrumental music. Few would choose or reject a karaoke song because of its visuals alone.

Four analytical levels can be used (Fornäs 1995a): materiality; form relations; meaning; and functions. On the level of *materiality*, text, music and images contribute different physical and sensuous constituents: the graphic texture of the words, the sounds of the music and the colours and textures of the pictures are combined to form a complex composite video text. On the level of *form relations*, similarities or discrepancies can appear between the syntax of the words, the rhythmic, melodic, harmonic

121

and formal ordering structures of the music and the visual forms or sequential film patterns. On the level of *meaning*, the three forms of expression join to build a narrative that can be understood in various ways by those who use the video. A first analysis can stop there, and try to 'freeze' the video into a solid artefact whose meaning can be firmly delimited.

But there is also a fourth level, one of *functions* and pragmatics. The actual use of a video both realizes and modifies all the earlier levels. In explicitly interactive media, this is particularly obvious, since a karaoke video is in fact not a piece of finished 'work' until someone sings to it. Each performance thus adds still other dimensions to all four levels: new sounds and gestures, new ordering patterns, new meanings and new functions. The performance of the karaoke singer completes the graphics of the written lyrics with his or her own verbal phonetics, the musical flow with a personal voice and the materiality of the images with bodily gestures. The improvised interpretation of the song adds a personal phrasing, while a daring choreography or only some micro-changes of the lyrics and the melody can modify its total form structure as well as its meaning, not least by playing with intertextual references to earlier versions and covers of the song or to other but somewhat related songs.

Where is the meaning of a karaoke tune? Its interpretation faces several difficult choices. The intersection between the united forms of expression (lyrics, music, images – on the screen as well as with the performer) forces the analyst to search for its meanings in the complex interplay between them rather than in any one of them alone. This is true for film, TV, video and all multimedia. The intertextuality in associations to various artists, songs, films and genres demands a choice of which of these, in principle, innumerable references are most relevant to an understanding of this particular karaoke performance. The interactivity between works and their users – between audience, performer and video in a context of use – adds still more complexities, including subjective identities as well as intersubjective relations. This abstract and complex model forms a background to the following more specific discussion of karaoke on the Nordic scene and the illustrative interpretation of a particular karaoke video.

Karaoke made in Sweden

Karaoke took root in Sweden in 1989, when karaoke machines were introduced and several national newspapers ran articles on the phenomenon. It had some success up to 1993, when it lost ground again and was often despised as ridiculously 'out'. Pioneer and the Swedish organizers are therefore putting considerable marketing effort into trying to raise its popularity again.

Karaoke can be found in certain restaurants and pubs (in particular Chinese and Japanese ones), at outdoor events in city squares and in parks,

or in the bars on the larger ferries to neighbouring countries, in partic-
ular to Finland, where karaoke is said to be more popular than in Sweden
and where more domestic material is also produced, though in Finnish
which Swedes cannot understand. In a few venues around Sweden, tiny
groups of regular *habitués* meet to perform a rather fixed stock of songs.
Karaoke video cassettes are on sale in record shops and petrol stations,
and the hardware may also be rented or purchased. There have some-
times (but rarely) been karaoke games in entertainment programmes on
television and commercial radio.

Professional karaoke organizers find it so hard to attract audiences
without the competition element that they almost always have to include
it. Therefore, even company parties are often included in the Swedish
championship qualification series, where the winner has a chance to go
on to some later final. A handful of people travel across the country and
organize such competitions on licence from the Karaoke-Sweden enter-
prise. In the summer, they are mostly public outdoor events, while the
wintertime is dominated by indoor parties for the employees of various
companies. An audience of perhaps 1,000 enjoys the national final in
Stockholm, where a Swedish karaoke master is picked among those who
have qualified in earlier local and regional competitions.

Swedish karaoke is most typically performed by a group of between
two and four women singing *schlager* or pop hits, or golden oldies from
the 1950s, 1960s or 1970s. Anglo-American and Swedish songs are roughly
equally chosen. Solo performances are rarer, as are mixed gender ones.

Just as Japanese karaoke was an invention which did not emerge from
thin air in a void, karaoke in other countries also had forerunners and
fits into earlier forms of interactive song and music use. In Sweden, karaoke
technology fits into a musical–social context in which the traditional group
'sing-along' was well established – not so much in pubs as in the British
case, but rather at either private parties or larger public gatherings. There
is a strong and well organized tradition in Sweden of choir singing, with
roots back into the nineteenth-century religious, political and trade union
movements. There is also a more intimate tradition of ballads and trou-
badour songs, both on record and in everyday get-togethers, where almost
everyone can, for example, still sing some of the extremely popular late
eighteenth-century songs by Carl Michael Bellman. Both these traditions
feed into the way karaoke is adapted in Sweden.

Whereas the Japanese technology and terminology have become inter-
national standards, different cultures have developed their own ways of
using the technology. International research points out some basic differ-
ences between Eastern and Western karaoke, and Swedish karaoke seems
to share many of the 'Western' traits.[2] It is less serious, both in its choice
of tunes and in the more spontaneous and informal use of them. Exact
imitation of the original is often less important than making one's own

original variant of it, and collective singing, where several friends get up and sing and even the whole audience sometimes joins in, is common-place. A loud and noisy audience is a sign of success, and each single performance is often interrupted by applause. Charging for the privilege of singing would only raise the threshold and make it even less likely that anyone would dare to perform. At least in Sweden many are still pretty shy about standing up and singing more or less alone in front of others, and the way to deal with this has been to incorporate some of the communal playfulness of a party sing-along. Honour and recognition are not at all as important as entertainment and fun in the Swedish karaoke set-ups I have experienced. Many Swedes find it embarrassing to display mediocre talents singing songs they cannot exactly identify with. They tend to feel a bit of a fake, inauthentic, as though they were betraying their true identity or risked losing it by performing a 3-minute song over which they do not have full control.

There are enormous differences within both Eastern and Western karaoke; indeed, it may turn out that these differences are far greater than the suggested polarity, which can only serve as a tentative, provoca-tively simplistic approximation of what in reality is undoubtedly a much more complex pattern. Edward Said (1978/1991) and Stuart Hall (1992) have problematized the mechanism of stereotypical dichotomization between 'the West and the rest', and one should definitely study this more carefully to see how ethnic and national differences are modified by inter-secting identity orders related to gender, sexuality, age, generation, class and subcultural commitment.

Certain institutions within Swedish rock and pop culture have strongly competitive and formalized features. There have been since *c.* 1980 nation-ally organized competitions both for young rock bands and for phantom-guitarists silently imitating the movements of various rock stars. There is also a range of live events and television programmes where mostly children mime to playback music or imitate well-known artists. Exactly how karaoke may fit into existing cultural patterns here has yet to be determined. It might split up into two separate courses of devel-opment: one leading towards semi-professional and highly organized individual contests, the other towards informal collective singing in bars and at private parties.

As for the playlists, most of the material is imported from Anglo-American sources. Among the fewer than fifty Swedish songs distributed on karaoke discs here, all except Abba's 'Waterloo' have lyrics in Swedish, and the vast majority can be classified as established mainstream hits in either the European *schlager* or the older Swedish dance band tradition. Less than a quarter of these songs have discernible rock/pop traits. Except for 'Waterloo', internationally famous songs by Abba, Europe, Dr Alban, Army of Lovers, Ace of Base, Roxette and many other Swedish artists

are blatantly absent from the existing karaoke discs. The same goes for almost all the pretty successful rock and pop material that would correspond to the tunes by The Clash, The B-52's, Prince and Sinead O'Connor that can be chosen here. No tunes here have subcultural roots, and there are hardly any real domestic rock parallels to the many Elvis Presley or Beatles numbers on the playlists.

New productions are on the way, so the picture might possibly change somewhat in the near future. But the Swedish karaoke market seems yet too small for any extensive domestic production of karaoke videos, in spite of the fact that popular music is today one of Sweden's largest export industries and Sweden is a key producer and market in pop music generally. There is probably an interdependence between (1) this conservative and adult-oriented choice of material, (2) the stylistic preferences of the dominant Swedish gatekeeping karaoke entrepreneurs, (3) the demographic basis of karaoke practices here in terms of (old) age and (not so modern) lifestyle, and (4) the relatively low status of karaoke and the reluctance among other cultural groups and strata to take it seriously. This might be interpreted as a vicious circle that hitherto has prevented karaoke from making a stronger impact in Sweden by appealing to the tastes of younger and more active and trend-setting music lovers. However, it also ensures that karaoke is firmly positioned as a form of 'low', popular mass culture, together with the Eurovision Song Contest and the traditional non-urban dance bands, which are at best respected for their craftsmanship but are carefully excluded from the general cultural public sphere where discourses in schools and in the media evaluate musical practices. Except for some occasions where it is mentioned rather as an item of curiosity, karaoke therefore remains invisible as an aesthetic phenomenon.

'My Way': an illustrative example

To illustrate how this complex web functions, I will make a rudimentary analysis of one particular example, chosen from the ones that can easily be found in many different places. Actually, the song 'My Way' is internationally one of the most popular ones in karaoke. Written by Paul Anka (with François, Reyaux and Thibault), it is particularly remembered as recorded by Frank Sinatra, but it has also been sung in quite differing versions by Elvis Presley, Sid Vicious of the Sex Pistols and the Gipsy Kings. It may fit well into a dominant stereotypical image of America in other countries, and its melody and lyrics are easy to remember and to perform. Its lyrical content, with its praise of individual freedom and courage, can be reinterpreted as a comment on the brave karaoke performer. It has therefore become something of a self-reflective anthem for karaoke. As an illustrative example of how video images, subtitled lyrics and musical sounds interact, I will analyse one karaoke version of

it, sold at Swedish petrol stations on a VHS-cassette as *The Original Karaoke Vol. 1* (Picture Music International and Toshiba–EMI 1991).

The lyrics shown in the text line, where each letter gradually changes colour from white to green as the music proceeds, correspond exactly to the Sinatra version. Its 'I' is an ageing man giving an account of his own life. The end is here, and he faces 'the final curtain'. The rather abrupt first words 'And now . . . ' indicate that the song might be heard as a coda to some earlier conversation. To a friend, he states his case of which he is certain – and self-confidence indeed turns out to have always been his defining characteristic. Looking back, he is fully satisfied, describing a life span that has matured to perfection through stubborn consistency. Like an artist to an intimate audience, the 'I' sums up how he has managed his role in life, and his regrets are 'too few to mention'. Life is described by metaphors of travelling: he has 'travelled each and every highway', 'planned each charted course, each careful step along the byway'.

A flash of nostalgic melancholy is covered under a massive self-justification in this confession, as if he were accused in front of a judge and had to 'state his case', feeling an urge to pile up a life history in order to get approval and thus peace. The humble talk about the byway course is an unsuccessful effort to disguise the unashamed bragging, that reminds one a bit of later youthful raps: after all, he seems sure that his life has travelled the highway. He has had his 'share of losing', but is now able to 'find it all so amusing', since whatever mistakes he has made, he takes full responsibility for them: he made them 'not in a shy way', but bravely and freely in his own way. He has never submitted to anyone – this is the confession of a true victor. 'The record shows I took the blows' but still he speaks 'not the words of one who kneels'. If it had been a common vinyl or CD recording, this 'record' could add a candid autobiographical connotation to the artist's product itself, but is here heard more as a metaphor for the collected results of the deeds of one's life. The lyrics emphasize his full knowledge of what he has done, his conscious planning and full control of his destiny, and his loyalty to his duties in life: 'I did what I had to do, and saw it through, without exemption' – 'I faced it all, and I stood tall – and did it my way.' The unspoken accusation against which he so strongly defends himself can be reconstructed through what he maintains he definitely has not done or been: he has not missed any opportunities, been shy, dependent, dishonest or out of control. He is no loser, and appears as an almost classically modern stereotype of a white male adult of indeterminate class and sexuality, whose peculiar mixture of enlightened reason, competitive individualism and patriarchal self-righteousness might feel strangely old-fashioned.

This message is not contradicted by the music, which also roughly follows Sinatra's version of the song in most musical parameters, with just a few melodic simplifications in order to make singing easier. Here, no elements

126

from any other recorded cover can be found, definitely not Sid Vicious' punk version (which, however, has another karaoke video version, not available here on the Swedish market). The hymn-like tune is played in a relaxed, slow tempo, clearly and smoothly articulated, with the song-line always performed instrumentally, and with verses and refrains differentiated by distinct markings, all making it easy for the potential performer to follow the flow.

After a minor introduction, the verse has a classical Tin Pan Alley form, with four equally long and pretty symmetrical melodic phrases, each one built up by four separated segments of 2–5 tones each. The song melody is played by the sax, supported by very soft percussion, a safely descending bass and a smooth web of fill-ins on piano and guitar. The daringly rising first two tones ('And now . . . ') are symmetrically balanced by the final, similarly determined descending motif on the key words 'my way'. The second verse starts with an upward-moving, shimmering harp-arpeggio, the volume and intensity are somewhat increased, and the strings add an elegant second part under the main melody, as played by the sax. Then comes a verse-like bridge built on three long phrases and more energetically aggravating movements. The next verse returns to the initial tranquillity, but with a sad flute added, and an accompaniment supplemented by chimes and muffled horn sounds. The last verse/bridge directly expands to full volume in a pompous climax, after which a final coda lets the music die out in a tender dialogue between winds, strings and harp, before the tune stops safely with a harp chord and a soft string ending.

The music in many ways parallels the lyrics: the form structures approximately overlap, as do the moods. The double climactic curves of the music add a clearer dynamic to the song and join the pompous boasting and bragging of the text. On the other hand, the falling 'sigh' motifs at the end of each line emphasize the melancholic trait, as does the hoarse saxophone sound, which is reminiscent of Sinatra's voice, which was shaped by life experiences and suggested adult wisdom, but probably derived as much from the consumption of liquor and tobacco. The arch-like musical form in each line as well as in each verse and in the whole tune is a highly conventional one, making the tune fit for easy singing and wide popularity. Simultaneously, it also works together with the lyrics' view of the life-course as a rounded and meaningful totality. Just as in old age when one can look back and see life as an ordered and closed whole, in each verse it is not any introductory phrase but the very final hook of ' . . . did it my way' which provides the melody with a significant shape and thereby its ultimate meaning. The visuals suggest a specific interpretive direction as to what this meaning of life may then be, which the rather abstract lyrics and music leave open.

Between beaches and barren mountains

On the visual level, this karaoke video is typical in its use of text-line and images. No musicians or singers are ever shown visually, but there are many formal similarities not only between lyrics and musics but also between each of them and the images. A slow musical tempo is accompanied by still or slowly moving pictures and few cuts, and shifts between verse and chorus are paralleled by shifts between two visual sequences. According to the copyright text which concludes the video, it is shot in California and Arizona, and the pictures move through soft dissolves between a beach and a barren desert.

The shorter and fewer Californian beach scenes contain some shots of rough waves, but also a series of pictures of a young man and a woman walking hand in hand, sometimes with a little child. A careful look shows that they are several different pairs, but if one more or less consciously wants to reconstruct some kind of a narrative in this rather loosely piled set of scenes, it is tempting to perceive them as one and the same. On one occasion in the middle of the song, right after the first bridge has ended, the couple looks into the camera through some wire netting.

Considerably more time is spent on Arizona's rocky Monument Valley and the Grand Canyon, with a lonely man in a desert-like mountain landscape. His silhouette is sometimes seen from behind as he stares towards the horizon, or he slowly walks, or drives a car. The asphalt road through the dry desert is an important feature, on which the car either approaches the camera or slowly disappears into the unknown horizon. Again, it is not the same car model in all scenes – sometimes it is even a small truck – but this variety does not seem to carry any semantic intention, other than possibly to reduce the importance of the photo story thus told. Just as the various couples on the beach never interact with each other, the different cars and men in the mountains never meet, and it is therefore easier to interpret them as metaphors for one and the same lonely (life-)journey, only (like the lyrics itself) made more abstract and general by implying that many or perhaps all men travel this way through life, alone or each with his woman and child.

The camera sometimes moves upwards from the man/car to a wide bird's-eye perspective, which initially is elucidated by pictures of a stately soaring grand white bird. Some camera movements are also made upwards to the sky and clouds, in particular towards the end of the video, in between cuts out of the side windows of the car towards the rocky landscape passing by. The film ends with a bird's-eye view of the car by the road, a zooming out up over the clouds and, at the very end, a zooming in on a dry, almost glimmering, tiny and parched bush in the desert. This ending in lonely death definitely adds a kind of tragic fulfilment to the lyrical message, semantically connected to the first line's 'now the end is here'.

In spite of the lack of precision in the photo editing, there are traces of efforts to synchronize images with sounds and text. Several cuts and trackings obviously coincide with main transitions between musical form-parts: it is no mere coincidence that a visual cut is made by almost every change of line in the lyrics, which in its turn coincides with a new four-bar phrase in the music. More than half of the cuts are placed right on such places. And as for moods, the slow cutting rate (*c.* thirty cuts during the 4′30″), the tranquil panning camera movements and the absence of any intense action all fit well to the slow musical tempo and the author-itative retrospective words of the elderly man. In meaning content, the sunset, loneliness, road and desert setting well illustrate the lyrics' reflec-tion on the sometimes hard way to accumulate individual experience. The sea waves also seem to harmonize with the wave-formed melodic structure and the softly billowing accompaniment that from a moderate position works up to spuming cascades and then gradually calms down again. Contrapuntally contrasting elements may be traced in the not very clear interpretive potentials of the strange changes of cars as well as of the child and the net on the beach, which are hard to relate to the lyrics or the music. But the many connections between all levels are more apparent.

The lyrics and the music of 'My Way' depict an individual, rough and male destiny in a serious, sometimes slightly sad but mature and proud tone, on a scale from the intimate to the pompous. The pictures awaken associations with the Wild West mythology of the lonely male's journey towards the sunset, from John Wayne to Lucky Luke or *Paris, Texas* (the 1984 Wim Wenders film). The man becomes a man by accepting his inescapable destiny: to walk his barren road through wilderness, leave his childhood, home and female company to instead invest fully in separation and autonomy. 'My way' is an expressedly male road, but its screening opens up at least two interpretive directions.

The car runs on a desert road, which can be connected to the lyrics' talk about the male lifespan as a 'byway'. If so, the images add a quali-fication of that life as desolate and tough, and the beach pictures of a community transgressing gender and generation are then moved back in time to a distant past, perhaps even to childhood, so that the man in the mountains could even once have been the child on the beach. Another possibility would be to interpret the mountain trip as depicting the old man's retreat to reflect upon the meaning of his life, like a hermit. Then, the travelling car becomes a metaphor for self-reflection as necessitating a retreat from the laughing and the talking of social life, rather than for male life in general, and the beach scenes do not have to be so far away in time. One might even think of the singing moment itself as such a journey into a temporary self-reflection, with the beach as an image of the noisy happy life just a short moment ago. But since this reflection in the text is already connected to the final curtain of old age and death,

this weary journey still tends to become irreversible. There is no way back for the 'I', and after some pictorial hints to the eternal skies, the camera comes to a full stop by a dead bush. In any case, the temporal direction seems to be *away* from the happy community at the waterfront (cf. the 'oceanic feelings' so often related to the infant's early maternal symbiosis), upwards *into* a final, sterile loneliness and, ultimately death, on the border between high mountains and heaven.

The almost obsolete male role staged by this 'My Way' contains no obvious (self-)ironies. It is straightforward and serious, on the verge of solemn. But if all levels can be perceived completely unambiguously, this is not the only option for its reception in a karaoke performance. It appears to present a traditional patriarchal male identity as a totally unproblematic solid whole, but already the form of its verbal statements indicate that it has been contradicted – and may be so again, in each of its performances. The singer can deliberately choose ironically distancing effects, for instance by singing with a grotesquely excessive cocksureness – or, alternatively, by incorporating traces of more broken voices: weak, insecure, soft, fragmented or lunatic ones, perhaps inspired by the unforgettable interpretation of the song by Sid Vicious. Or just by singing from a young or female position instead of the implied male one, which would also induce a certain deconstructive *Verfremdung* of its meanings. When a young rebel like Sid Vicious sang an old man's retrospective, there was already a contrast with Sinatra's earlier version, and yet other fascinating ruptures can appear if women or non-whites choose to do it 'their way'. Its karaoke version provokes counter-interpretations, as well as the opportunity to reproduce faithfully its preferred earnestness.

The pictorials hardly take up a definite position in this choice, as they may both be laughed at and seen as romantically sad, but they offer some hints to a critical or at least sceptical interpretation of the text. There are some aspects of the lyrics which have been consistently avoided in the visuals. The 'I' speaks to a 'you': he is not quite alone but has a listening friend, just like Sinatra had his audience and the karaoke performer his or hers. But even though couples stroll on the beach, the narrative framing with the final dead tree tends to place them in a flashback rather than narrator position, and the desert man is indeed very much alone. Sitting on a bar stool, spouting to one's mates about how right one has always done in a tough life, is probably a considerably more pleasant reward than to have to die all by oneself in a stony desert, in spite of all its beauty. And where the lyrics hint at a life full of decisions, conflicts, happiness and tears, the beach vacation and the desert trip fuse into a much less socially rich and energetic image of his life experiences. The lyrics say it was tough but worth it, the film makes it rather more tragic and failed, thereby considerably enlarging and reinterpreting the 'byway' motif into more critically tragic dimensions. This might invite a more questioning

interpretation, where the stereotype of total male autonomy so strongly evokes its negative drawbacks in the form of emptiness and loneliness, rather than its positive side of purposeful strength.

By a subjective or rather intersubjectively and contextually bound rendering, the meaning of the whole tune can thus be considerably displaced, not least through intertextual references to earlier versions of it, or of other, similar songs. One may slide between Sinatra's and Vicious' famous versions, strolling in and out through the well-known tones, words, images and role models, thereby disclosing and crossing meanings in new ways, using the song and its genre/s, the social setting and the multiple subjectivities that are encoded into one's thus actualized experiences. In this way, new levels of meaning can be invented or discovered, that may already have been potentially there, but that first appear in the specific interpretations of particular performances.

Gaps open for interpretive acts

As in all other forms of cultural expression, the use of karaoke contains a 'disappearing act' (Modleski 1982/1984: 35ff.), but only as temporary identity shift. In addition to the liking and enjoyment of the group, one can also learn something new about a genre of music and about unknown layers (strengths and weaknesses, competences and abysses) in one's own identity. The karaoke singer is therefore not permanently *lost* in the music but can rather *find* his or her self strengthened and enlarged by the experience. By trying on Sinatra's maturity or Sid Vicious' cynical brutality, or (for this or other songs) Madonna's or Michael Jackson's provocative styles of expression, one might discover new potential in oneself, in the modes of expression and in the response of one's friends.

Popular culture creates gaps that may be filled with hitherto unknown subjective expressions. Karaoke opens public spaces that allow a special form of social interaction. It serves as a paradigm for how media texts always present their users with voids. Listeners, viewers and readers enter into these gaps and fill them with their own (re)constructed meanings, which are born in the moment of reception, in the meeting between readers and texts (cf. Iser 1976/1984; Fish 1980). In listening to music, the interpretation of the sounds heard is never merely a copying of the intended structure of meaning, but always involves the creation of new layers of meaning. The karaoke experience puts a general aspect of all cultural consumption and reception in focus. The music listener enters into complex fabrics of symbols and produces unique patterns of impressions, experience and meaning.

In listening to pop music the work/'text' consists of a foreground of vocally delivered lyrics and melody against a background of instrumental accompaniment. Here the gaps (of meaning) are filled with perceived (and

perhaps hummed or whined) melodic figures and textual interpretations. In the case of genres like house and techno, different rhythmic configurations form the foreground, and the interaction between these rhythmic configurations and a complex, polyrhythmic backcloth creates openings that invite listeners to fill them with the motion of their dancing bodies.

In the case of karaoke, this interpretive creativity has been enhanced to include the production of real sound heard by others, not just of meaning and bodily dance motion. Users of karaoke have the opportunity not only to be listening meaning-makers, but also to be singing sound-makers and to hear and see their own voices and gestures in the hybrid audiovisual fabric that results. The auditive and visual 'voices' of the video fuse with one's own sounding voice and dancing body, which one can then listen to, view and feel, and thereby learn something about oneself. A study of karaoke use would have to be very multi-dimensional, including, first, all the symbolic layers (lyrics, musics, visuals) encoded into the canned video; second, all those body and song expressions added by the performer; third, the contributions (glances, shouts, applause) by the other participants present in the audience; as well as, finally, the complex interrelations between all of these interacting agents.

Karaoke is an interactive form of media technology that demonstrates how media use opens up public arenas for intersubjective communication and social interaction, while also affording opportunities for forms of meaning–creation that allow the viewing, listening or reading subject to enter into gaps in the 'text'. Depending on social and psychological preconditions, the technology may be used for individual self-assertion or for collective play, for the testing of role models or original improvisational play with conventional norms and boundaries.

When entering the voids in the music, the karaoke performers bring along their own voices, laden with subjectivity. They sing in styles and to recordings over which they have no autonomous control, but their voices none the less express something unique that makes each performance special. Those who were brave enough to sing, 'faced it all' and 'stood tall' in front of the karaoke screen and the audience, they really did it 'their way': they created something of their own in a dialogue with all those other real and virtual voices surrounding them. Such users never have full control of the process, but neither do the artists, the producers or the bar owners. Just as all media texts construct certain preferred readings but do not prevent (and may in fact elicit) other interpretations, the karaoke singer may choose a way that deviates from an exact imitation of the 'hit'. The song cuts out a conical sector of meaning, within which unique constellations of subjective identities and intersubjective interaction between individuals and genre codes construct specific sounds and meanings.

The human voice is in Western culture often very strongly identified as the most authentic expression of the subject. In horror films, it is generally

much more frightening when an apparently normal body has an uncanny, alien voice, than the other way around. A wicked voice in an attractive body leads us to suspect an evil soul in a handsome package, whereas a friendly voice can make even the most hideous monster more human. It is interesting to note the relative absence of vocoders and other dramatic manipulations of the singer's voice in popular music as well as in karaoke practices, in spite of the technical potential of that direction. One may experiment with strange songs, but it seems to be of continual importance to be able to recognize the voice as one's own, in order to identify authorship and hear the result as something done 'my way'.

Karaoke has low status in the dominant cultural hierarchies in Sweden today, for several reasons. The history of pop and rock discourses is full of instances where new technologies are denounced as being inauthentic: first, the electric rock guitar was perceived as less 'natural' than the jazz saxophone, then, the synthesizer became the artificial evil that suddenly made the electric guitar almost revalued as a genuine folk instrument. Likewise, singing to a pre-recorded backing and in front of a video screen is today rarely understood as quite as seriously artistic as performing the same song to a live ensemble. And just like covers tend to be valued as less serious than original versions in pop and rock music, singing pre-written songs to pre-recorded backings is firmly placed within a low stratum of popular culture, though it has not yet attracted much critical debate. The image of people miming like apes or string-puppets to karaoke discs fits all too well into traditional fears of mass consumers duped by an authoritarian cultural industry. This has not been seriously challenged by 'post-modernist' debates on the aesthetics of artificial 'simulacra' and second-hand trash, whose musical variants have been inspired by the rise of sampling and other reproductive techniques. As long as the range of the karaoke playlists remains so narrow in generic terms and so scarce when it comes to Swedish productions, this is unlikely to change, in particular since karaoke is also mostly found in the low-cultural contexts of competitions, parties, commercial outdoor festivals and pub entertainment.

Still, just like making rock covers enables bands to explore and widen the meanings and potential uses of the covered songs, and intertextually to comment upon other music while producing it differently, karaoke makes a similar creativity and exploration accessible to larger numbers of people. Dancing to music, miming to playback, playing phantom-guitar, standing behind plyboard figures and having pictures taken, or painting in colour-books, these activities, too, afford some leeway for creativity and subjective expression. Uniqueness and idiosyncrasies can be communicated by many means, not only through visual and auditive expressions but also by the senses of touch, taste and smell. However, it may well be that the voice, our most direct, versatile and subtle means of making ourselves heard, has assumed a special salience in modern Western culture. Even though it is a

question more of degree than of kind *vis-à-vis* other means of expression and media, this salience makes karaoke particularly exciting. In karaoke, the subject's entry into the texts is particularly apparent, even though echo effects and prior rehearsal may make it possible to veil oneself even here. Including human voices in a media montage may have a stronger affective impact than if a visual art form or medium turns just a visual mirror toward the audience. It is generally held that we see ourselves 'from without', whereas we hear ourselves 'from within'.

With its delicate balance between individuality and communality, and between imitation and invention, karaoke actively intervenes in the late modern problematization of the individual subject and of collective communities, as well as the intensified vacillation between self-forgetting involvement and self-mirroring, self-objectifying reflexivity. Entering into the gaps that media open for collective meaning construction, individual subjects emerge as voices in a polyphonous web of sound. Karaoke calls attention to an interaction that is central to all cultural praxis, in which identities meet and are transformed through the use of media genres to create both public spaces and meanings. Together with music on CD-ROM and on the Internet, the development of which will affect the future of karaoke by offering other means of distribution as well as other ways of interacting with the recorded song, karaoke deserves attention as a particularly clear example of important but otherwise rarely focused-upon facets of music and media use as processes of interpretation, identification and interaction.

NOTES

1 This text propounds ideas on karaoke put forward in Fornäs (1994a and d) and further developed in an ongoing study of how interactive digital music media like karaoke, CD-ROM and the Internet relate to media reception, subjectivity formation and late modern reflexivity. See also Fornäs (1994b and c; 1995a and b) on identity, reflexivity, authenticity and media use in general. I am deeply grateful to all my friends among karaoke researchers in Japan (Tōru Mitsui and Hiroshi Ogawa) and the USA (Robert Drew and Casey Lum), and in particular to Shūhei Hosokawa for many inspiring questions to my text. Thanks also to the Stockholm karaoke expert practicians David Bradish and Cliff Barnes for useful answers to some of these questions.
2 Cf. Drew (1994), Hosokawa (1995), Hosokawa *et al.* (1993), Kelley (1995), Lum (1996), Macaw (1995) and Ogawa (1995).

References

Crafton, Donald (1982) *Before Mickey: The Animated Film 1898–1928*, London: MIT Press.
Drew, Robert Sanford (1994) 'Where the people are the real stars: an ethnography of karaoke bars in Philadelphia', Philadelphia: University of Pennsylvania (dissertation in Communication).

Fish, Stanley (1980) *Is There a Text in this Class? The Authority of Interpretive Communities*, Cambridge, MA: Harvard University Press.

Fornäs, Johan (1994a) 'Karaoke: subjectivity, play and interactive media', *Nordicom-Review*, vol. 1, pp. 87–103.

Fornäs, Johan (1994b) 'Mirroring meetings, mirroring media: the microphysics of reflexivity', *Cultural Studies*, vol. 8, no. 2, pp. 321–40.

Fornäs, Johan (1994c) 'Listen to your voice! Authenticity and reflexivity in rock, rap and techno music', *New Formations*, vol. 24, pp. 155–73.

Fornäs, Johan (1994d) 'Meningsskapandets korsvägar: "My Way" i karaokeversion', *Filmhäftet*, vol. 88, pp. 58–67.

Fornäs, Johan (1995a) *Cultural Theory and Late Modernity*, London: Sage.

Fornäs, Johan (1995b) 'Do you see yourself? Reflected subjectivities in youthful song texts', *Young: Nordic Journal of Youth Research*, vol. 3, no. 2, pp. 3–22.

Hall, Stuart (1992) 'The West and the rest', in Stuart Hall and Bram Gieben (eds) *Formations of Modernity: Understanding Modern Societies: An Introduction*, Book 1, Milton Keynes: Open University Press, pp. 275–331.

Hosokawa, Shūhei (1995) 'Singing not together: karaoke in São Paolo'. In W. Straw *et al.* (eds) *Popular Music: Style and Identity*, Montreal: Centre for Research on Canadian Cultural Industries and Institutions, pp. 149–54.

Hosokawa, Shūhei, Matsumura, Hiroshi and Shun'ichi, Shiba (eds) (1993) *A Guide to Popular Music in Japan*, Tokyo: IASPM-Japan.

Iser, Wolfgang (1976/1984) *Der Akt des Lesens. Theorie ästhetischer Wirkung*, Munich: Wilhelm Fink Verlag.

Kelly, William H. (1995) 'The adaptibility of karaoke in the United Kingdom', in W. Straw *et al.* (eds) *Popular Music: Style and Identity*. Montreal: Centre for Research on Canadian Cultural Industries and Institutions, pp. 177–80.

Landow, George P. (1992) *Hypertext: The Convergence of Contemporary Critical Theory and Technology*, Baltimore, MD: Johns Hopkins University Press.

Lum, Casey Man Kong (1996) *In Search of a Voice: Karaoke and the Construction of Identity in Chinese America*, Mahwah, NJ: Lawrence Erlbaum Associates.

Macaw, Heather (1995) 'A comparison of the use and appeal of karaoke in Japan and Australia: how has karaoke adapted to the Australian culture?' in W. Straw *et al.* (eds) *Popular Music*. Montreal: Centre for Research on Canadian Cultural Industries and Institutions, pp. 201–4.

Maltin, Leonard (1980) *Of Mice and Magic*, New York: Plume.

Modleski, Tania (1982/1984) *Living with a Vengeance: Mass-Produced Fantasies for Women*, New York/London: Methuen.

Ogawa, Hiroshi (1995) 'Karaoke in Japan: a sociological overview', in W. Straw *et al.*, op. cit, pp. 225–8.

Radway, Janice (1984) *Reading the Romance: Women, Patriarchy, and Popular Literature*, Chapel Hill, NC: University of North Carolina Press.

Said, Edward W. (1978/1991) *Orientalism: Western Conceptions of the Orient*, London: Penguin.

Straw, Will, Johnson, Stacey, Sullivan, Rebecca and Friedlander, Paul (eds) (1995) *Popular Music: Style and Identity*, Montreal: Centre for Research on Canadian Cultural Industries and Institutions.

Turkle, Sherry (1995/1996) *Life on the Screen: Identity in the Age of the Internet*, London: Weidenfeld and Nicolson.

Part III

7

SINGING IN A CULTURAL ENCLAVE

Karaoke in a Japanese-Brazilian community

Shūhei Hosokawa

Walking around Liberdade

'Liberdade': a district whose name means 'liberty', situated in the southern part of São Paulo. It is an area where many Japanese immigrants have lived since the 1910s and is the centre of the Japanese-Brazilian community, the largest Japanese group abroad (1.2 million, a quarter of them living in the greater São Paulo area). Along the streets one finds Japanese grocery stores, book shops, souvenir shops, kimono and futon shops, tourist offices, and, of course, dozens of karaoke bars with Japanese names such as Ichiban, Midori, Minami, Hime, Tugaru, Hakuchō, Mugi, Furusato . . .

For Brazilians[1] it is difficult to find karaoke bars in Liberdade since many of them don't put up a sign in Portuguese. Obviously evening strollers notice them easily because of the sounds drifting outside. Such 'Japanese' karaoke bars are also found in various cities around the world where Japanese businessmen are more or less concentrated. What specifically characterizes the karaoke culture in Brazil is the high occurrence of Japanese immigration (especially *issei* or the generation born in Japan). Unlike America and Canada, where Japanese immigration was stopped in the middle of the 1920s owing to the Anti-Asian immigration laws, Brazil continued to receive them until the beginning of the 1970s when the Japanese economy had completely recovered from the wartime damage and Brazil in turn no longer needed immigrant workers (the immigration flow was of course interrupted in the 1940s because of Brazil's alliance with America and post-war confusion). It is precisely due to the the the fact that they were not allowed to enter North America that the ships with Japanese immigrants aboard headed for South America. In the case of Brazil, migration peaked in the mid-1930s and the late 1950s. Therefore the first generation, for all its drastic diminishment during recent years, is still

139

culturally visible and very influential in the Japanese-Brazilian community. The karaoke scene, as we will examine, is evidence of their presence.

Our aim in this chapter is to argue the triple mode of karaoke as technology, place and behaviour in the Japanese-Brazilian community, focusing upon the cultural effect of trans-Pacific travel of the artefact in question from Japan as well as the social and ethnic significance of the practice of singing for the immigrants. In short, we would question how karaoke marks the ethnic boundaries in a multi-ethnic country,[2] and how the culture of singing assists in the construction of identity by way not only of aesthetic elements such as melody and rhythm but also of social factors such as language and form of socialization.

We will deal more with the karaoke scene than with the singing and technology *per se*. By the term 'scene', I mean the ensemble of interacting and intertwining webs of relationship between production, distribution and reception. Barry Shank, in his ethnography on the rock'n'roll scene in Austin, Texas, defines the same term as 'an overproductive signifying community'. To be precise:

> far more semiotic information is produced than can be rationally parsed. Such scenes remain a necessary condition for the production of exciting rock'n'roll music capable of moving past the mere expression of locally significant cultural values and generic development – that is, beyond stylistic permutation – toward an interrogation of dominant structures of identification, and potential cultural transformation. The constitutive feature of local scenes of live musical performance is their evident display of semiotic disruption, their potentially dangerous overproduction and exchange of musicalized signs of identity and community.
>
> (1994: 122)

In short, 'overproductive signification' means redundancy in expressions and displays, significant only to local identity construction including not only specific sounds but also hairdos, costumes, jargon, modes of socialization, etc. Musical performance is certainly the core of such signifying but is not sufficient to determine the scene. His research tells us how the 'dissonance' of rock as an international commodity ('dominant structures of identification') and as local production, distribution and consumption constitutes the identities of 'local scenes of live musical performance' as much as how the micro-level session can be related to far-reaching institutions such as national circuit impresarios and transnational record companies.

Without doubt, Texan rock'n'roll has musically nothing to do with what Japanese-Brazilians sing in their karaoke clubs. The Japanese popular songs we are concerned with are themselves far from oppositional voices and 'dissonant' practices. The point of Shank's discussion lies in his emphasis

upon the irrational (or redundant) mode of locality construction and upon the relevant approach to the 'structure of feeling', or 'social experiences in *solution*, as distinct from other social semantic formations which have been *precipitated* and are more evidently and more immediately available' (Williams 1977: 128–35). On the other hand, his work is marred by psycho-analytic jargon serving only to make a transiently Lacanian 'scene' in his otherwise vivid work. Going further than the usual 'contextual' analyses current in anthropological ethnomusicology since the 1960s, he accurately points out the performative significance of music-making and listening to music that forms an urban communal setting made up of disparate, hetero-geneous but interconnected 'micro-scenes'.

In this chapter I will try to show the formation and transformation of the karaoke scene in Brazil, or how the practice of singing makes sense of the ethnic bond. To begin with, we will reconstruct the early years of karaoke in Brazil.

Karaoke arrives in Brazil

It is in 1975, a few years after its appearance in Japan, that we find the first reference to karaoke in a Japanese newspaper in Brazil. 'The accom-paniment record', an advertisement for a Japanese record shop says,

> or what is called karaoke record is now very popular in Japan. When you sing along with this record, you can be accompanied by the same orchestra as Hibari Misora [the greatest post-war female singer] is. You may use it for vocal training and *nodojiman* [amateur singing contest]. And, of course, you can listen to it as light music [instrumental popular music]. The first accompaniment record in *colônia* ['colony' in Portuguese, a Japanese-Brazilian self-classification] includes well-known party [*enkai*] songs. It is because now is the season for end-of-year parties and New Year parties. Since the *enkai* is a man's world, the recording is tuned to the tone range of drunken men and its tempo is a bit slower than the original. The biggest party opportunity of the year! Ready for the accompaniment of your year-end party. Everybody! Let's start!!
>
> (5 December 1995, *São Paulo Shinbun*)

This advertisement shows us the musical situation implied in the release of the first karaoke album: karaoke made its debut in LP form; the word 'karaoke' was not known to readers so the sponsor had to explain what the 'accompaniment record' was; the first karaoke record imported to Brazil was intended to be used for Japanese traditional parties (in other words, night-time use); it was associated with instrumental music previously

known for background use; the sponsor anticipated that consumers would be basically drunken men; they also implied its home use ('vocal training'), and a daytime function ('amateur singing contest') was considered only as an afterthought.

Not surprisingly, such a concept of karaoke was not so different from that in Japan. Yet we don't know how that album was used at parties in Brazil nor do we know how popular the karaoke record was. But the instrumental album alone was not enough to revolutionize the practice of singing. It is likely that the record hardly sold at all because there was not a single article written covering the new type of singing. A 1977 column in the *São Paulo Shinbun* headlined '"Karaoke" Age' ('karaoke' with quotation marks suggests the novelty of this word) says that although 'karaoke is a word unfamiliar in our *colônia*', it has recently become very popular in Japan (18 November, see also 24 November, *São Paulo Shinbun*). 1977 was then the year in which karaoke became a large-scale phenomenon in Japan and the tidal wave soon struck Brazil.

Probably the opening of the first karaoke bar in Brazil, *Donguri* (acorn), in the same month of the same year stimulated the Japanese-Brazilian press. *Donguri* accommodated 30 to 40 people (relatively large for Japanese-Brazilian standards) and its hours of operation were 7.30 p.m. to 2.30 a.m., the same as many night spots in São Paulo (20 September 1985, *São Paulo Shinbun*). It should be noted that *Donguri* was opened on a strategic site in the middle of Avenida Brigadeiro Luiz Antônio, a main street which connects Liberdade and Avenida Paulista (the business centre). Such a geographical situation invited both short-term visitors and residents from Japan (mainly businessmen) working and living around the Paulista area (most of them would have had experience of karaoke in Japan) and the immigrants whose daily life was centred on Liberdade's commercial activities. Along with its location, the use of tape cassettes, or technology handier and less delicate than vinyl, might help to explain the success of *Donguri*. After this bar was established, the number of karaoke bars increased steadily in São Paulo: seven in 1979, thirty-eight in 1982 (11 December 1982, *São Paulo Shinbun*).

Towards the end of the 1980s, nevertheless, the growth of karaoke bars in São Paulo slowed and later stopped when the number of clubs reached approximately between sixty and seventy. This saturation may be related to the demographic size of the community and the ethnic limit of Japanese-Brazilian entertainment. But it did not lead to the decline of karaoke. In other words, karaoke spread widely in the 1980s to include singers who were not necessarily drunk, male or even adult. The shift in focus from night-time to daytime use encourages rather than suppresses the growth of the karaoke scene in the community. 'Daytime use' here does not only denote singing before sunset but includes female, child, youth and non-alcoholic use of karaoke at night.

Karaoke's take-off from exclusive night-time use is an important turning point for the development of the scene in the Japanese-Brazilian community. Karaoke is grafted on to the pre-existent form of singing, *nodojiman*, or amateur singing contest with an orchestra which had been popular since the 1950s. In order to understand the transition from *nodojiman* to karaoke, we now turn briefly to examine the post-war music culture of the community, then to the organization of the karaoke scene today.

The singing contest

Nodojiman or amateur singing contest, as discussed elsewhere (Hosokawa 1995a: Chapter 2), enjoyed tremendous popularity in post-war Japan by being broadcast nationally on the radio. It was imported to Brazil in the beginning of the 1950s (although the radio singing contest had been already very popular with Brazilians in the 1930s) and was solidly organized in a hierarchical structure, ranging from the central (São Paulo) commission to village singers. Each singer had to be registered in each local subsidiary that belonged to the cultural association of the Japanese-Brazilian community on each level. The same was true of the accompanying band. Each local institution, presenting the contest, chose a definite number of representatives for the next round. To sing on the stage of an annual *Concurso Nacional de Cantos* (National Contest of Song, *Zenpaku Kayō Shōka Konkūru*), a singer had to win three or four elimination rounds.

The winner of this summit contest was theoretically the best singer of the year. He or she, however, could not become a professional because of the limited size of the showbusiness community. Ethnic radio stations and night-clubs could afford only to pay part-time wages. A few ambitious winners went to Japan, where the amateur contest functioned as a possible gateway to showbusiness, though their dreams of becoming professional were often in vain.

The singing contest consisted of four elements: jury, musician, singer and audience. While in Japan the jury were quite often music professionals themselves (composers, lyricists, talent scouts, radio or television producers, professional singers), in Brazil, they were usually music teachers and leaders of various associations in the community. In short, the singers were not professional but the jury members were, in that they made a living by teaching the pupils who wanted not only to improve their singing but also to win the contest. Therefore, it is reasonable to think that contestants expected certain favours from their teacher–jury. From the very beginning of *nodojiman* in Brazil, an unfair jury was a constant problem, as was claimed by both the singers and the audience. But again, because of the size of the showbusiness sector, teachers and jury could not be separated from each other.

143

Nodojiman was short-lived in Japan since it almost disappeared from the mass media in the early 1960s and was replaced by a more spectacular television show in which the participants (usually young teenagers) imitated the singing, gestures and costume of the original star. The amateur contest is no more than an appendix to the advanced Japanese music industry based on professionalism. However, in Brazil, it remained the core of musical life until live bands gave way to automatic reproduction in the 1980s.

Karaoke fundamentally took over the organization and structure of *nodojiman*. In the early years of karaoke, the use of pre-recorded tape was prohibited by the *Associação Nipo-Brasileira de Cultura Musical* (Japanese-Brazilian Association of Musical Culture), the organizer of *Concurso National de Cantos*, because it was conceived as artificial and just pure gimmickry. Masao Maruyama, the president of the *Associação*, notes in the 1979 programme of *Concurso* that

> the singers shouldn't show off their dexterity or superficially copy the record or cassette tape. Whether the singing is successful or not depends upon how accurately one learns the pronunciation, vocalization, intervals and rhythm as basic elements of music as much as upon how deeply one understands the lyrics and melody of the song.

In spite of his strong objections, however, Maruyama could not stop the trend of the technologization of singing. Around 1980, karaoke machines were used in small competitions and gradually took the place of the contestants' live accompaniment. Technologization had many benefits for the vocalist: you can practice any time you want, you can dispense with tuning with a band, and you needn't worry about the poor sound of the backing orchestra, so why not choose to sing along with the cassette tape? Another reason for the decline of live bands is that the new songs favoured by the young were too technically difficult for the brass-centred band. Musical elements such as rock beat, synthesized strings and horns, and colourful orchestration were beyond the scope of part-time musicians in particular. The end of the band was inevitable. Although there were forty or fifty bands in the heyday of *nodojiman*, only one survives today, which got back together in the early 1990s for nostalgic reasons.

The *Concurso* faced a crisis in 1983 when the North Paraná branch, the strongest opposition to the central power of São Paulo, boycotted the contest because of an unfair judgement against them in the previous round and the refusal to allow karaoke to be used by the *Associação* (the inter-regional politics and private rivalry between teachers, it is said, affected the boycott, too). Two years later the pro-karaoke faction set up the *Associação Brasileira da Canção Japonesa* (ABRAC, or the Brazilian

Association of Japanese Song) and organized their first annual contest in February 1986, with more than 200 singers from the various regions. Rallying against the São Paulo centrism of Maruyama's association, each ABRAC contest is held in a different city. With the establishment of the ABRAC contest, the *Concurso Nacional de Cantos* was forced to drastically reduce its scope, abandoning at first the inter-regional competition, then the individual one. Nowadays their contest looks more like a 'song festival'. The participants are as few as twenty or thirty who naturally do not represent their regions. The band rehearses with them no more than a couple of months before the contest (often at Maruyama's home). Today only a handful of singers have had experience of singing with a band.

Competition as a device for equality and distinction

ABRAC developed the hierarchical organization and competition-oriented system of the *nodojiman*. Their annual contest is regarded as the most prestigious and competitive event in the community. As seen in Figure 7.1, it keeps on growing. The 1994 competition, for example, had 520 participants and more than 700 songs were sung (almost every category has eliminatory and final rounds. In the eliminatory one, singers are allowed to sing only the first verse of the song and the winners of each category go on to the champions' round where they compete for the prize of best singer of the year.) The Saturday session started around 9 a.m. and ended around 3 o'clock in the morning, while the second day, the Sunday session began at 9 a.m. and finished at 1 in the morning, thirty-four hours in total. The audience (99 per cent are Japanese immigrants) of course do not sit throughout all the songs. They go in and out, and eat lunchboxes as they like (even during the performance). Outside the auditorium they can loiter, eating and drinking. Some spend more time in the restaurant and lobby than in the auditorium. Karaoke contests are more than just a music event: they are an important place for immigrant socialization.

That karaoke covers the whole range of age group is shown by the category in the competition system: *dōyō* (school song singers) and *tibiko* (pronounced 'chibikko', child imitators) (younger than 13 years old); youth (14–17); adult (18–40); veteran (over 41) and pop (no age limit).[3] Furthermore, the child categories (*dōyō* and *tibiko*) are subdivided into four sub-categories (younger than 6 years old; 7–9; 10–11; 12–13) and the veteran, into three (forties; fifties; over-sixties). As a result, singers in these two groups constitute the majority (about 60 per cent) of total participants in recent competitions.[4]

Two juries work alternately to judge the long event and the scores from each one are calculated by computer. The jury consists of one representative from each region and the delegates of ABRAC. Each set includes one person who checks if the singer sings the correct words (one letter

Table 7.1 Numbers of participants in the ABRAC karaoke contests, 1986–94

	Youth	Adult	Veteran	Dōyō	Tibiko	Pop	Total
Age	14–17	18–40	41–	–13	–13	no limit	–
1986	46	99	72	–	–	–	217
	20/26	31/68	46/26	–	–	–	97/120
1987	34	98	77	21	–	16	246
	9/25	62/36	52/25	4/17	–	8/8	135/111
1988	44	111	96	28	20	39	338 (305)
	15/29	65/46	37/26*	6/22	7/13	12/27	142/163
1989	45	108	112	32	19	43	359
	18/27	66/42	66/46	1/31	6/13	16/27	173/186
1990	41	113	115	38	17	48	372
	12/29	66/47	67/48	3/35	8/9	18/30	174/198
1991	44	115	123	32	32	33	379
	12/32	68/47	74/49	2/30	12/20	9/24	177/202
1992	55	137	156	48	42	42	480 (453)
	18/37	54/56*	96/60	4/44	11/31	12/30	195/258
1993	59	119	149	53	46	30	456
	17/42	61/58	60/89	11/42	8/38	7/23	164/292
1994	58	121	151	109	51	30	520
	18/40	61/60	89/62	22/87	9/42	7/23	206/314
Total	426	1021(994)	1051(1018)	361	227	281	3367 (3307)
	139/287	534/460	587/431	53/308	61/166	89/192	1463/1844

Notes: 1 Figures are based on the programme and the unpublished files of ABRAC
 (courtesy of Rikiti Origasa) (the second row in each line indicates the ratio of
 male to female participants)
 2 Asterisks indicate the missing pages in the material consulted (about 60
 participants)

costs three negative points; one word, five; one phrase, ten; and one verse, twenty). To eliminate possible favouritism, the highest and the lowest points are not added to the result. If one member of the jury gives dubious points to a singer, the others can interrogate him/her. If the decision is not unanimous, the matter is sent to the supervisor who has been a professional composer and music teacher for forty years. Such a well-ordered procedure does not only give credit to the judgement but also standardizes the aesthetic criteria. The technologization of singing is correlated with the mechanization of judging.

ABRAC nevertheless finds it hard to get rid of possible claims of unfairness and has had difficulty in establishing the authority of the jury. The contest has become more competitive than before not only because of the higher level of performance but also because of the enhanced control of the singers. I once saw a singer disqualified one second after the song started because the unfortunate man had forgotten to rewind the tape and the wrong tune was played. Despite complaints from his home region, he had no chance to show what he had trained for one year to do. His

sudden tears were only partially compensated for by the sympathetic applause from the floor. Paradoxically, the more the organization tries to be fair, the more the singers feel frustrated.

The control of singers became more mechanical in 1989 when the *União Paulista de Karaokê* (UPK = São Paulo Union of Karaoke) was established. This union was formed as an official association of thirty or forty local karaoke groups in the greater São Paulo area. It adjudicates the achievement of singers according to the following categories: Category B is for singers who have not yet won cups. Every singer in São Paulo must start in this category and this Category B is subdivided into three sub-categories by age: B3, over 56 years old; B2, 40–55; B1, less than 40. When someone wins twice, he or she is promoted to Category A (same age subdivision as that of B). Beyond A category, you have *Especial* [Special] (two wins) and *Extra* (with three other wins). The range of points awarded for each category is also set in 10-point intervals (for example, B singer gets between 60 and 70 points; A, 65–75; *Especial*, 70–80; *Extra* 75–85. See *Karaoke Press*, no. 10, February 1982).[5] Every relevant contest must have more than six singers in each category and be registered by UPK and the jury must be acknowledged by this organization. UPK competitions are often divided into sections, B for B singers and A for A singers, in order to give a better chance of promotion for beginners. This system shows a notion of equality and distinction among Japanese-Brazilians and functions like the ranking and licensing system in traditional Japanese arts such as judo and calligraphy. To get a better *dan* or ranking, you must regularly participate in the official contests. Only an authorized association can recognize your achievements. *Extra* singers or the best vocalists in São Paulo by definition were at one time very few and thus respected but are now common. The limited goal discourages them from singing. To let them continue their careers – their presence attracts the audience – the UPK plans to add a *Super-Extra* category. Although the ceiling can be raised, there is no way to become professional unless one leaves the small scene. The limits of amateurism cause frustration for some *Extra* singers. The competition system vitalizes as well as restricts the activities of the individual.

The way of karaoke

'In terms of structure and organization [of singers]', says the president of UPK, Tuyoki Mori, 'Brazil is further advanced than Japan' (16 March 1994, *Diario Nippoku*). Of course Japan has singing classes, amateur contests and teachers' associations whose hierarchical structures and organizations are no different from those in Brazil. Some large events are broadcast nationwide on television but they are still marginal to the whole karaoke scene and to show business. For there are more karaoke users

active outside the competitive system and even the title of 'singer of the year' has less significance in a country with highly developed professionalism. In other words, Japanese karaoke associations are able to control the singers less effectively than their Brazilian counterparts. Is it because the Japanese-Brazilian community is much smaller than Japanese society? We will return to this question later.

One of the main aims of UPK is to establish the correct criteria of judgement and singing. One commentator has called it the Way of Karaoke (*karaokedō*) and some of the karaoke hierarchy informally use this term too (30 September 1987, *São Paulo Shinbun*). The notion of Way (*dō*) implies – like judo, *sadō* (tea ceremony), *kadō* (flower arrangement), *shodō* (calligraphy), *budō* (martial arts) – the ethos and artistic discipline deriving from the Chinese philosophy of *tao*. The Way doesn't only mean 'method' or 'skill', but attitude, self-control, perseverance and morals and implies a certain type of transmission or system of reproduction (Minamoto 1989). The real Ways remain only in the area of authentic–traditional (*dentō*) arts (or better put, the 'traditional arts' are something inherited from the Way) but the practices and the philosophy derived from them are pervasive in Japanese sports, education and other aspects of daily life. The Ways emphasize authenticity. Legitimate form-patterns (*kata*) are transmitted and authorized only through the authentic 'master' (*iemoto*) who resides over a 'family' of each art. The 'family' doesn't always consist of biological lineage but in an 'adopted' sense; in other words, it creates 'licensed' sons and daughters. The technical transmission and licensing system (from master to disciple) is closely connected with economic flow that goes inversely (from disciple to master). This two-way transaction forms a closed circle for each Way and makes it difficult for disciples to get out of the technical and moral control of their *iemoto*. As the patriarchal system does not allow for deviation from the transmitted patterns, it maintains almost intact the homogeneity and similarity inside the fictive-familial system (Nishiyama 1982).

The categorization of singers by the UPK is basically akin to the ranking and licensing system of judo (although UPK itself does not teach nor does it regulate the technique of performance as the real *iemoto* system would). By claiming a *karaokedō*, Way of Karaoke, the organizers intend to elevate the cultural status of karaoke to that of an authentic–traditional art. It obviously opposes the professionalism that tempts the singer to sing for money, considered a base motivation for the Way. The rigid structure and organization Mori takes pride in are a result not only of the limits of ethnic showbusiness but also of the disciplinary philosophy–practice of Way underlying the Japanese-Brazilian lifestyle.

Although only a few explicitly insist on following the Way of Karaoke, many experienced singers (in the *Extra* category) implicitly believe it as is shown in my interviews. They claim:

I have never been satisfied with my singing; I have made progress to a certain level but cannot surpass it yet; I need to practise this song [his winning tune] until I die if I want to sing it well; I should sing for my own heart and not for the jury; one must sing for one's own self-improvement; the audience knows my singing better than I do.

This sort of statement is in fact often made by Japanese professionals. In short, amateur singers share the philosophy of singing with stars in Japan. The ideas of the ABRAC singers are directly or indirectly affected by the Japanese model. A similar example would be a judo champion saying, 'the most difficult rival is inside myself'. To be or to show him/ herself a champion, however, he or she must participate in various championships. He or she must compete against an adversary in public to demonstrate how he or she fights with him/herself. Unlike Western athletes, Japanese judo players and their coaches often interpret their sports-Way from such a self-assessing point of view. The *Extra* singers quoted above seem to interiorize a similar conception. The disciplinary practice is clearly seen in the singing class that most of the ABRAC singers attend.[6]

Disciplined amateur

The first private singing class began in São Paulo in the early 1950s immediately after *nodojiman* was established. A prerequisite for teaching was that instructors had to read sheet music and play an instrument (especially piano). Such a musical education (although most of them were self-taught) endowed them with authority and their piano in the classroom was sometimes only there for prestige rather than as an instrument to play. Many singers used to train in such classes and rehearsed with bands before they went to the official contest. Veteran singers often remember how their rehearsals with the band were very serious because they could sing only a few times a day (as a band had to rehearse with more than thirty or forty singers during the weekend). The rehearsals were for the musicians a source of joy as well as pain, especially when the singers could not sing in tune. From the singers' point of view, the band was responsible for their frustration, when they could not play the score as the vocalist desired.

It goes without saying that karaoke equipment has radically transformed how and where one rehearses. The new machine has affected not only the didactic method (teachers only need a cassette recorder and a microphone) but also the location where one sings. Singers can sing at home (if the family does not mind), go to private lessons (once or twice a week, individual or group lessons) or to karaoke bars (if they want to sing with better equipment) and finally they can participate in weekend competitions.

149

Approaching an important event, one enthusiastic singer may sing their registered songs (one for the eliminatory round and another for the final round) more than twenty times in a week. The most persevering singers continue to sing the same songs for more than ten years even after they have won the national contest. These songs are recognized as their artistic 'property' so that only a singer competing against them in competitions may sing them.

One of the most obvious consequences of the introduction of pre-recorded tape is the increase in group lessons/rehearsals in the singers' artistic lives. Growing numbers of teachers provide group lessons as well as individual lessons. Group lessons with five to ten people present are held both in the daytime and at night-time, lasting two to three hours. Compared to karaoke bars, the advantage of night lessons is that one pays less and can sing for longer among acquaintances in a better environment. If one is affiliated to two such clubs that provide bi-weekly sessions, he or she can sing at least four times a week and not in front of complete strangers.

Japanese small-group management is more or less maintained in the organization of singing classes: members alternately play the roles of secretary, treasurer, 'charwoman', and so on. Membership fees are used for tuition, the room rental, tea, and other services. The rental is usually low (or free) because at least one of the members has a personal connection with the place. Since all the members know each other (some are family), they feel more relaxed than in night-time karaoke bars. Unlike the karaoke clubs that are usually situated in a busy and possibly unsafe area (Liberdade, for example), the places for group lessons are often found in residential areas where Japanese immigrants live. The physical security and ethnic exclusivity allow some peace of mind for women whose husbands or parents don't let them go out to karaoke bars alone or who are themselves reluctant to do so. This is also the case for many elderly singers. The sobriety of the session is also important to them: they do not go there to waste time but to *exercise* their voices and thus *enrich* their 'cultural' life. Such an excuse is certainly derived from the competition system. When this motivates the singers, singing is more than entertaining or pleasurable in itself: it becomes a 'rehearsal' and 'training session' for higher achievement in forthcoming public presentations. Such a socially related goal is certainly esteemed more highly than mere personal exhilaration. The presence of a teacher guarantees the educational nature of the class. Hence, the success of daytime karaoke is firmly based on the moral aspect of collective life.

In provincial cities the group session presented by the local association makes the karaoke bars superfluous (although some major Japanese restaurants own equipment for weddings and other festivities). Such a session is usually held at the association, the regular meeting point of the

community, and is open to every member subscribing to the karaoke department of the association. When the membership is relatively large, the session is divided by age with sub-sessions like 'children's session' or 'youth day'. When someone wants to sing informally with friends (and drink alcohol), he or she usually invites them to their home because it costs less and guarantees their security. Perhaps the home karaoke party is influenced by the Brazilian way of socialization.[7] Owing to the variety of ethnic places in which to sing, karaoke bars are difficult to run in provincial cities.

Besides the regular karaoke sessions, local Japanese-Brazilian associations organize barbecue parties with karaoke a few times a year (on the anniversary of Japanese-Brazilian immigration, the celebration of the city at Christmas and New Year, and so on) in order to raise funds for the department and the association. Another means of raising finances is to organize a weekend tour to smaller towns and villages with a few excellent singers recognized as technically 'almost professional'.

Beyond the language barrier?

For most young Japanese-Brazilian singers, Japanese songs are 'foreign' in the sense that they do not understand the lyrics. They usually know whether the lyrics deal with tearful romance, desperation or homage to the morale of fishermen, but neither the literal meaning nor the nuances are understood. Why don't they choose Brazilian or American music as their schoolmates do?[8] The most influential factor is their families' orientation to Japanese music. There are only a few whose parents are not interested in Japanese popular music (by contrast, many children are indifferent to what their parents listen to and sing and rarely come to karaoke contests). Karaoke contests provide occasions for family socialization. Youngsters in the karaoke scene have usually grown up with Japanese songs, listening to them either live or recorded. It is not therefore an odd choice for them to sing in Japanese, and those who sing in Portuguese or English are systematically excluded from ABRAC. The only foreign tunes admitted are songs the Japanese versions of which were interpreted by mainstream singers. 'Theme from *Love Story*', 'Adoro' and 'My Way' represent those songs sung in the ABRAC competitions (but the Beatles, Elvis, and Abba among others are out).

What comes out of linguistic incomprehension, the inevitable consequence of a linguistic border crossing? As is shown throughout history, from the European reception of Italian opera in the eighteenth century to the contemporary explosion of 'world music', semantic understanding can be dispensed with in its reception and can be overwhelmed by the primordial power of the voice – the 'grain of voice' – itself. It is not the meaning but the sound of Japanese that matters for young singers.

151

The 'sound' of Japanese is familiar if not semantically intelligible to their ears. That there are no Portuguese cover versions of Japanese songs may imply the separate character of Japanese songs in terms of language. When sung in Portuguese, many young and elderly interviewees answer wryly, 'The songs will not be Japanese any longer.' The sound of Japanese can cross the language barrier in a confined manner because it cannot appeal beyond ethnic borders. The semantic alienation for the young singers, the same as for Brazilians, doesn't always result in an emotional one: Japanese is a family language rather than functional one.

Singing in a foreign language, as we know it, starts with (and usually ends with) imitating the correct phonetic sound to the best of the singers' ability. To voice unintelligible phrases is good fun to many people (since Cab Calloway?). The translation process intervenes in the interpretation and makes the relationship between the lyrics and the voice indirect and the singing tends to become stiffer by tracing the model patterns with considerable effort. I don't wish to imply that singing in a foreign language is inauthentic but that when crossing linguistic borders one thing is lost and another is gained.

The linguistic situation of the Japanese-Brazilian karaoke scene is radically different from the majority of popular singing where performers sing in a common language. This is almost an axiom for popular music around the world. When the community shifts the language because of an uprooted lifestyle, the music also changes the language. This is seen in the history of the polka in which the language sung has moved from Polish or Slovenian to English. Japanese language certainly functions as an ethnic marker in Brazil but in a fundamentally different fashion from, for example, Spanish for salsa or Yoruba for Nigerian juju, for it represents the ethnicity but does not always speak for the singers' and listeners' sentiments.

Closely related to semantic alienation is the characterization of karaoke for a new generation by an absence of original songs and new styles. Except in extremely sporadic cases such as Japanese pop songs arranged in Carnival march (*marcha*),[9] there has been no attempt to hybridize Japanese and Brazilian music. There might be several reasons for this rigid compartmentalization: musical incompatibility and Brazilian mono-cultural national politics ('all the great cultures are miscegenated in one'). This may be responsible for it as much as Japanese cultural exclusivism and purism (partly tied with the concept of Way) and the either–or identity construction among the descendants who are more willing to recognize themselves as *brasileiros* [Brazilian] while society classifies them as *japones* [Japanese]. Despite a hyphenated identity as *nipo-brasileiro* gradually substituting their either–or identity (see Maeyama 1979), mainstream society will hardly accept this alteration. As far as one maintains a certain physiognomy by birth, people automatically define him/her as *japones*.

This is what Mark Slobin, in his essay on 'ethnic' music in the US, terms '"involuntary" subcultures'. That is to say, the 'non-Euro-American' social formations

> are constrained within well-defined administrative and cultural boundaries established partly through (very different) historical circumstances, but primarily through appearance: you can tell one when you see one, through the superculture's [Euro-American] eyes – or, by crude extension, if you've seen one, you've seen them all.
>
> (1993: 53)

This 'involuntary' nature of Japanese-Brazilian identity is linked with the *passive expression of ethnicity* because to sing in Japanese conforms more to how society recognizes the singers than how they identify themselves. Although karaoke singing consolidates their feeling of belonging to one 'subculture' in the sense of Slobin, what is in question is not the sense but the sound of language. Therefore, Japanese songs are not for those young generations the same as, for example, Spanish songs for the Chicano teens in San Diego, California, or Arabic *rai* songs for the Algerian youth in Marseilles. It is likely that the importance lies less in what they sing than how Brazilians are indifferent and insensitive to their singing. It is complicated to answer the question, *whose music* do they sing?

Musically and linguistically, the songs belong to modern Japanese culture to which the singers do not always belong. Owing to the family relationships at work, our case is different from Finnish samba, Japanese flamenco or German delta blues, as the music practice is dissociated from the ethnic/racial implication. It is also different from the case of affluent Chinese-Americans singing 'Hey Jude' (Lum 1996: 2) because they can understand what they sing.

Child singers

As is seen in Table 7.1, what is characteristic of the recent ABRAC contests is the increase in the number of child participants. This feature differentiates Japanese-Brazilian karaoke from Japanese (homeland) (where child singers exist but are totally peripheral) and Euro-Brazilian karaoke (where children are almost competely absent).

The separation of child singers into two classes (*dōyō* and *tibiko*) started in 1988 when the *tibiko* (literally 'little child') category was added to the existent *dōyō* one. Here *dōyō* (literally 'child song') means the songs included in Japanese school books. Since the first edition of *nodojiman* in the 1950s this category has mainly consisted of the pupils of Japanese schools, with piano accompaniment. The lyrics are educative and the

singers must sing the songs in a non-vibrato voice with upright posture (similar to a proper classroom). The *dōyō* participants usually wear Western refined dress associated with the upper class.

By contrast, *tibiko* in Brazil refers to child singers who precociously imitate adult singers. Although children usually like to imitate what their family listens to, it was not until the 1960s that the copying of adults by children was formally institutionalized by popular television shows in Japan. Visual appeal became crucial for the popularity of such 'premature' singers who imitated the stars' gestures and costumes as well. In Brazil, a similar show has been broadcast since the 1970s in weekly programmes for the community (*Imagens do Japão* and *Japan Pop Show*) but this did not form part of the live contest because of its 'uneducative' nature. Children had to sing, the organizers of *nodojiman* believed, proper school songs.

The absence of the child categories in the first ABRAC contest shows that this association at the outset intended to differentiate itself from the *Concurso National de Cantos* by its adult orientation. Lack of karaoke tapes of school songs could have had something to do with it as well. Certainly for the Japanese software manufacturers, children were out of the market. The *dōyō* category revived in the second year probably because parents as well as organizers thought the participation of children was necessary to complete a large-scale ethnic event like a karaoke meeting. The massive presence of children is also important for audience numbers since children must be accompanied by their families. Private singing classes for children have gradually made up for a decrease in music teaching in Japanese schools in Brazil. Some teachers record at home the keyboard accompaniment of school songs for their pupils. Such a practice is uncommon in Japan, where the school songs are still obligatory in primary school curriculums (in choirs with piano accompaniment) and rarely taught outside of school (except in children's choral societies).[10] In Japan, school songs are not suitable music for competition or to be sung with pre-recorded sound.

More and more, parents of *tibiko* singers are investing not only in singing classes but also in the luxurious stage costumes that match the star model (colourful kimono for girl *enka* singers, black tie for boy *enka* singers, for example). In addition to costumes, the *tibiko* singers usually learn how to pose on stage by watching video tapes of the original singers. No other competition than ABRAC's has the *dōyō* category in Brazil, while *tibiko* contests have become increasingly popular. This may come from the different degrees of affective involvement with the songs on the part of the parents who wish to see their children singing songs they like. As with the words, school songs rarely contain personal sentiment and are usually detached from daily life. Musically, they are simpler than most popular songs. School songs are almost frozen in time

while new popular songs are constantly being made. In a word, school songs lack entertainment. While adult songs are open to children, school songs are limited to a certain age group. *Tibiko* singers can develop more than *dōyō* singers who must stop singing school songs after leaving primary school. Many *tibiko* singers continue singing similar types of tunes after they enter the youth and adult categories.

Although the repertoire of *tibiko* singers is as wide as the adult's, *enka* is especially favoured, probably owing to their parents' taste. One karaoke teacher told me that she wanted the third and fourth generation to sing *enka* because it expressed the Japanese heart, which was otherwise hard to transmit to those who had but sporadic contact with Japanese culture. Another teacher thought that many *enka* songs dealing with Japanese nature (especially the winter landscape) were good for children so they could learn and feel what their grandfathers experienced (see Yano 1995). *Dōyō* or *tibiko*, the child singers are expected to learn Japanese through singing. It seems to me, however, that very few of them really understand it.

In conclusion, I will add a few words on the gender roles of child singers. As is clear from Table 7.1, girls are predominant in *dōyō* and *tibiko* categories (particularly, the former). This may be related to three factors:

1 The Japanese traditional concept of singing as a female hobby: since the seventeenth century, popular vocal genres accompanied by *shamisen* have been practised mostly by women and thus music-making (and dancing) used to be a part of female culture (except for court music of *gagaku* and Nō music of the samurai class that were and are exclusively male). Some conservative educators in the early Meiji period (1870s) objected to the introduction of music to primary schools because it was considered effeminate.

2 In Japanese popular music, girls in their early teens have much more access to professionalism than boys of the same age. For example, *Musume Gidayū*, or intoned narration by female performers popular towards the beginning of twentieth century, was a typical example. Since the 1920s, several girls in their early teens have become known nationally through their radio appearances and their recording of children's songs (*dōyō*). The post-war girl singers started with Hibari Misora, 12 years old, who made her debut in 1949. From the 1960s to the 1980s, Momoe Yamaguchi (14), Masako Mori (14), Harumi Miyako (15), Fuyumi Sakamoto (15) and many other girl singers became famous. Some of these singers, especially Hibari Misora, are role models for the *tibiko* singers. It seems to me that their parents project their musical memory of past decades on their talented children.

3 Gender differences in after-school activities in Brazil: some parents told me that boys had more variety of after-school life including sports

155

(such as baseball, soccer, judo) and were allowed to go out on their own, whereas the girls were more strictly controlled by their families. Singing with friends is then one of the few occasions for girls to go out with or without their parents. Group lessons for children function as an opportunity for socialization for their mothers as well.

'A real carnival'

In order to better understand the ethnic boundaries of karaoke, we now turn to Brazilian society. Although karaoke emerged in the Japanese community in 1977, it is not until 1984–5 that the apparatus crossed the ethnic boundary.[11] In 1985, a weekly magazine, *Veja*, featured the rising boom of *karaokê* in São Paulo as follows:

Millions of young people in São Paulo last month incorporated into their vocabulary a word unknown to prior generations: karaokê. It is not, however, some novelty in the world where jargon is always changing — karaokê (empty orchestra in Japanese) is a term which today designates bars whose frequent customers not only sit down around tables and dance on a floor but also go up on to the stage, accompanied by a tape recorder providing only background instrumental music, and have vocal adventures. The first of them already appeared seven years ago at Liberdade, the oriental quarter of São Paulo. Today there are 130 karaokê bars. A year ago, however, the fashion began spreading to the city, reaching the quarters with intense night life like Moemas and Jardins, and challenging the hegemony of *danceterias*.

(29 May 1985: 61; my translation)

The accent on -kê suggests that the mode has come from Liberdade (because Japanese pronounce karao-*ké*. Yet, 130 karaoke bars in Liberdade seems exaggerated). 'Karaokê', defined by the wife of a night-club owner, 'is a programme of non-professionals in an enclosed space and there nobody is booed nor pretends to follow an artistic career.' When she goes on the stage, she doesn't want to leave because she 'feels like Liza Minelli herself'. Her favourite karaoke bar is Lullaby, situated in Rua Augusta (a busy street in the Paulista area), where a popular television presenter, Marília Gabriela, enjoys herself so enthusiastically that she is about to start a karaoke section in her variety programme (I cannot confirm if this idea was finally realized).

Another crowded karaoke bar was 'O Carra o Qué?' (pronounced o-kara-o-ké, a colloquial expression for 'so what?') in Moema, a sophisticated entertainment area in the southern part of São Paulo city. According to the article quoted above, it had 170 Brazilian and 600

American songs in its tape repertoire. Among the most requested were 'Besame Mucho' and 'I Just Called to Say I Love You' (Stevie Wonder). Because of its location and American-dominated repertoire, O Carra o Qué? was frequented mainly by the (upper-)middle-class public. Other karaoke bars for non-Japanese were mostly found in the upper-middle-class areas (Boca Livre and Desafinado in Bixiga, Shōgun and Sebastian Bar in Jardins, Tatitibati in Pinheiros, for example).

Its sudden popularity spontaneously led to '*teatrokê*' (*teatro* = theatre and *karaokê*) which opened in Rio de Janeiro in 1985–6. There, the customer performed an act with a professional actor–presenter using prepared props. It was described as 'a new type of karaokê' by *Veja* (22 January 1986: 47).[12] In other words, 'karaokê' was not only associated with amateur singing but also with a variety of amateur performances on stage. From this association appear phrases such as 'live karaokê' or 'piano karaokê', an oxymoron in Japanese, where the clients are invited to sing on stage with a piano or a guitar. Here *karaokê* does not mean 'empty orchestra' but 'public participation'. As in karaoke in Western countries, the role of the MC (called *animador*, or animator) is so important that his/her name is put in the centre of the advertisement.

In addition to regular karaoke places (like O Carra o Que?), in the late 1980s there were several bars and night clubs in São Paulo where a primitive PA system was set up for singing clients once or twice a week. According to Doro Junior, who worked as a karaoke *animador* and ran the first shop specializing in karaoke equipment in São Paulo from 1991 to 1992, there used to be about fifteen clubs with karaoke apparatus towards the end of 1980s (interview, April 1992). Although a dozen karaoke albums were released towards the end of the 1980s, many bars had local musicians (sometimes equipped with only a synthesizer and a rhythm box) pirate instrumental versions of well-known songs and often used this dubbed cassette tape to enlarge their music list on the cheap.

The Japanese owner of Kyoto, a karaoke bar in Liberdade, mentioned the ethnic differences in the practice of karaoke singing: 'Originally it was a well-behaved diversion. But the Brazilians are making it *a real Carnival*' (*Veja*, 29 May 1985: 62, emphasis mine). By 'a real Carnival' he certainly implied the hilarious, cheering, noisy, and thus 'badly behaved' mood of Brazilian karaoke. The public often sing together, chatter among themselves and the main voice from the loudspeaker is sometimes neutralized by a larger 'chorus'. Sometimes three or four singers go on the stage together but none of them can be heard on the floor. They can leave whenever they want. The other singers comically exaggerate the gesture of stars and dance with the performer on stage.

Such 'chaos' was defined as 'a real Carnival' by the old Japanese. It is far from the disciplined 'Way of karaoke' ('well-behaved diversion') and is incompatible with the Japanese notion of the collective/the individual

in the use of karaoke space, which calls for individual performances (except for a mixed duo for dialogue-type love songs), the strict division of stage and floor (except for some comical pieces), no interference between groups, and no dancing (except for a slow foxtrot for some *enka*). Yelling and whistling are rarely heard in karaoke bars in Liberdade. These hidden rules (see Ogawa, Chapter 2 in this volume) control such 'well-behaved' space as the owner of Kyoto characterizes (many Japanese-Brazilians I interviewed agree with him). Brazilian and Japanese karaoke bars are as different as the Japanese tea ceremony and a Western tea party. Naturally there are as few Japanese in non-Japanese karaoke bars as there are non-Japanese in Japanese ones and there exist no intermediate spaces in between them. The rules of behaviour are so incompatible that 'crossover' has not taken place in the karaoke scene in Brazil, a nation proud of its racial miscegenation. Consequently, there are few places which provide both Japanese and Brazilian (and international) songs (although Japanese bars usually have at least several standard melodies like 'My Way', 'Autumn Leaves', 'Besame Mucho' and 'Yesterday').

Karaoke fever among the non-Japanese public, however, did not last more than five years. In 1991 it was already thought to be *passé* by the majority of non-Japanese middle class I interviewed. Unlike the situation in the Japanese community, karaoke in Brazilian society saw its five limitations: class (middle class), age (from student up to thirties), location (mainly the city of São Paulo), time (only 'night market') and period (from 1985 up to 1990 or 1991). In other words, it could not become popular nationwide. The boom faded away before international corporations entered the local market.

Economic barriers hindering access to karaoke among the underprivileged are clear. Enclosed and paid space *a priori* excludes the underprivileged who sing along not with pre-recorded tapes but with guitar and makeshift percussion instruments (or with a loud radio). The ceremonial setting of karaoke seems unimportant for them since socialization is based upon the street performance of *pagode* (party samba), for example, which emphasizes body movement more than pure vocal expression.

The shift from night to day is, as argued above, crucial to the spread of the Japanese-Brazilian karaoke scene to women, children and the elderly. The growth of daytime use has been brought about by the pyramid organization stretching from the grassroots level to the upper strata of show-business. The 'night market', in turn, has been stimulated by a series of technological innovations (especially in laser karaoke). None of these conditions – such as social organization and technological renewal – has been at work in the Brazilian scene. When a middle-class, relatively young, urban – and capricious – audience has become tired of singing with a pre-recorded tape, karaoke has had no other choice but to fade away. In Japan, recorded sound has almost totally eclipsed the use of instruments often

used for popular singing (such as the *shamisen*, the guitar and the accordion in the past) and it is difficult for Japanese to sing without a microphone. On the contrary, Brazilians use handy and easy instruments such as guitars and percussion in their daily music-making so that the street is an important space for singing and dancing for them. Therefore, rich or poor, they are able to create a place for singing without plugging in some machine. It is unlikely that the belated popularity of karaoke in North America and Europe will bring about a revival – it *was* only a fad in the late 1980s.

Conclusion

It is true that karaoke as an apparatus provides new practices and experiences of singing in many cultures but how it is used depends as much on the pre-existing concept and behaviour of singing as on the industrial and technological features of this device. In the case of the Japanese-Brazilian community, the hierarchical organization of *nodojiman* created by the first generation in the 1950s is crucial to the social aspect of karaoke scene and the discipline. This is because our sing-along technology adopts the seriously competitive institution such as *nodojiman* and this largely conditions the concept and behaviour of karaoke singers today. I would thus emphasize the continuity with the past in spite of the novel appearance of karaoke practice. The flourishing singing classes are a result of the particular institutional heritage of the *nodojiman*. This strong influence of the amateur contest characterizing the formation of Japanese-Brazilian karaoke scene was because the *nodojiman* was too ephemeral to find continuity with karaoke in Japan. This historical difference between Japan and its cultural enclave in Brazil may derive from the absence of professionalism in musical performance.

Another notable characteristic is compartmentalization. The ethnic boundary Japanese immigrants set up by means of music-making and listening to music since their arrival in 1908 has not been broken down by the technology shared with non-Japanese Brazilians. This was the case with many instruments used by *nodojiman* bands. Usually Japanese saxophonists, for example, had no musical exchange or communication with Brazilian musicians. Similarly, karaoke in the community has practically no interplay with outside society. Such 'pluralistic coexistence of karaoke' (to paraphrase Kartomi 1981: 237) is found in multi-ethnic economic centres (New York and London, for example) where the karaoke scene for Japanese businessmen is usually separated from that of local people because of their different socializing patterns and language boundaries.

However, language is not a final instance for the compartmentalization of karaoke, since Portuguese-speaking mono-lingual descendants share the scene with the Japanese-speaking mono-lingual generation. Without a

competitive framework inherited from *nodojiman*, this generational crossover would be rare. In Japan, by contrast, the use of karaoke seems more strictly divided by age groups partly because of diversified musical taste. Japanese popular music is exposed or over-exposed to every kind of mass media and public space. Songs used for television dramas and commercials are so intensively and instantly tied up with collective memories of Japanese youth that they are extremely popular in karaoke boxes. Today such a multi-media hype linked with karaoke dominates the music industry in Japan. Certainly, the Japanese-Brazilian community is far away from this and young descendants have little access to the latest Japanese pop songs. Dependent upon restricted channels of information, their taste tends to be less diversified than that of their counterparts in Japan and more in line with the tastes of the older generation.

Nevertheless, it is misleading to think that *all* Japanese-Brazilian youth sing Japanese songs in karaoke. In fact, though no statistics are available, the majority of Japanese descendants in Brazil live outside the reach of Japanese associations and, consequently, the Japanese karaoke scene. In particular those who marry non-Japanese tend to disconnect themselves from Japanese social circles. They are culturally and musically 'assimilated' with the mainstream (or dominant) society. Some of them might have sung in the late 1980s in Brazilian karaoke clubs but never appeared in the Japanese scene. What I have discussed in this chapter is therefore only the Japanese-oriented end of the vast immigrants' community. Through singing as Japanese do, however, the immigrants do not always *insist* on their Japaneseness. As noted above, singing Japanese songs is *passively* related to their ethnicity. Resulting from compartmentalization, Japanese music has no intercourse with Brazilian music at the level either of sound, behaviour or concept (Merriam 1964) and there are no intermediate styles or genres that could articulate the double identity of Japanese-Brazilian youth.

Recently, many ethnomusicologists have studied how migration groups express their identity through music and how pre-departure cultures interact with post-migration conditions ('Forced Migration' issue of *The World of Music*, vol. 32/3, 1990; Hirshberg and Seares, 1993). At the sound level, broadly, some (try to) maintain the homeland music culture, whereas others may be susceptible to a new synthesis. The case in question here is certainly the former because of the absence of musical affinity. Another similar example is provided by Peruvian inter-state migration from the Andean highlands to Lima. This group tried to continue to make music as they had done in their home towns. But the *meaning* of 'highland sound' changed radically in the capital because of the 'differences in musical practice, value, occasions, and style' (Turino 1993: 35). In Lima, where various styles of local, national and international music coexist, the migrants' musical practice made them feel 'at home', differentiating themselves from

other people. Performing the Andean panpipe music in the capital, as Turino discusses, is affected by local politics, national ideology and the international market. This is somehow true for Japanese-Brazilian musical practices. Although they try to sing and show themselves as Japanese, the meaning of singing Japanese songs in a country where the Japanese are demographically a minority and culturally marginal is radically different from the meaning of doing so in their homeland. This is especially shown in the non-Japanese-speaking singers, who personify an interesting example of musical transfer.

Unlike the Peruvian case, however, the songs we have been examining are all industry-made, nationally (not regionally) distributed and performed, and impermeable to mainstream society. Here impermeability means that Japanese music is practised and consumed inside ethnic borders and is rather inaudible from the outside. Japanese songs are by no means a kind of regionalistic, nationalistic or nativist music that refers to the authentic history of the Brazilian nation as the Peruvian panpipe ensemble is. This may reinforce the compartmentalization.

As Casey Lum concludes in his work on Chinese-American uses of karaoke space and apparatus, karaoke in the Japanese-Brazilian community

> provides the social and symbolic structure for people to create, maintain, and transform social realities and meanings that are true and significant to them. Karaoke is by nature intensely indigenous because the unique blend of interpretive frame of reference, ethnicity, material expression, and gender arrangement that people bring to each and every performance defines the dramaturgical character, as well as the social and cultural experience, in the *scene*.
>
> (1996: 112, my emphasis)

Acknowledgements

The author is grateful to the Toyota Foundation, which supported part of his research in Brazil conducted for eighteen months between 1991 and 1994, to Dr Carolyn Stevens whose critical feedback was indispensable for the anthropological reflections, and especially to Noboru Yoshida, Masako Yoshida, Shōichi Shimada, Hisae Sugishita, Rikichi Origasa, Dore Junior and many other teachers and singers who granted him interviews.

Notes

1 In this chapter the term 'Brazilians' mainly refers to 'non-Japanese Brazilians' (excluding Japanese descendants with Brazilian nationality). This text summarizes Chapter 3 of my book in Japanese (1995a). See also Hosokawa 1993, 1995b.

2 We will not deal with the third type of karaoke in Brazil: clubs for Japanese businessmen and diplomats. Briefly, these bars are much more expensive than venues for Japanese immigrants; they have more refined sound and light equipment; there are hostesses; their clientele is predominantly male and middle-aged; its owner usually recognizes the names and business affiliation of their regular customers; they are mostly found in the Paulista area; and they usually have an exclusive parking lot. They resemble the luxurious karaoke night-clubs in Japan. Few Japanese immigrants go there by themselves because of the high cost, while some karaoke bars in Liberdade are visited, if not frequented, by Japanese businessmen. These temporary inhabitants have established no hierarchical organization of singing as the immigrants do. There are cultural boundaries between the Japanese and Japanese-Brazilian communities, even if they are less strict than those between Japanese(-Brazilian) and Brazilian societies. A fourth type of karaoke, Korean karaoke, is also outside the scope of our examination (Liberdade has at least five Korean clubs).

3 The 'pop' category was first seen in the second series (1987) with young singers who sang in the first series with choreography. Their performance was thought to be 'badly behaved' by some judges but the others supported them on condition that the singers were to be separated from conventional ('well-behaved') competitors. Thus a new category was made. 'Pop' singers, usually in their upper teens to twenties, dance and/or have accompanying dancers. The singers and dancers learn the choreography and design comparatively extravagant costumes after watching video tapes of Japanese television shows. Usually these pop songs have longer and more dramatic introductions and interludes than *enka* (favoured by 'adult' singers) in order to show off the choreography. Young audience members scream and yell the name of the singer to simulate the live performance on Japanese television. The lighting and strobe flashes used only for the Pop category provoke this simulated overreaction. The dancing is judged separately from the singer by a non-Japanese jury formed of local dance teachers, gymnastic teachers, and so on. In the 1992 edition, three break dancers performing to a disco-like tune won the trophy. They were the only black presence in three shows I attended (1992–4), although there were always three or four Euro-Brazilian singers. Unlike the original stars, the pop singers in Brazil do not use 'lip-sync' technology nor wireless microphones so that their dancing is from time to time disturbed by handling the microphone.

4 The predominance of 'veteran' and 'child' in the contest does not reflect the real proportion of age groups of karaoke users because these two groups use night-time karaoke much less than the 'adult' group.

5 *Karaoke Press* (March 1988–July 1991) was the only Japanese-Brazilian magazine specializing in karaoke (first issues were monthly and last ones were irregular). According to its editor-in-chief, Noboru Yoshida, it sold around 1,000 copies monthly (interview, November 1991). It included national and Japanese news (Top 10, music sheets, interviews) reprinted from Japanese *Karaoke Taishō* [Karaoke Grand Prix]. Articles in Portuguese were classified into two categories: translation of Japanese text published in the same issue and original text that had no correspondence to the Japanese pages. The latter, which increased in the course of time, addressed the younger readership and was mainly concerned with Japanese pop music. The transition of this editorial policy is related to the generational and linguistic shifts of the Japanese-Brazilian karaoke scene.

6 The co-owner of Donguri remarks that Japanese-Brazilians sing after hard training while Japanese businessmen just come to karaoke to sing (1 October

1983, *Diario Nippaku*). She implies that the former sing better. What is at stake is that Japanese businessmen have no such organization of karaoke similar to the Japanese-Brazilian community and they consider the singing merely as a pastime. When I asked several descendants about the comparison, they replied that because Japanese-Brazilians are more shy (more country-bred) than Japanese, they don't want to be embarrassed in public by a bad performance. 'Shyness', naturally associated with the feeling of 'shame', is often proclaimed as a 'national' ('ethnic' in the case of immigrants) characteristic of the Japanese (compared to 'bold' Western, 'shameless' Brazilian) by Japanese themselves. Such a notion of 'national character' survives in popular belief even after anthropologists have abandoned this theory.

7 Parties in the home are much less frequent in Japan partly because of smaller housing conditions and partly because of different inter-family relationships and the different use of private and public space–time.

8 On the importance of childhood in the formation of 'musicality', see Loza 1993: Chapter 6.

9 Ricardo Kawauchi, who formed Appa Tota, one of the best-known rock bands in the community in the early 1970s, sings Japanese pop songs with a Brazilian samba band in the Carnival held by the Japanese-Brazilian Cultural Association of Anhanguera (São Paulo). He takes it as a sort of special joke (*brincadeira*) for Carnival and has no intention of recording this performance because it is for him just for fun and not for money and fame (interview, March 1994). At least two Japanese-Brazilian rock group/singers are known in the 1980s (Okoto and Goemon) but their music sounds like international pop in Portuguese and has no reference to Japanese-Brazilianness (except for the atmospheric use of *koto* sound by Okoto in their first album). A Brazilian-born singer, Jorge Saiki, released two singles but in common Brazilian style (*Diario Nippaku*, 6 February 1982).

10 In the 1970s, there was one children's chorus of Japanese immigrants in Brazil, the Little Singers. They appeared in Brazilian choral festivals and on television programmes. As in Japan, the choral activity in the community was heavily represented by women. In the choral scene there was no competition, but mostly non-competitive festivals. One of the organizers explains that there were too few groups to set up competitions (fewer than ten in 1994) and that the association feared that their defeat might discourage further activity. In Londrina, Paraná, a choral group of the Japanese-Brazilian Cultural Association invited some Brazilian women to join them and rehearsed both Japanese and Brazilian songs with the intention of participating in the Brazilian choral festivals. Such an attempt at crossover is an exception but is possible in the choral scene because the Brazilian chorus scene is operated on an amateur basis and oriented to the middle class as well as Japanese-Brazilian one.

11 This doesn't mean that the word karaoke was not known outside the Japanese-Brazilian community before 1985. As early as 1980 a *karaokē* album for non-Japanese consumers was released (CID 4096): *Você é o Cantor* [You are the Singer]. The word *karaokē* on its cover suggests the penetration of Japanese culture beyond Liberdade. This album includes international disco hits like 'Gengis Khan' and 'D.I.S.C.O.' and Brazilian ones like 'Rasta-pé' and 'Abri a porta'. This album may be the first 'karaoke' album produced outside Japan ('playback' albums were known in the 1970s). However, the four sequels of *Você é o Cantor* released before 1985 have no such explicit reference to *karaokē* although their contents are not dissimilar to the first volume. That word was probably still unfamiliar to the Brazilian audience. Some of their covers have

the photo of an audio set with cassette, radio and LP functions (in Brazil this type of stereo was called *somgame* [sound-game] or *3 em 1* [3 in1]).

Brazilian 'playback' albums after 1986 are again referred to as karaoke explicitly in the titles (e.g. *Karaokê em ritmo de partido alto* [Karaoke in a rhythm of good party], CID 4190; *Karaokê Infantil*, Carrousel 10051). By the beginning of the 1990s, at least ten albums claiming to be 'karaokê' had been released that contain instrumental versions of Brazilian songs of *sertaneja* (Country and Western), *pagode* and other genres. This phenomenon was certainly related to the wide diffusion of karaoke as a word and practice among the non-Japanese public. Some of the album covers show several young white persons singing with a microphone in front of the neon sign of Lullaby, one of the busiest karaoke bars for non-Japanese towards the end of the 1980s. These covers allude to the fact that the album as well as the karaoke bar are oriented to (upper)-middle-class consumption.

A second-hand record shop in São Paulo, Elite, on the other hand, puts instrumental music recorded in the 1960s by an American orchestra in the rack of 'Karaokê'.

12 I don't know if this *teatrokê* comes from a Japanese variant of karaoke, *shibaoke* [*shibai* = theatre + *karaoke*], where sets of special costumes and hair pieces for the roles in *jidaigeki* (a form of 'costume play' set in the Edo Period, 1603–1867) are used by the singers–players. In *teatrokê* the accent is on the dramatic element, whereas in *shibaoke* singing is still the main attraction. There used to be one *shibaoke* in Liberdade called 'Roppongi'.

References

Hirshberg, Jehoash and Seares, Margaret (1993) 'The displaced musician: trans-plantation and compartmentalization', *The World of Music*, vol. 35, no. 3, pp. 3–34

Hosokawa, Shūhei (1993) 'A história da música entre os Nikkei no Brasil. Enfo-cando as melodias japonesas', *Anais do IV Encontro Nacional de Professores Universitários de Língua, Literature e Cultura Japonesa*, Centro de Estudos Japoneses da Universidade de São Paulo, São Paulo, pp. 125–47.

Hosokawa, Shūhei (1995a) *Samba no Kunini enka wa Nagareru* [Enka in the Country of Samba], Tokyo: Chūō Kōron.

Hosokawa, Shūhei (1995b) 'Singing not together: karaoke in São Paulo', in Will Straw *et al.* (eds), *Popular Music: Style and Identity*, Centre for Research on Canadian Cultural Industries and Institutions, pp. 149–54.

Kartomi, Margaret J. (1981) 'The processes and results of musical culture contact: a discussion of terminology and concepts', *Ethnomusicology*, vol. 25, no. 2, pp. 227–49.

Loza, Steven (1993) *Barrio Rhythm: Mexican American Music in Los Angeles*, Urbana and Chicago: University of Illinois Press.

Lum, Casey M. K. (1996) *In Search of a Voice: Karaoke and the Construction of Identity in Chinese America*, Mahwah, NJ: Lawrence Erlbaum.

Maeyama, Takashi (1979) 'Ethnicity, secret societies, and associations: the Japanese in Brazil', *Comparative Studies in Society and History*, vol. 21, no. 4, pp. 589–610.

Merriam, Alain (1964) *The Anthropology of Music*, Evanston, IL: Northwestern University Press.

Minamoto, Ryōen (1989) *Kata*, Tokyo: Sōgensha.

Nishiyama, Matsunosuke (1982) *Iemoto no Kenkyū* [Study of Iemoto], Tokyo: Yoshikawa Kōbunkan.

Shank, Barry (1994) *Dissonant Identities. The Rock'n'Roll Scene in Austin, Texas*, Hanover, NH, and London: Wesleyan University Press.

Slobin, Mark (1993) *Subcultural Sounds: Micromusics of the West*, Hanover, NH, and London: Wesleyan University Press.

Turino, Thomas (1993) *Moving Away from Silence: Music of the Peruvian Altiplano and the Experience of Urban Migration*, Chicago and London: University of Chicago Press.

Williams, Raymond (1977) *Marxism and Literature*, Oxford: Oxford University Press.

Yano, Christine Reiko (1995) 'Shaping tears of a nation: an ethnography of emotion in Japanese popular song', PhD dissertation, University of Hawaii (anthropology).

8

THE KARAOKE DILEMMA

On the interaction between collectivism and individualism in the karaoke space

Casey Man Kong Lum

The analysis presented in this chapter is part of an ongoing research programme to study how people engage in karaoke as both a transnational media form and a cultural practice in diverse everyday contexts.[1] In this analysis, I examine how collectivism and individualism are expressed in the social, as well as performative spaces of karaoke. I draw my analysis on a comparison of how Asians and Anglo-Americans differ or concur in their approaches to karaoke.

It is important to note that the analysis put forward in this chapter does not suggest that there is no collectivism in Anglo-American culture or that there is no individualism in Asian cultures. As Changsheng Xi (1994) contended in his comparative study of American and Chinese societies, collectivism often goes hand in hand with individualism in these two societies; collectivism and individualism cannot be neatly polarized. As the title of this chapter suggests, collectivism and individualism are not viewed or treated as two mutually exclusive phenomena in the context of the karaoke space.

In fact, it should be obvious that some form of collectivism and individualism does co-exist and intertwine in the karaoke space: that while a karaoke event is a collectivistic activity for social interaction, it is also an opportunity for individuals to express themselves or, put metaphorically, to have a voice of their own. My goal, therefore, is to understand how the co-existence of and interaction between collectivism and individualism can help to define the ways in which people behave or manage their interaction in diverse karaoke spaces.

Methodologically, I base my analysis partly on my participant observation in a few dozen karaoke scenes in Hong Kong (May 1996), in Kanazawa, Japan (August 1996), and in the New York–New Jersey metropolitan area

(between 1993 and 1996). Karaoke scenes are events where karaoke singing is the defining activity that facilitates interaction among the participants (Lum 1996). The karaoke scenes I observed for this analysis took place in public places, such as bars, night-clubs, karaoke lounges, restaurants, hotel ballrooms and karaoke boxes. All of the occasions when I was a participant observer included strangers among the participants, that is, not all the participants at the scene knew each other before the event took place. On most of these occasions, some of the participants at the scene remained strangers after the event was over. I have also conducted in-depth interviews with informants in Hong Kong, New York City, and various locations in New Jersey. My analysis will begin with a brief discussion of the context in which this study was conceived.

Differing reactions to karaoke

My analysis of the expression of collectivism and individualism in karaoke began with an observation that people who are brought up in predominantly collectivistic or group-oriented cultures (e.g., Asian cultures) have tended to be more receptive to karaoke as an everyday cultural practice than people who are brought up in predominantly individualistic cultures (e.g., the Anglo-Americans). To contextualize this observation, it should be noted that while the technical components of karaoke remain relatively uniform regardless of their make, the ways in which people engage in karaoke singing can and do differ across diverse cultural contexts or spaces (Drew 1994; Hosokawa 1993; Lum 1996; Ogawa 1993a).

Originating in Japan early in the 1970s, karaoke has in the ensuing two decades spread to many parts of the world, notably many Asian countries (Li 1992; Lin and Lu 1992; Lu 1992; Ming 1992; Tang 1991; Yamamoto 1993). It made its public debut in the United States in 1983 (Zimmerman 1991) in bars that catered mostly to Japanese business people and Japanese-Americans. The diffusion of karaoke among other Asian-American communities, such as those originating from Hong Kong, Malaysia, South Korea, Taiwan and Vietnam began a little bit later in the 1980s (Lum 1996; Wong 1994). Meanwhile, bars that served a more general American clientele began to use karaoke as a promotional tool in the mid-1980s. For example, certain neighbourhood bars set aside one weekday evening as their special 'karaoke night' to attract curious customers who might not otherwise come and, of course, to give their regular customers something new to do.

Around that same time – that is, towards the end of the 1980s, the consumer electronics manufacturer Pioneer introduced the first consumer models of laser disc karaoke systems. In view of the fact that the economy along the Pacific Rim was booming in the 1980s, the laser disc system could not have been introduced at a better time. While the digital laser

disc system is more expensive, it is also much superior to its analogue audio and videotape predecessors. With increasing disposable income, aggressive promotion by karaoke hardware and software producers, as well as constant exposure to karaoke in the media and in entertainment establishments, many people in Asia were ready and delighted to embrace karaoke as a new form of entertainment.

While karaoke was originally conceived in Japan to enable certain singers to practise or perform their art without employing live musicians, it also owed part of its beginning to a pre-existing social need for an affordable musical medium for entertainment and social interaction in public spaces such as bars and night-clubs. In view of karaoke's social origins, it is therefore reasonable to suggest that the extent to which a society may accept karaoke as an 'imported' medium for communication depends on the extent to which the receiving society is accustomed to the cultural practice of participatory singing in public space. In other words, it is suggested that one of the reasons for karaoke's transnational diffusion is the fact that social singing is part of the indigenous culture of many places it has landed.

For example, karaoke-assisted sing-along has been a commonplace communal activity in pubs in England since the mid-1970s (Kelly 1993). But an informant in Liverpool insisted to Hiroshi Ogawa (1993a: 21) that 'Karaoke is not a Japanese cultural export. It's part of English culture. People have been singing together in pubs for ages.' Singing karaoke strikes a similar responsive chord elsewhere. A Vietnamese-Cantonese businessman who emigrated to New York City in the mid-1970s, Mr Cheung (1994) thought it was natural that karaoke should be well received in his native land. He observed that as late as in the 1960s, some people in Vietnam were already accustomed to taking a turn to sing at parties of all kinds. As Mr Cheung recalled, 'Many of my friends used a microphone to sing; some even played backing music from cassette tapes as background' (ibid.).

Commenting on karaoke's popularity in Vietnam, Mrs Tu (1994), a Vietnamese-Taiwanese immigrant in Phoenix, Arizona, told me of a similar experience: 'When we were in Vietnam, my older sister started to sing like that some thirty years ago.' In other words, karaoke becomes popular in England or Vietnam not because it is something novel to the locals but because it is consistent with the pre-existing indigenous cultural practice of social singing. On this level, to people who are not strangers to participatory singing in public, karaoke is but a technological reincarnation of an existing, indigenous cultural practice.

But while karaoke has been very popular among millions of people in Asia and other parts of the world, the Anglo-American population in the United States by and large still seems to feel somewhat lukewarm about singing karaoke in public. Of course, I am not suggesting that karaoke has completely failed to make its mark on the Anglo-American population

in the United States. In fact, there are indications that more and more bars in the United States are hosting karaoke nights. Similarly, a few of my Anglo-American informants have seen more of their friends or relatives buying karaoke machines in the past few years, even though many of their machines are of the more elementary audiocassette tape variety (instead of the more advanced digital laser disc versions). However, even as more Anglo-Americans are catching up with karaoke, one can see that many others still exhibit a noticeable degree of unease about karaoke singing in public.

Many reasons can be given to explain why the Anglo-American population as a whole has generally been slow to embrace karaoke as an everyday cultural practice. For example, one may suggest that karaoke is a foreign invention to Anglo-Americans and therefore it may take longer for them to accept it. In fact, many of my Anglo-American informants still have a hard time remembering or pronouncing the word karaoke, even though some of them have heard of the word and generally know the type of entertainment it represents.

But looking at karaoke as a 'foreign import' alone cannot fully explain why America has been slow in accepting karaoke as an everyday cultural practice. After all, karaoke has also become very popular in places where social singing in public has not been part of the indigenous social and cultural landscape and yet karaoke has been embraced with enthusiasm. For example, in the twenty odd years I lived in various urban areas in Hong Kong until early in the 1980s, I never had the good fortune of having been to – nor had I ever heard of – a birthday party, wedding banquet, dinner at a restaurant, or otherwise any social gathering whereby people would, as a matter of custom, take a turn at singing for entertainment or any other reason. Many people in Hong Kong, at least before the introduction of karaoke in the late 1980s, were not accustomed to social singing in the way people in Japan, Vietnam, or Liverpool were, as is described above or elsewhere in this volume.

In short, it is suggested that some deep-seated cultural forces are also at work to explain why many Anglo-Americans feel uneasy about karaoke singing in public. In the remainder of this chapter, I offer an analysis of how the co-existence of and tension between collectivism and individualism in the karaoke space may have been one of these cultural forces. I shall begin this analysis with a discussion of how social or participatory singing in public space may create unease among Anglo-Americans in the United States.

Karaoke's violation of the Anglo-American quest for privacy in public space

Marshall McLuhan observed in 1976 that 'North Americans may well be the only people who go outside to be alone and inside to be social' (1976:

46) and that 'North Americans have not developed institutions suited to socializing away from home. It is not only in the movie and in the theater that we seek privacy, but also at restaurants and in nightclubs' (ibid.: 48). What McLuhan alluded to was the Anglo-Americans' quest for and insistence on maintaining privacy in public space which, by comparison, contradict certain European traditions or practices of socializing in public places such as sidewalk cafés.

In comparing the ways in which Latin Americans and Anglo-Americans interact with people in public, particularly with strangers, Elizabeth Lozano (1997) made a similar suggestion that Anglo-Americans have tended to prefer to remain private in public places. In her 'structural ethnography' of human interaction at a shopping mall near the Miami marina, Lozano (ibid.: 198) observed:

> The Miami Bayfront is a place in which two cultural styles of body expressivity can be seen enacted simultaneously, interacting and overlapping. Although the Hispanic passers-by are strangers to one another, there is a sense of interaction among them. If I were to be addressed by anyone in this crowd, I would not be surprised, nor would I feel threatened. It would be no different from being addressed by someone in a crowded room. When I am walking by myself along the halls of a 'Hispanic' mall, I am not *alone* ... I am in a crowd, with the crowd, and anyone there has access to my attention.
>
> The Anglo American passers-by understand their vital space, their relationship with strangers, and their public interaction in a different manner ... Pragmatically speaking, Anglo Americans are alone (even in the middle of the crowd) if they choose to be, for they have a guaranteed cultural right to be 'left alone' on their private way to and from anywhere.

In other words, Latin Americans have tended to be communal among themselves, even with strangers in public places, whereas in similar situations Anglo-Americans have tended to be protective of what they consider as their personal privacy in public.

The point I am trying to make is that one of karaoke's intrinsic expectations of its participants' social behaviour seems to have violated the Anglo-American conception of and insistence on maintaining privacy in public spaces. To begin with, being in a karaoke scene is inherently a communal experience. As Ogawa (1993b: 2) put it:

> Karaoke encloses a 'karaoke space' with its music wall. People there are thought to be friends. And a person singing in the presence of the others in spite of shyness is thought to be trusted.

> Both sharing a 'karaoke space' and singing in the presence of the others reinforce group consciousness.

It is important to note that what Ogawa referred to as 'friends' did not necessarily mean people who actually know each other well, although it can be understood as such in certain contexts where the participants in a karaoke scene are companions well acquainted with each other. Instead, Ogawa referred to the kind of bonding among participants in a karaoke scene that is created and maintained by what Johan Fornäs (1994) otherwise called karaoke's 'social contract', that everyone in the karaoke scene is expected to take their turn to perform, that is, to alternate between the role of being a member of the audience to support a performance and the role of being a performer putting on a show for others.

In a certain sense, this 'social contract' of karaoke is somewhat of an alien notion to the Anglo-American conception of human interaction in public places. For example, in movie or stage theatres, concert halls, and night-clubs, the customers play only one role, that of members of an anonymous audience. They watch the performance. They usually do not cross the line and venture on to the stage area to perform and be watched. In this context of singular role playing, the individuals, as McLuhan (1976) suggested, can be left alone in public. They can choose to remain anonymous in the crowd and maintain their privacy in public places in much the same way that people in Lozano's (1997) Anglo-American streets are not expected to, nor would they normally feel obliged to, be active interactants with others.

But the line between being a member of the audience and being a performer in the karaoke space is often blurred in that the spectator is also supposed to be the one to be watched by others. If one were to accept and play the dual role of being both an audience member and a performer, one would invariably expose oneself in the eyes of others, thereby removing one's anonymity in the crowd. Such exposure – the attraction of gazes of or attention from strangers on to oneself, according to Lozano's (ibid.) observation, is a violation of the Anglo-American body polity or civility in public.

I believe this is one reason why many Anglo-Americans feel uneasy about karaoke as a cultural practice, let alone actually entering the stage area in the karaoke space to perform. If they do, they essentially have to give up their cherished right to privacy in public. They have to stand the chance of being exposed before strangers. They have to be willing to be singled out in front of other audience members, thereby allowing others to trespass on their guarded personal space in public. In his ethnography of karaoke performance at bars in the Philadelphia area, Robert Drew (1994) observed that some of his subjects, who were mostly mainstream, middle-class Americans, resorted to getting themselves half-drunk or

wearing dark glasses to help manage their unease before and during their act. A similar observation was also made at a number of local bars on Long Island in the spring of 1995 by a group of my students who carried out participant observation for their senior research projects. The action of these Anglo-American bar patrons of wearing dark glasses or getting half-drunk seemed to have been an attempt to create a psychological veil to shield themselves from being totally naked before the audience so as to retain their lost privacy in the karaoke's public space.

But one may argue against the above interpretation of the Anglo-American unease with karaoke by suggesting that these people are simply suffering from some kind of stage fright. In fact, it is not uncommon, nor is it a secret, that people can become nervous or apprehensive about being 'put on the spot' or 'on stage' or when they have to speak or perform before others, particularly strangers. But having stage fright is none the less too easy, if not too simplistic, an explanation in this context. After all, Anglo-Americans in the United States are certainly not alone when it comes to having stage fright in the karaoke space.

Some of my informants in the Chinese immigrant communities in the New York and New Jersey metropolitan areas have confessed to me that they were so nervous the first time they sang karaoke in public that they lost their voice as they approached the stage area (Lum 1996). So the question is, if both Anglo-Americans and Chinese can have stage fright, as can all other people, how do we account for the fact that, by and large, Anglo-Americans have seemed to be more uneasy or have adapted less in the karaoke space than do their Asian counterparts?

To address this question, I shall elaborate on the analysis I put forward above by looking at the co-existence of and tension between collectivism and individualism in the karaoke space.

The tension between collectivism and individualism in the karaoke space

If McLuhan (1976: 48) was correct to say that North Americans 'have not developed institutions suited to socializing away from home', I suppose karaoke may not be the easiest institution for them to begin such an endeavour. After all, karaoke's social contract is a collectivistic, communal code of decorum that does not seem to sit well with the North American or, more specifically, Anglo-American conception of human interaction in public which is individualistic in nature. I shall begin to elaborate on this observation with an intriguing comment by Kimindo Kusaka (cited in Ban 1991), who said that:

> Karaoke is part of the 'culture of form'. In any country, more than half of the citizens live a life of following orders from above.

Once in a while, these people want to express themselves in front of others. They have difficulty doing something completely different from what others do, but they can do something if they can practice a fixed form.

What did Kusaka mean by doing karaoke as practising a 'fixed form'? What is the 'fixed form' of karaoke? What does this 'fixed form' do for those who engage in karaoke singing in public? What does this 'fixed form' reveal about the underlying cultural assumption about karaoke as a medium for communication?

My interpretation of Kusaka's observation is intimately linked to my analysis of karaoke's social contract that all participants are supposed to follow. To fulfil this social contract is to follow a pre-determined ritual, a commonly shared routine, or a fixed form, as it were, that all participants support each other's co-existence in the karaoke space as both the performers in the stage area and participants in the audience area. For example, Ogawa (1993b) observed that everyone in the Japanese karaoke space is expected to take a turn at performing on stage for the enjoyment of others no matter how well (or how badly) they perform.

The dual role that people are expected to play in the karaoke space helps to facilitate an obligatory bonding among the participants. As members in the audience may later be called upon to perform on the stage, it is only reasonable that they would choose to be supportive of or at least be polite to the present performer, who would later become a member in the audience and can pass judgement on them. Therefore, the act of booing a performer, if it is indeed meant to be derogatory, or any such similarly uncomplimentary gesture, must therefore be viewed as an anomaly in the karaoke space.

Of course, this fixed form of karaoke can be expressed in ways that are determined by the local cultures where the karaoke event takes place. Put differently, there are different codes of conduct in karaoke's space or 'karaoke decorum' (Lum 1996), as well as different ways of honouring such codes of conduct across divergent social and cultural spaces. While everyone in the Japanese karaoke space is expected to take a turn to sing, according to Ogawa (1993b) and based upon my personal experience in Kanazawa, Japan, in August 1996, I have otherwise observed in the United States how unwilling audience members in many Chinese-American karaoke scenes may be excused. On many such occasions, even after the unwilling or perhaps unprepared audience members have politely turned away the microphone, the hosts would show no disdain, though often leaving the former with a suggestion of 'Maybe we come back to you when you are ready.' Some of these audience members never did pick up the microphone but their role as supporting members of the scene was none the less accepted. In other words, regardless of how it is expressed,

there is a communal, collectivistic understanding among participants in the karaoke space that they should support their co-existence throughout the event without interruption.

Karaoke's fixed form, its social contract, is one of the most defining elements of the communicative 'context' of karaoke as a medium for social interaction. But it is not an explicitly written set of regulations that people can read and learn about at the entrance to a karaoke scene. Instead, it is implicit in the communicative context of the karaoke space, in much the same way as cultural information is deeply, unspokenly, or invisibly embedded in what Edward T. Hall (1976) referred to as high-context cultures.[2] People in high-context cultures do not have to discuss verbally the embedded information before they know how to act with it. They come to know the embedded information by being part of their culture in much the same way as people come to know the implicit social contract of karaoke by immersing themselves in or by living the cultural practices in the karaoke space, that is, by acculturation.

The collectivism of karaoke's fixed form embodies a preferred script for social interaction, that participants in a(ny) karaoke space first consolidate their group identity through pre-determined, mutually agreed upon rituals before they each strive to establish and express their individual identity. Collectivism comes before individualism in the karaoke script. By following or acting out this preferred script, this implicit social contract that is karaoke's fixed form, participants in the karaoke scene can construct and maintain a sense of group membership. Group membership then gives the participants the security and mutual support they need as a collective whole before they as individuals can venture on to the stage to perform or to express themselves in front of others. On this level, one can see how liberating karaoke can be, as Kusaka (cited in Ban 1991) suggested, for people who have been taught to obey and conform to their group to be able to safely construct and maintain an individual identity without jeopardizing their group membership. This may explain why karaoke has been well received in Asia because Asian cultures are predominantly group-oriented or collectivist by nature.

On the other hand, the collectivistic, fixed form of karaoke that requires the participants to follow a set of rules not of their own making, where the individual should come after the group, seems to contradict the Anglo-American individualistic cultural pathos. Being individualistic means, to many people in the United States, being independent of others in thought and action, that is, being distinct from others. It means that the individual comes before the group, that the individual is treated as the most important element in any social setting (Hofstede 1984). But as is suggested above, the communal experience of karaoke demands a certain degree of selflessness on the part of the individuals. Indeed, some of the common anxieties of my Anglo-American informants include their concern about

having to do what everybody else is doing, about whether they could deliver a good performance for their audience, and whether they might make fools of themselves with a bad performance in public and perhaps tarnish their public image. These are concerns that put the individual before the group.

With the above comparison in mind, I believe we can begin to imagine how strange and confusing it can be for people who are individualistic by cultural upbringing to have to first shed their individual identity as a way of conforming to a group so that they can re-capture or reconstruct their individual identity again later. This may explain why many Anglo-Americans, or people who are individualistic in their cultural upbringing, can be less eager to participate in the karaoke space than those who are more collectivistic in their cultural upbringing.

Conclusion

In this chapter, I offer an analysis of how the co-existence of and tension between collectivism and individualism can help to define human behaviour in karaoke scenes. Karaoke is an interesting cultural practice whereby ample opportunities for the expression of individualism are contained in a social–interactional structure that is inherently group-oriented or collectivistic by nature. While collectivism and individualism are not mutually exclusive in the karaoke space, their co-existence has none the less created an intriguing tension, or what can be called the 'karaoke dilemma'. The 'karaoke dilemma' arises from the fact that people have to choose or, perhaps more importantly, strike a balance between two conflicting desires. The first desire is to remain an anonymous part of the crowd in the karaoke public space in exchange for privacy and security. The second is the desire to be set apart from the crowd, to exalt their individuality, while risking the loss of their privacy and security. How people from different cultural backgrounds 'negotiate' or resolve their karaoke dilemma can give rise to diverse and interesting or even seemingly paradoxical cultural expressions.

For example, it has been observed that many Anglo-Americans sing karaoke in groups. Isn't this a form of collectivism? Indeed, it is. But one may suggest that this form of collectivism is an attempt to use the group on stage to shield the individual performers from the public scrutiny of the audience members, some of whom are likely to be strangers to the performers. On the other hand, one can be curious as to why *enka* is one of the most enduring musical genres in Japan, and among the most decisively collectivistic styles of karaoke, particularly when *enka* is predominantly about individual sentiment, has no chorus part, and is mostly sung solo. Interestingly, it is exactly because of the understandably collectivistic nature of the Japanese karaoke fixed form that such individualistic musical genres as *enka* can thrive, for acculturated individuals can feel safe in the

cradle of their karaoke group membership to venture on to the stage alone. They know they will not be hurt, humiliated, even if they bare their souls with a minimum of musical competence.

Indeed, it is suggested that embedded in karaoke is a world view that cherishes a harmonious yet dynamic equilibrium between the needs for maintaining with our fellow human beings a sense of group identity and solidarity while at the same time striving for a sense of individuality, that while we hold together as a group, we should never let ourselves lose a sense of who we really are and what we can be as individuals.

Notes

1 An earlier version of this chapter was presented at the 1996 Asia Forum in Ishikawa, Japan, which was sponsored by the JAL Foundation Tokyo.
2 Among the high-context cultures Hall (1976) identified are China, England, Japan, Korea and Vietnam whereas some of the low-context cultures include Germany, Switzerland, and the United States. Incidentally, high-context cultures are often described as cultures that value group sense while low-context cultures are said to value individualism.

References

Ban, Satomi (1991) 'Everyone's a star', *Look Japan*, April, pp. 40–2.
Cheung, Mr (1994) interview, 13 May.
Drew, Robert S. (1994) 'Where the people are the real stars: an ethnography of karaoke bars in Philadelphia', unpublished doctoral dissertation, University of Pennsylvania.
Fornäs, Johan (1994) 'Karaoke: subjectivity, play and interactive media', *The Nordicom Review of Nordic Research on Media and Communication*, vol. 1, pp. 87–103.
Hall, Edward T. (1976) *Beyond Culture*, New York: Doubleday.
Hofstede, G. (1984) *Culture's Consequences*, Beverly Hills, CA: Sage.
Hosokawa, Shūhei (1993) 'Singing and ethnicity: karaoke in São Paulo', Paper presented at the 8th International Conference on Popular Music Studies, Stockton, California, 11–15 July.
Kelly, W. (1993) 'Karaoke in the United Kingdom: a class act?', Paper presented at the 8th International Conference on Popular Music Studies, Stockton, California, 11–15 July.
Li, Che Hung (1992) 'The sound of karaoke is heard everywhere: Taipei', *China Times Weekly*, American edition, 27 Dec.–2 Jan., pp. 14–15 [in Chinese].
Lin, Fan and Lu, Chia (1992) 'The sound of karaoke is heard everywhere: Hong Kong', *China Times Weekly*, American edition, 27 Dec.–2 Jan., p. 15 [in Chinese].
Lozano, Elizabeth (1997) 'The cultural experience of space and body: a reading of Latin American and Anglo-American comportment in public', in A. Gonzalez, M. Houston and V. Chen (eds) *Voices: Essays in Culture, Ethnicity, and Communication*, Los Angeles: Roxbury, pp. 195–202.
Lu, Chia (1992) 'The sound of karaoke is heard everywhere: Guangzhou', *China Times Weekly*, American edition, 27 Dec.–2 Jan., p. 16 [in Chinese].
Lum, Casey Man Kong (1996) *In Search of a Voice: Karaoke and the Construction of Identity in Chinese America*, Mahwah, NJ: Lawrence Erlbaum Associates.

McLuhan, Marshall H. (1976) 'Inside on the outside, or the spaced-out American', *Journal of Communication*, vol. 26, no. 4, pp. 46–53.

Ming, Hsin (1992) 'The sound of karaoke is heard everywhere: Beijing', *China Times Weekly*, American edition, 27 Dec.–2 Jan., p. 17 [in Chinese].

Mitsui, Tōru (1995) personal correspondence, 10 April.

Ogawa, Hiroshi (1993a) 'Unstoppable karaoke', in *Pacific Friend*, May, pp. 17–21.

Ogawa, Hiroshi (1993b) 'Karaoke in Japan: a sociological overview', Paper presented at the 8th International Conference on Popular Music Studies, Stockton, California, 11–15 July.

Tang, Jung (1991) 'Karaoke in the Lion City [Singapore]', *Sinorama*, September, p. 86.

Tu, Mrs (1994) interview, 11 June.

Wong, Deborah (1994) '"I want the microphone": mass mediation and agency in Asian-American popular music', *The Drama Review*, vol. 38, no. 2, pp. 152–65.

Xi, Changsheng (1994) 'Individualism and collectivism in American and Chinese societies', in A. Gonzalez, M. Houston and V. Chen (eds) *Voices: Essays in Culture, Ethnicity, and Communication*, Los Angeles: Roxbury, pp. 152–8.

Yamamoto, Akihiko (1993) 'Singing along', *Look Japan*, October, pp. 40–2.

Zimmerman, K. (1991) 'Can karaoke carry U.S. tune?', *Variety*, 5 August, pp. 1, 108.

9

KARAOKE IN EAST ASIA

Modernization, Japanization, or Asianization?

Akiko Ōtake and Shūhei Hosokawa

Karaoke is increasingly spreading to the countries around Japan. First, for Japanese businessmen, then for local users – this is a standard pattern of karaoke diffusion. The first step is more or less similar to the case of Western cities, since Japanese businessmen overseas entertain themselves after work in a similar way in a similar space as in Japan. Also, the Japanese karaoke industry exports a more or less similar package of hardware and software to small bars almost exclusively serving the Japanese. However, the second step, that for local users, varies from country to country depending on the pre-existing entertainment industry and practice of singing, as well as to the image of Japan and the tech-nology available. The geographical proximity of each country to Japan and the musical affinity throughout the area (ballad and pop, for example) may encourage the diffusion of karaoke equipment (the notion of 'prox-imity' is slippery as we will see).

To understand the formation of the triple mode of karaoke as concept, space and behaviour (see Introduction in this volume), we need to examine regional, national and international conditions of musical and technolog-ical production, distribution and consumption. It is true that the presence of Japan is crucial in the karaoke scene around the world but it has a different significance in East Asia from that in the West because of Japan's ambiguous position in East Asia as a colonizer in the past and an economic leader at present. Is the modernization of East Asia Japanizing or Westernizing? We will treat karaoke not as an apt metaphor to describe the contemporary cultural situation but as a material public space that embodies the specific concept and allows the specific behaviour. We will emphasize the conjuncture between the processes of producing sound-and-vision, spaces and listeners/audience. Certainly, the construction of

public space for singing with technology is intertwined with the triangular economic and cultural relationship between Japan, the West and East Asia.

Our purpose is to provide a historical outline of karaoke cultures in East Asia and to discuss the cultural significance of karaoke. To begin with, we will make a brief trip to several East Asian countries to see how the local scenes are made.[1]

Short histories of karaoke in East Asia

Taiwan: from movie room to karaoke box

The first karaoke bars known in Taipei were established sometime in the second half of the 1970s under the overpass along the Hsin Sheng North Road. According to the composer Lin Erh, who was a regular customer of one of those shabby bars in the dusty and noisy neighbourhood, all the venues, with or without alcohol, had a small stage on which the clients could sing with the owner–bartender–hostess when they wanted. As there was no Chinese rendering of 'karaoke' at that time, these karaoke bars had a sign that said 'Singing' (*ko chang*) in Chinese ideograms or 'Karaoke' in Japanese writing. The decor and atmosphere of the bars resembled that of Japanese bars (or 'snacks' as they are called) where karaoke was born (see Mitsui, Chapter 1 in this volume). The majority of the clientele were males over fifty who knew Japanese (because of Japanese colonization up to 1945). As is often the case in such small bars, the customers came to know each other and established informal social circles. Many of them were retired and spent lazy afternoons and nights in the homely bars to sing along with Japanese old-time songs on an imported 8-track cartridge system. There were only a handful of Japanese there. Certainly those who had had a Japanese education before the war had little problem reading the Japanese lyric books and no songs could evoke more nostalgia for them than the old Japanese ones.

It is difficult for the older generation to explain their mixed feelings about their ex-colonizer's music. As numerous Japanese songs were covered in Taiwanese even after 1945, the post-war generation is well acquainted with Japanese songs. The flood of Taiwanese versions of Japanese songs can be explained by the official prohibition of original songs in Taiwanese by local authors because the government acknowledges only Mandarin Chinese as the national language. Not until 1988 did the government authorize the release of original songs in Taiwanese. It is said that those who were born in Taiwan during the Japanese colonization generally prefer Japanese songs to the tunes in Mandarin Chinese, the official language imposed by the Nationalist Party, because they usually do not speak Mandarin and have an emotional resistance to Mandarin culture. It is those Taiwan-born old people who were at first tempted to

179

use karaoke to sing Japanese songs. Consequently, all the local operators had to supply was the lyrics notebook written in Taiwanese. Japanese manufacturers did not need to produce software for local use and this encouraged the smooth importation of karaoke machines in Taiwan. In terms of the popular music industry, Japan was and is by far the top in East Asia in the post-war period. The popular music scene in Taiwan is largely correlated with the Japanese hit parade and people often sing these songs without knowing that the authors are Japanese. Therefore, Japanese machines could make their first step in Taiwan without locally made tapes. The close connection between the two music markets accelerated the diffusion of karaoke earlier here than in other Asian countries.

Meanwhile, Japanese businessmen usually went to the more expensive bars and restaurants that were situated on Lin Sen North Road, just a few streets west from the cradle of karaoke in Taipei. At that time, Lin believes, Japanese bars did not consider the installation of karaoke apparatus seriously because they were large enough to afford other services for affluent Japanese clientele such as Japanese-speaking hostesses, a piano, a dance floor, and so on. As in Japan, karaoke was at first taken to be vulgar by the owners of established night-clubs so it started in small bars at first. However, in the 1980s, when visual karaoke appeared, Japanese night-clubs began adopting it on a large scale. Somehow karaoke became indispensable to night-clubs in Japan. In Taiwan, the new machines slowly encroached into the local entertainment zones and replaced the 8-track cartridge system. This was the downfall of the small bars on Hsin Sheng North Road because they could not afford to install visual karaoke. As discussed later, however, visual karaoke in Taiwan developed in a different way from that in other Asian countries.

As well as the introduction of images, the appearance in the songbook of new Chinese songs from the end of the 1970s contributed to the growing popularity of this new form of leisure. It invited the younger generation to pick up the microphone. In addition, local musicians began recording instrumental versions of non-Japanese hits. Although the karaoke box became popular in the late 1980s, its prototype can be traced back even before its importation from Japan. It was not derived from karaoke bars but from a small room for viewing music videos usually called MTV (M for music, but not to be confused with the international music video station). This MTV was launched around 1984 but soon after was used for video movies too, since it cost less than the cinema and allowed the clients to see the movies they rented at video shops. At that time, rental video shops were spreading faster than home VCRs: the M of MTV changed to represent 'Movie'. At first, MTV had thick curtains inside the room to separate one monitor from another for better spatial efficiency, and the audience used headphones. Later, when owners switched speakers, the audience numbers grew so dramatically that there were around 400

MTV salons operating in Taipei alone by the mid-1980s. Certainly, MTV had a wider variety of programmes than the cinema. One could see, for example, old Hong Kong movies and American television dramas. It is also said that MTV originated in pornographic shows viewed in 'love hotels' or rented rooms for 'lovers'. Because of the strict moral code on movie houses, such an underground video scene was developing in Taiwan. In 1988, when GATT's Uruguay Round accused Taiwan of video piracy, however, most of MTV was forced to close. This devastating act gave birth to KTV (K for karaoke).

Another historical antecedent related to KTV is a traditional Taiwanese form of male entertainment with hostesses in a small room. Patrons would call for a *nakashi*, an itinerant singer with a guitar or an accordion who performed in small bars (etymologically it comes from the Japanese word *nagashi*, the same type of singer and musician popular before the dawn of karaoke, see Mitsui, Chapter 1 in this volume). As in Japan, such itinerant musicians were gradually replaced by mechanical devices. Although the numbers have drastically decreased in the last couple of years, there are still small-room restaurants where the clientele can dine and sing with hostesses and *nakashi*. In spas, there were usually Japanese-style inns with small *tatami* rooms where the male clientele called for hostesses and musicians. Today this tradition of male pastime in a tiny space remains in the form of the 'KTV bar', a small bar not only for singing but for negotiating with pimps or prostitutes: this 'bar' is different from the KTV which the young and women can use. KTV bars usually have gaudy neon signs outside and showy decor inside. Their clients are attended by hostesses and in some bars they are met by a 'master', who asks you the 'budget'. The relationship of karaoke with the underworld is most pervasive around East Asia and has caused moral and social friction. Although the early years of the karaoke box in Taiwan are pretty obscure, the spatial arrangement of KTV and the KTV bar seemed to develop from a pre-existent form of small-room entertainment. Karaoke boxes have an intimate affinity with it.

What is unusual about KTV is the use of video tape (instead of laser disc) and the 'auto-changer man'. In Japan and Western countries, video tapes are rarely used because of their rapid degradation and Japanese corporations' distribution of laser karaoke world-wide. Yet in Taiwan, most music video production companies are likely to have special contracts with record companies covering image copyrights of new songs. This complicit relationship prevents Japanese distributors of laser and other technologies from penetrating the Taiwanese market.

An 'auto-changer' is a device for changing discs (CD or LD) automatically by computer (applied technology from the juke-box). This innovation in karaoke equipment was remarkably labour-saving. But it is inapplicable to VCRs and consequently KTV relies on manually operated video tapes. A man in a tiny room behind the monitors reads the numbers sent

electronically by the clients in each room, swiftly looks for the video cassettes requested, and sets them one after another on the appropriate decks. He also has to rewind and relocate the tapes on the rack. As long as video tape continues to be used, then this acrobatic manual labour will continue to be performed.

Hong Kong: singing in Cantonese

Karaoke for local Hong Kong people is relatively new because laser discs in Cantonese, Hong Kong's official language, did not become available until 1988. Unlike in Taiwan, Japanese corporations triggered the boom: Nikkōdō released the first Cantonese laser discs in that year and caused an instant sensation. About forty companies immediately followed suit and the small market for karaoke software soon faced the problem of over-production and dumping. In 1991 Dai'ichi Kōshō opened a karaoke box chain, Big Echo, and the following year Nikkōdō fought back by franchising BMB Karaoke Box. Due to this Japanese influence, the term 'karaoke box' (not the same as 'KTV') is current. Cantonese laser discs are now available in the entire Cantonese-speaking region of China – an economic frontier of mainland China – crossing over the former border between China and the Commonwealth of Hong Kong. As in Japan, the majority of karaoke box users are middle-class youths (around 17 to 30 years old) and their repertoire is heavily dominated by contemporary pop tunes.

What is characteristic of the Hong Kong karaoke scene is the absence of elderly people. In Taiwan and in the Singapore-Chinese community as well as in Japan, elderly people are so committed to karaoke that they sometimes organize competitions only for elderly people. Hong Kong is different. According to an interviewee, older people in Hong Kong prefer old opera songs to popular songs (see also Lum 1996: Chapter 3). This is partly because popular songs in Cantonese did not appear until the early 1970s when Samuel Hoi started to sing on television and the Hong Kong government acknowledged Cantonese as an official language (along with English) in order to differentiate Hong Kong from China and Taiwan, two nations recognizing Mandarin Chinese. For those who had grown up before this nationalization of Cantonese, popular songs are not part of a generational memory because, while some cherish Cantonese folksongs, others yearn for Mandarin songs or Taiwan-made Chinese songs. In other words, they grew up with 'foreign' tunes. Besides, old Chinese popular songs are usually in too high a key for amateurs to sing, as they were written for specially trained singers: they are better for appreciation than for singing.

At the time of writing, six months before China's reterritorialization of Hong Kong, it is difficult to guess what will happen to the karaoke scene in Hong Kong, and Cantonese pop songs. All that is certain is the establishment of a larger music market throughout the two or three Chinas.

China: a sign for a new era

Karaoke takes on another image in mainland China. There the machines were introduced in the mid-1980s, several years after the controversial shift of the economic system to permit some conviviality between socialist state control and a capitalistic free market in 1980. In Shanghai, the first exposure of karaoke to the masses was when it was set up in a hamburger shop run by a Hong Kong businessman. Certainly hamburger itself symbolized modernization (in fact, Americanization) as much as karaoke did. Like discos, cafés and piano bars, karaoke comes from wealthy countries, and therefore had capitalist connotations from the beginning. Because of this strong association with 'bourgeois' leisure and occasional links with underground entertainment, karaoke clubs are constantly harassed by the authorities (Shirahata 1996: 33; Suzuki 1996). A Shanghai-based media person explains the persistent popularity of karaoke since then as follows:

> Karaoke came to China along with the political reform and economic freedom. Self-expression used to belong only to artists. Common people had no place to express themselves and professional singers were distanced from us. It is true that people sang during the 'Cultural Revolution' but the songs at that time dealt exclusively with 'us'. Not until the era of political reform and economic freedom did we sing about 'me', not 'us'. Technology that allows each of us to hold a microphone and sing for each other became popular because it appeared with such good timing. Karaoke would not have been successful if it had come during the Cultural Revolution.
>
> (Ōtake 1997: 104–5)

Hence, karaoke is intimately related to the post-Maoist freedom of self-expression in China. The new lifestyle of the 1980s was clearly conveyed by the first programme with audience participation on television in China, the Casio Cup Family Singing Competition, broadcast in the area around Shanghai starting in 1985. The Japanese sponsor awarded an electronic piano to the winners of the contest. Shanghai was the first Chinese city where publicity on television was licensed by the state (television was a luxury item at that time) and the programme in question was the first sponsored by a private (and, to make things worse, a Japanese) corporation. Although it caused a political and moral uproar, the programme was so sensationally popular with the audience that other stations imitated the form of audience participation. The appearance of common people on television itself was symbolic of the new 'democratic' era. Singing in front of the public on the mass media therefore symbolizes the new awareness of individualism in China. Although the Casio programme consisted

of both individual and family categories, later singing contests have focused only on the individual contests. They also expanded the categories to include folk songs, children's songs, pop, classic songs, and so on. While the Casio Competition was becoming popular, video decks with microphone jacks entered wealthy homes. Suddenly singing with a microphone became fashionable and home karaoke turned into a status symbol (see Lum 1996: Chapter 4).

The emergence of amateur singing as a powerful medium for nation-wide popularity caused changes in the style of popular songs in Mandarin (or 'Shanghainese') Chinese, and became a way of recruiting new stars. Mandarin tunes were, as the Chinese interviewee intimated, usually objects for appreciation and not for the self-expression of amateurs. However, composers gradually accepted the influence of karaoke and incorporated the light style of Taiwanese and Hong Kong pop which was legalized in the mid-1980s (although this had been circulated by pirate cassettes since the 1970s). The music business is obviously most sensitive to this trans-formation. Large music publishers and promoters were born in Beijing and Shanghai with venture capital from Japan, Taiwan or Hong Kong. Since the late 1980s it has become common for Taiwanese or Hong Kong singers to tour in China and record in Mandarin Chinese (some Japanese singers like Noriko Sakai now record in Chinese as well). Conversely, some Chinese singers perform and record in Hong Kong (like Fey Wong). To be sure, karaoke is only one factor but probably one of the most influential elements (along with satellite television, tape cassettes, and so on) contributing to the formation of a common East Asian popular music scene.

The emergence of new methods for recruiting new singers is illustrated by the 1993 talent-scout caravan produced by Hori Production, one of the largest 'star factories' in Japan. Amazingly, 400,000 would-be singers tried it out. Karaoke clubs play a key role. They are places where would-be singers train. In addition, production companies not only visit karaoke clubs to discover talented singers but also use them for promoting unknowns. The metropolitan karaoke scene in Shanghai and Beijing is a bridge between professionalism and amateurism and those who sing for a hobby, future professionals and would-be stars get together in one place. The music industry is not established enough to discover and promote new stars and songs and still fears state control of mass culture. New pop singers are no longer born in traditional opera conservatories: their cradle is now karaoke.

In China, karaoke equipment has also been installed in luxurious night-clubs with a dance floor, large TV screen and/or dining room. Grand clubs usually have music and dance spectacles arranged by the manager in addition to the clients' singing time. Some traditional dance troupes owned by the prefecture present regular shows at karaoke spots to make money.

Dining while singing is not a Japanese custom although some restaurants are trying to attract customers by offering lunchtime karaoke boxes (or, rather, some karaoke boxes offer lunch). Japanese usually go to karaoke after or before dinner and singing is more usually combined with drinking. At banquets, singing starts after most of the guests have finished eating. It took until the early 1990s before karaoke equipment gradually appeared in grand hotels in Japan. Because of its obscure past (see Mitsui, Chapter 1 in this volume), karaoke is not seen as high class or modern in Japan.

Viet Nam: pirate karaoke

Triggered by the radical change in China's economic system, Viet Nam also adopted in 1986 a free-market policy within the socialist state and this reform encouraged the importation of Western and Japanese commodities including karaoke. No other countries were to have such an immense difference between 'high' karaoke and 'low' karaoke as in Viet Nam. Just a few blocks from gorgeous karaoke restaurants with the large TV screen under chandeliers, one finds illegal karaoke rooms operating in ordinary private houses. Probably pirate karaoke is most developed in Viet Nam.

In the narrow alleys of downtown Ho Chi Min City, many karaoke bars operate in small private rooms. The authories do not always welcome them and sometimes force them to close because of their supposed connection with the underworld and, more importantly, their tax evasion. They are usually not seen from the street because they are often found upstairs in old buildings. The clientele must hear of the location on the grapevine. When they reach one of those establishments, they pay approximately 20,000 dong (about US$2) per hour, choose the video tape they want, go to one of the small rooms inside and set up the tape by themselves. It is not five-minute tape (one song for one tape) as Taiwanese karaoke places use, but a 90-minute tape. The customers must fast-forward and rewind, while checking the track list, until they find their desired songs. The number of songs they can sing depends upon the tape they choose. In more established karaoke bars, a dextrous woman sitting in a tiny 'console room' behind the wall cues four video tapes simultaneously with both hands and both feet. This agility resembles that of a hip hop master DJ.

The quality of tapes is fairly poor probably because they are used too often and are illegally copied in one of hundreds of neighbourhood copy shops. In 1995, an imported CD (usually a pirate copy made in South China) cost about 30,000 dong, while a 90-minute cassette tape with two CDs recorded, cost 9,000 dong. One can also order custom-made compilation tapes. Covers and lyrics card are xeroxed in other shops specializing in that. Since the international copyright association is trying to impose sanctions against outlaw countries like Viet Nam, the situation is fluid. But

the flood of imported sound is unquestionably changing the Vietnamese music scene, as is seen in various local versions of Japanese and Hong Kong pop songs. Moreover, music videos with superimposed lyrics are gradually becoming an indispensable medium for promotion and their visual style clearly mimics imported video. Due to the precarious technology available in Viet Nam, the majority of images are produced in the United States, although all the pop tunes are domestically recorded. This gap reflects the difference in technological demands for recording sound and editing images. Even the poorest countries in the world have at least one recording studio. By contrast, the production of video and/or film is possible only in countries with a more or less solid infrastructure in terms of technique and finance.

Korea: against Japanism

'Karaoke' does not officially exist in Korea, although people usually know what it means. The public room for singing is called *norae bang*, which means 'singing room' and the sign saying 'Karaoke' (in the Roman alphabet) is found only in some shady areas usually used by Japanese businessmen and male tourists. Probably Korea is the only country where karaoke is called something else and Japanese corporations are practically excluded because 95 per cent of karaoke apparatus is domestically made. A Korean karaoke machine consists of a ROM board with digitalized sound information. The device is also called CMP, or Computer Music Program. Instead of playing a CD or an LD as Japanese products do, Korean karaoke 'plays' ROM (just like telecom karaoke in Japan). This digital machine named ASSA was released in 1988 by Yong Pung Electronic Co., a venture company born in 1979. According to its public relations staff,

> Towards the end of the 1970s and the beginning of the 1980s, Japanese karaoke machines were launched in Pusan [a southern port with regular ferryboat operation to Japan]. Our founder-president felt it was an *invasion of Japanese culture* and made up his mind to invent Korea's own karaoke with a computer. There were no previous models and nobody believed it possible. But he was so absolutely committed to the project, and worked so hard on it that others thought he was crazy.
>
> (interview, 1996, our emphasis)

Rivalry between Korea and this ex-colonizing neighbour is a key constituent of Korean nationalism. This national tension is evidently the reason for the prohibition of the word of 'karaoke' in public. Similarly, songs in Japanese are purged from the mass media (the use of Japanese on the air and on stage is prohibited even for Japanese artists). Japanese CDs and cassettes are not officially sold. Even so, Korean youth know much about Japanese contem-

porary pop which is imported secretly and the censorship against Japanese culture is gradually relaxing due to the stealth and sheer power of the Japanese mass media and the shrinking distance between the two countries in terms of the economy.

After a gradual increase over several years in the 'night market', a karaoke boom exploded around 1988, the year of the Seoul Olympic Games, and has dramatically spread around the country since 1990. Although the first machines were Japanese-made, the predominance ended all of a sudden in 1991 when the Yong Pung apparatus became extremely fashionable in a Pusan game centre. The Chinese owner set it up as an attraction for waiting customers (the majority were in their early and mid-teens) and after a while many people came not for the games but to sing. At the time, the machine cost around 600,000 wong (*c.* 780 US dollars), one-fifth the price of Japanese laser equipment. Due to this low price, it is estimated that 7,000 *norae bang* were opened throughout the country within six months. Today Korean machines are exported to Viet Nam and Korean communities around the world.

The earliest models by Korean manufacturers (Yong Pung Electronics and Tae Hung Electronics), however, had disadvantages compared to the expensive Japanese machines: they had no sub-titles. In other words, the singers had to read the songbook, whereas imported Japanese models had Korean sub-titles. Nevertheless, distributors of equipment succeeded in putting the Korean sub-titles on since it was not a difficult task for the game programmers to add words on a ROM board. Surprised by this innovation which had not been considered by the manufacturers, Yong Pung then created a new model with lyrics on the screen in 1992. From its inception, it seems that the Korean karaoke industry was closely linked with the game industry. At the same time as the Japanese karaoke industry was forced out of Korea due to domestic technology production, Japanese computer game companies like Taito and Sega entered the scene with their sophisticated game technology and computerized sound sources in Japan. They activated the telecom karaoke business. The same IC chip technology is applied for different purposes in the two countries: in Japan it is used for centralized control of franchised karaoke boxes and, in Korea, for cultural independence from Japan. A smooth transition to telecom karaoke in Korea is likely if an ISDN and/or optic fibre network system is constructed.

In spite of its Korean name, *norae bang* is often associated with social evils such as youth delinquency, drug traffic and prostitution. Karaoke symbolizes the 'Four Evils': night, alcohol, women and *Japaneseness*. Just as Western stereotypes see evils as coming from the non-West, in Korea decadence is often attributed to Japan. Under a suspicious gaze, the authorities enacted in June 1992 the *norae bang* law to prohibit entry of minors (under 18) and the serving of alcohol. *Norae bang* is legally differentiated

from bars for singing, *danran ju-jeom* (literally, 'getting joyfully together bar–restaurant'), which are more expensive than *norae bang* and mainly used by after-work businessmen and their friends. The implicit rules governing behaviour in these spaces (microphone turn, applause, interjections by others) are less formalized than in Japan.

As in Japan, Korean housewives get together in *norae bang* in the afternoon and a television competition called *Singing Housewives* started in 1995 and became very popular. Simultaneously, in some department stores in large cities, an Academy for Singing Housewives was established. However, journalists often accuse them of immorality and frivolity (Lee 1996). The daytime female karaoke market has no counterpart in the West so far. As Oku examines in Chapter 3 in this volume, the relationship between women and karaoke in East Asian countries is an intriguing question.

Okinawa: from juke-box to karaoke

Okinawa, the southern archipelago of Japanese territory, has endured a complicated history of double subordination to the Chinese Dynasty of Sin and Japan (Satsuma Han, or the present Kagoshima Prefecture) since the seventeenth century (for more than two centuries, the Okinawan government was forced to pay tax and tribute to both countries). Though in 1879 it was officially 'annexed' to the Great Japanese Empire, the people have rather mixed feelings towards Japan. The American occupation (1945–72) further complicated the Okinawan identity. Okinawan language belongs to the same family as Japanese but is almost incomprehensible to Japanese mainlanders owing to the lexical and phonetic differences. Due to mass media and school education, Japanese is naturally current but many people use Okinawan at home and among themselves as well. Although the majority are 'bilingual', the elderly in remote islands may not speak Japanese.

Okinawan music in turn shares little in common with Japanese music in terms of scale, rhythm, instruments and melodic figure. In our context, however, what is the most relevant feature of Okinawan music culture is the practice of performing folk songs. While in mainland Japan industry-fabricated songs monopolize not only the hit charts but also people's memory, Okinawan culture still has an active practice of part-time song-making and singing. It is the only prefecture in Japan where places called *min'yō sakaba* ('folk song bar') provide the pleasure of live performance by semi-professional singers; where a local instrument like *sanshin*, a three-stringed instrument with snakeskin cover, flourishes among the young in spite of the omnipresence of Japanese pop music; where original 'folk' song contests are held annually; where new songs in folk style are constantly made and some young groups are successfully fusing folk idioms with rock

or reggae; where *kachashi* rhythm, an uptempo beat for the climax of all the festivities, thrives in people's lives. In the karaoke industry, local folk songs are indispensable to Okinawan users. Certainly, this makes a sharp contrast to mainland Japan, where folk songs constitute only a marginal part of the repertoire. Okinawan people like to sing in their own language just as Hong Kong-born people prefer singing in Cantonese to Mandarin.[2]

Part of the American influence in Okinawan music culture was the juke-box. While they were hardly available on the mainland, the nickel-slot machines were installed in every bar, club, grocery shop, barber shop and other place that American soldiers frequented. Towards the end of the 1950s, bars for local people installed second-hand juke-boxes to play 'imported' Japanese songs as well as Okinawan songs recorded and distributed by small local companies. 'Folk song bars' came later in the 1960s. Juke-boxes mark the beginning of the era of reproductive technology in Okinawan folk songs (although the local record companies had begun operating as early as the 1920s on much smaller level).

Towards the end of the 1960s, juke-boxes for local use became too wide-spread to make money from them and their popularity slowly declined. Some began 'exporting' them to Japan. One of the local distributors of juke-boxes, Yoshikatsu Nakao, taught the future owners of a machine how to maintain and repair it. He learned the mechanism of the juke-box through tuning up the much-used machines disposed of by the US Army. His knowledge was therefore more practical than theoretical, thus good for the owners of small bars who could not afford to employ technical staff. When his 'disciples' went to Japan to sell the apparatus, they also transmitted their technical knowledge to the buyers. Without teaching the methods of maintenance and repair, it would have been difficult for them to sell juke-boxes to mainland Japan. Partly because of the Okinawan contribution, Japan experienced an ephemeral 'juke-box boom' around 1970–73. One of the reasons for its short life was the 24-hour cable broadcast system (*yūsen*) intensively established in urban areas during the 1960s. Another reason may be the birth of karaoke in the early 1970s.

Nakao had the idea of incorporating a wireless microphone and tuner in a juke-box, and achieved moderate success. This was before karaoke was industrialized and some coin-slot machine manufacturers were trying to recycle the basic device of the juke-box to make a sing-along machine and they asked Nakao to collaborate with them. He, a man with an adventurous spirit, tried to invent a new type of amusement machine by making use of his technical knowledge of juke-boxes. Later in Okinawa, he met up with the founder of Ōsaka-based Nikkōdō, Kisaburō Takagi. As Ōsaka was and is the most Okinawan-populated city in Japan, Nakao's fame spread around the newly established juke-box industry.[3] Takagi was still struggling to invent a karaoke model suitable for mass manufacture and they worked hard at improving an unsatisfactory Japanese-made apparatus

with an 8-track tape by means of the more developed American juke-box that Nakao was familiar with. Unlike other distributors on the mainland, he doubted the quality of the Japanese machine and tried to create a better 'Americanized' one. His first 'juke–karaoke' machines went on sale in Okinawa around 1976 to be set up in local bars. Not until a local television station broadcast the first karaoke contest in Okinawa (and in Japan) in September 1977 did the majority of Okinawans know what this new way of singing on the mainland was. Its sponsor Nikkōdō virtually monopolized karaoke equipment in Okinawa (c. 80 per cent) for the decade.

Unlike mainland Japan, where karaoke removed live accompaniment from everyday singing, Okinawa continues singing with live performance in 'folk song bars' (although most of them install laser karaoke of local songs, they are rarely used). Other examples are wedding banquets and *eisā* (a summer festival for the spirit of ancestors). Local festivities always end with the lively dance rhythm of *kachashi* performed by *sanshin* and percussion players. The difference from Japan is also found in the brisk production of laser karaoke of Okinawan folk songs compared to that of mainland folk songs. While in Japan, folk songs are mainly transmitted by preservation societies that authenticate the correct words and melodies, or by the official 'family-school' that licenses future masters (see Hughes 1992), Okinawan folk songs are much more flexible and variable. They constitute the everyday life of local people. Although since 1984 Tōei Video (a subsidiary of the large film production company Tōei) has been annually producing video and/or laser discs of twenty-five Okinawan folk songs selected, performed and recorded by local staff and musicians, it is difficult for the staff to decide who records, and which words out of dozens of different variants are to be put in the sub-title. This is something hard to imagine in Japanese folk song production. Some 90 per cent of these discs are sold in Okinawa and the rest in mainland Japan and Okinawan communities in Hawaii, Peru, Bolivia and Brazil. In Okinawa, at least, these laser discs are used only in small bars where the male-dominated clientele sing Okinawan songs as well as Japanese ones. No one would notice any Okinawan features in the karaoke boxes full of teens showing off the latest fashion and singing loudly the latest pop tunes in the urban and resort areas. These old and young singers, however, never use karaoke at weddings and other family and traditional events. How Okinawan people choose to use and not to use the reproductive technology depends upon how they conceive of Okinawan and Japanese music and what the spaces for singing mean to them. The co-existence of Japanese (and American) and Okinawan music has much to do with that of plugged and unplugged forms of singing. By means of singing with or without karaoke and choosing Okinawan or Japanese songs, they articulate the duality of their identity and locality.

Karaoke in an Asian context

Karaoke as cultural technology

Our research has focused upon the local differences in the reception and appropriation of a Japanese-made entertainment machine in five East Asian countries/regions. The differences reflect the pre-existing culture of people's singing and socializing, and the organization of the entertainment industry (music, television, restaurants, sex, and so on). International copyright control (in the cases of Taiwan and Viet Nam), the American occupation (Okinawa) and national antagonism to Japan (Korea) also play important roles in the karaoke scenes in each region. Furthermore, Japanese governance of Taiwan up to 1945 made old people's desire for Japanese songs precede its popularity among the young. The radical change in the economic system in China stimulated new kinds of individualism that is in turn symbolized by such things as karaoke and hamburgers, that is, 'global' commodities born of capitalism. Karaoke at first appealed to the urban upper-middle class in China, as in Hong Kong and Viet Nam. The prosperity of karaoke in restaurants is common in China and Viet Nam.

This contrasts with the other two cases of Taiwan and Okinawa that show more similarity with the history of karaoke in Japan. In both societies, karaoke was at first found in small bars for middle-aged and old men who sang Japanese songs. In Taiwan, the tradition of small-room entertainment seems to have been of importance for karaoke to reach a wider audience, whereas in Okinawa, local people supported the 'juke–karaoke', a symbolic product appropriating the relic of American occupation, without abandoning the unplugged performance. In Korea, the first karaoke bars for local people were set up in small bars, too. In spite of national rivalry, Korean businessmen started to use the equipment in a similar way to their Japanese counterparts. It is partly because of this association with Japaneseness that the Korean authorities tend to frown on karaoke establishments.

In every case in question except for the Okinawan, the karaoke space is apt to be associated with delinquency and prostitution. Almost axiomatically, the introduction of visual karaoke and the karaoke box, no matter how varied they may be from region to region, ignited the boom with the youth participation. The exploding popularity of the karaoke box, although usually regarded as a place for delinquency by the authorities, is brought about by dissociating the young from adult entertainment (old songs, alcohol and/or hostesses). In many countries, karaoke consumption is a key factor in pop production and distribution.

What is at stake is the production of space correlated with a form of technology, the structure of industry and the articulation of singing and listening bodies. It is misleading to think that there exist audiovisual products separate from the space they occupy and the bodies they are addressed to.

Crucial to this idea is the complex intertwining of the production and consumption of products, the spaces and the sound-and-vision effects, that is to say, 'cultural technologies' as Jody Berland defines them. She emphasizes by this concept the mediation between the processes of 'producing texts, producing spaces, producing listeners' (1992: 39). This concept, she continues,

> draws our attention to the ways that pop culture represents a mediation between technologies, economics, spaces, and listeners: or in other words, to the often paradoxical dynamics of contemporary culture as it is technologically articulated with the changing spatiality of social production.
>
> (1992: 39)

The shift of cultural technologies used in the space in Taiwan – from Music TV to Movie TV and Karaoke TV – provides a conspicuous case of the 'mediation between technologies, economics, spaces, and listeners'. The small room itself is an old spatial arrangement for men's entertainment and the installation of a monitor in it, realized by the growing economic power and the development of consumer technology of Taiwan, transformed not only the ways of using the space but also the relationships between sound-and-vision and audience.

Consider, for example, the Taiwanese case and the way technologies transform the private to the public, and reflect on the spatial signification of headphones, speaker and microphone. The experience of viewing VCR tape with headphones is private, and thus structurally different from the use of speakers, a more public event. Whether the viewers receive sound scattered from speakers and shared with co-viewers or addressed exclusively to their ears is a significant difference. Similarly, when a singer's voice is mechanically amplified (with echo) and shared with the anonymous audience, it becomes more 'publicized' than an unamplified singing voice. Speakers can produce, we infer, a more communal feeling in the space than with headphones. Headphones and microphone – these immediate objects attached to the body of the viewer/singer occupy a special position in spatiality because they transmit the final sound the viewers receive or the singers emit. While the former (headphones) enclose the ready-made sound in an extremely private 'head space' (privatization of the public), the latter (the microphone) scatters the individual voice to an open space (publicization of the private). As J. Fornäs remarks in Chapter 6 of this book, the significance of the visual in karaoke lies in the subjective and collective participation in it in order to 'fill the gap' rather than in viewing it from outside as ready-made and the interpretation of it as work established by others. The transition of compartments in Taiwan would need further research with respect to the shift in technology and the construction of subjective experience.

The transition from juke-box to karaoke in the 1970s should not be interpreted in the same way. For the difference between these two sound machines is found not in the meaning of sound-and-vision experience (e.g., the difference between MTV and KTV) but in the theatricalization of space by separating the 'stage' from the 'floor' (although the 'stage' is not always an elevated area physically distinguishable from the 'floor'). The amplified voice of the standing singer is the focus of the karaoke space just as the bodies and voices of actors in the theatre are. Just like 'free-style' rapping, however, all the listeners can in turn pick up a microphone and make their own 'spectacle'. This 'egalitarian' feature of 'participatory consumption' characteristic of karaoke behaviour is echoed in the video game centre in Pusan. Individual players of various electronic games take turns instead to be engaged in the transitory but communal relationship between singers and audience. The interaction between these occupants–participants is certainly born out of the pervasiveness of amplified sound and the act of singing to the listeners. How cultural technologies such as karaoke transform the spatial arrangement is clear-cut in these cases.

Cultural technologies produce not only the content of precedent media as McLuhan formulated but also 'material practices with their own structural effects and tensions' (Berland 1992: 45). In other words, no cultural products exist *per se*, isolated from the 'structural effects and tensions' specific to the 'material practices' in particular socio-political and economic settings. These effects and tensions include gender relationships, family formation, spatial arrangements, racial/ethnic segregation, the commodity economy, and so on. The concept of 'material practice' in Berland's quote may designate more properly the agent's intervention with cultural technologies than that of 'use': when we 'use' specific products, we are forced to appropriate ourselves to the *mode of operation* intrinsic to the materiality of them (see de Certeau 1980: 75–82). This does not mean, however, a deterministic view of technology. On the contrary, we would insist, 'material practices' (singing with pre-recorded sound, for example) vary depending on the localities, ethnicities and subjectivities involved. New cultural technologies raise questions 'addressed specifically to their place in the technological proliferation, cumulative privatization, and spatial expansion of global capitalization' (Berland 1992: 47). Our comparative study addressed these questions and we now turn to the question of the 'modernization' of East Asia emphasizing the three problematics mentioned here – proliferating technology, private space and increasing capitalization.

Modernization, Japanization and Asianization

In all the cases we have dealt with, karaoke is regarded as something related to modernity and Japan, an Asian country that can allegedly say

'No' to the West. The Japanese 'No' (Ishihara 1991) is followed up by *The Asia That Can Say No* by the Malaysian Prime Minister Mohama Mahathir (1994) and by *The China That Can Say No* by Chinese journalists (Zhang 1996). These authors generally emphasize the economic independence of 'Japan', 'Asia' and 'China' respectively from the Western system and argue for the establishment of a third economic bloc after North America and the European Union, centred in East Asia. Their common scenario is roughly as follows: if Japan's advanced technology (or Asia's or China's advancing technology) and the huge market of workers and consumers in the most populated area on our planet co-operate with one another, then Japan (Asia, China) may be able to threaten (or finally end) the Western (more precisely, American) domination of the twentieth century.

Coincidentally, Japan, Malaysia and China (and their nearby countries) all have thriving karaoke scenes and the local people *in grosso modo* take karaoke more seriously than people in the West. Of course we do not claim that karaoke and economic growth in East Asia are causally related. Instead, we will pursue the triangular connection between Japan, the West and 'East Asia' (excluding Japan) with respect to the phenomenon of 'global karaoke'. Japan is ambiguous in the sense that it is geographically situated on the fringes of East Asia and has much more biological, historical and cultural affinity with Asia than with the West, but at the same time in terms of the economy it is closer to and much more competitive with the West than East Asia. The triangle we are dealing with has much to do with the triple interconnected processes of Japanization, modernization and Asianization.

To begin with, we fly to Lhasa, Tibet, with an American anthropologist to see how karaoke bars are operated under the repressive Chinese politics against Tibet and under the disinterested gaze of Western tourists. According to Vincanne Adams, in spite of the desire of Western visitors to keep Tibet Tibetan (more generally, to keep Tibetan religiously and exotically authentic), the local people who can afford to spend a certain amount of money on dancing, drinking and singing are fond of going to karaoke, where Chinese songs are predominant and sometimes MC Hammer clones are dancing. It symbolizes the modernizing façade for the Chinese government, and at the same time the Western contamination for tourists. Adams thinks that 'karaoke may in fact be an indicator of how important it is to not efface modernity but to acquire, participate in, and benefit from modernity' in Lhasa and 'to do so, for some Tibetans, can mean eroding the boundaries between Chinese, Tibetan, and Western that are used to define *difference*' (1996: 537). Therefore Tibetan karaoke singers can become, even if for only three minutes, Western and Chinese simultaneously 'while still remaining Tibetan and modern' (ibid.: 538). Karaoke accomplishes this because fundamentally it produces simulacra.

It is likely that the karaoke equipment in Lhasa is mostly imported from Japan via Beijing or Shanghai by Chinese proprietors. We presume so because in China, as noted above, karaoke machines are almost always Japanese-made. Furthermore, karaoke is affectively as well as economically associated with 'modernity' after the introduction of the free-market system. However, the Japaneseness of the technology does not figure in Tibetan karaoke and is thus combined with the modernity, at least in Adams' interpretation. This erasure of origin interests us when we ask why Japan massively exports hardware while hardly selling any of its cultural products except animated films and computer games. The dissemination of karaoke apparatus abroad does not mean disseminating Japanese popular songs.

As far as karaoke is cultural technology, it is irrelevant to conceive it as the product itself and we have to examine the 'structural effects and tensions' (Berland) intrinsic to it. In this context, Koichi Iwabuchi, in his work on Japanese technology and mass media in the Asian audiovisual market, remarks that 'what Japanese cultural industries try to export are not products *per se*, but items of urban middle-class culture constructed through an *indigenization of "the West"*' (1995: 95, our emphasis).

It is precisely the 'urban middle class' that constitutes the karaoke main stage in East Asia. Unlike other consumer technologies such as cassette tapes and television, karaoke apparatus has hardly penetrated the rural and/or underprivileged life in Asia. Theories concerning modernization of the formerly colonized countries generally claim that the economic and social growth of the 'middle class' can indicate proximity to the hegemonic countries, although the definition of 'middle class' may vary from one author to another. The rising middle class can consume new cultural products for their private pleasure and as status symbols and thus stimulate the national commodity economy. Different from the consumption by the upper class, whose economic effect is usually seen only in limited sectors of the country, the middle class can bring about the amplification (or emergence) of domestic markets and thus reinforce domestic capitalization.

In East Asia as well as in Europe and North America, it is with video or laser karaoke that the boom exploded (with the exception of Taiwan and Okinawa). It was generally oriented to the urban middle class. They may not know that the first decade of karaoke had no visuals. Karaoke is not only a sing-along machine but also a variation of image consumption for Asian (and Western) people. Not coincidentally, the middle class in various countries accepted karaoke when home video viewing was becoming more popular to them. The 'hi-tech' image of karaoke equipment is as crucial for its middle-class consumption as the evocation of a desire to sing in front of an audience, though the technology applied to karaoke is itself no more 'hi-tech' than other audiovisual technology such as video, laser disc and stereo. The technological image of karaoke may result from

its contrast with pre-existent forms of non-professional singing. Unlike television and cassette tapes, cultural technologies that deeply penetrate mass music consumption in Asia and other areas (see Manuel 1993; Wong 1995; El-Shawan Castelo-Branco 1987; Sutton 1985), karaoke cannot for the moment receive *nationwide* support in East Asia except for Japan, Korea and Taiwan, and it remains an urban middle-class leisure activity (in Viet Nam and China, for example). Although in Japan karaoke has almost wiped out singing without pre-recorded sound, in East Asia, 'unplugged' singing still co-exists and continues to thrive among the rural, the destitute and/or the older strata of society. We may infer that the nationwide diffusion of karaoke in Japan is related to the predominance of 'middle-class' consciousness.[4]

Re-made in Asia

Now we turn to the (non-)Japaneseness of karaoke. None of the basic parts of the karaoke apparatus – microphone, magnetic tape, video, laser disc, PA system – is a Japanese invention: what Japan created is a new combination and style of use in a certain spatial setting. In this, it resembles the Walkman whose uniqueness is clearer in its outdoor use of headphones than in its mechanism itself (Hosokawa 1984). Street use of headphones was possible before the ground-breaking release of Sony's Walkman in 1979. But nobody thought to do so because street walking and listening were conceived as two different acts. What Sony created was the desire and imagination *par excellence*: a new gadget that merged walking and listening into one simultaneous act.

This discussion relates to the case of karaoke. The two 'Japanese-made' cultural technologies create the playful theatricality in music consumption as well as bringing about the instant transformation of private/public spatiality. They are more intimately linked with Japaneseness than other technological products such as video decks and televisions not only because of the semi-monopolization by Japanese manufacturers but also because it is a particular mode of material practice. Both karaoke and Walkmans doubtless use Western technology, however, far from the realm of Western desire and imagination. These inventions and the image evoked by their use in public space are certainly modern but not necessarily Western. They were, at least to the first Western beholders, alien, bizarre and 'Japanese'. They did not represent striking technological progress one might envy (e.g. digital movies, giant video monitors, streamlined automobiles) but material practices twisted, material practices originating from the 'Orient'. In the domain of audiovisual consumption, they show that modernization is not always related to some forms of Westernization but sometimes to Japanization.

Like the Walkman, karaoke embodies both Japaneseness and modernity. They are 'transcending and displacing western modernity' as Japan

asserts itself (Morley and Robins 1992: 153). This connotation, however, depends on the local images of Japan and modernity. For example in Korea, a country whose nationalism is founded on the difference from its neighbouring colonizer, Japaneseness is downplayed or even erased by renaming it in the local language and manufacturing it domestically. In Tibet, a country which has little cultural connection with Japan, the image of modernity is put to the fore.

The integration of Japaneseness and modernity is certainly tied up with the 'indigenisation of "the West"' characteristic of Japanese consumer technologies. Iwabuchi notes,

> I would argue that if there is anything attractive for Asians about Japanese culture, it would be precisely its habit of hyperactive indi-genisation and domestication of 'the West', which makes modern Japanese culture scandalous to and subversive of 'the West'. In other words, I suggest that it is the *process* of indigenisation rather than the product *per se* that captures the attention of Asian people . . . [W]hat Asian audiences are consuming is no longer 'the West' or 'a Westernised Asia', but an 'indigenised (Asianised) West'; they are fascinated neither by 'originality' nor by 'tradition', but are actively constructing their own images and meanings at the receiving end.
>
> (1995: 103)

To sum up, Japanese consumer technologies are trying to promulgate in Asia neither a 'Western way of life' nor a 'Japanese way of life' but a Japanized version of the 'American way of life' (see Tobin 1992), that is more simply 'Japanese middle-class material life'. This is in turn domes-ticated by Asian people and becomes, for example, a Malaysian version of a Japanized American way of life mixed with a Malaysianized American way of life imported by Chinese-Malaysian American repatriates. This situation of double domestication is typically found in karaoke bars in Kuala Lumpur (or in Hong Kong or Bangkok, if you like) where they sing not only locally made melodies but also many Japanese pop songs in one of the local languages, and some American and British oldies in English.

Karaoke and 'Asian' pop

Asian pop songs[5] are unambiguous examples of the double indigenization of Japan and the West by local musicians. Many Japanese Top 10 tunes that usually consist of Western-borrowed sound are today covered in Cantonese and Taiwanese, and, with more luck, in Mandarin, Vietnamese, Thai, Burmese, Indonesian, Malay, and so on. They may in turn inspire local composers and arrangers. Not only the songs but also the formation

of Japanese pop groups such as five handsome boys, three cute girls, or one female lead singer with four male backing vocalists–instrumentalists are sooner or later followed up in East Asia. Some Japanese singers make extensive promotional tours in China, whereas a Filipino singer's debut in Japan was publicized all over East Asia with the expectation of the positive effect of earning a reputation in Tokyo. The above-mentioned karaoke talent-search in China organized by Hori Production shows the new direction of Japanese show-biz to Asia in the 1990s.

Synchronized with the expansion of the Asian karaoke scene towards the end of 1980s, Asian pop became known to some Japanese listeners at least inasmuch as there are currently two specialized monthly magazines, *Pop Asia* and *Asian Pops Magazine*, in Japan. Large CD retailers in Tokyo have as much space for Asian pop as for the rest of 'world music'. We do not intend to causally relate the formation of the Asian karaoke scene with the increasing interest in Asian pop in Japan, and in Japanese pop in East Asia. Instead, these two phenomena are, we suppose, triggered by the intensified cultural intercourse inside Asia through telecommunications, satellite TV, film, tourism, and so on. It is economic growth and political links in East Asia that encourage musical communication. The pan-Asian popularity of Japanese pop songs may in part be due to their karaoke play. Certainly, they are translated into local languages and interpreted by local singers. In this sense, to call the phenomenon simply the 'Japanese invasion' misses the point. If the Hong Kong-based STAR TV broadcasts those songs, for example, in Cantonese or Mandarin from above, karaoke bars and boxes on each corner follow it up from below. Japanese karaoke software manufacturers are trying to establish their local subsidiaries in the capitals of Asian countries in order to enhance copyright control and probably hoping for taste standardization as well.

It is important to note that the exportation of karaoke to East Asia has been accompanied by the increasing concern of JASRAC (the Japanese Society for the Rights of Authors, Composers, and Publishers) over illegal covers of Japanese songs and piracy in Asia. In the end, Asia is the marketplace for Japanese record labels and was discovered as a potential source for royalties for Japanese authors, composers and publishers. It is because of pressure from Japanese record companies that JASRAC strives to raise copyright consciousness in East Asia. On the other hand, JASRAC is criticized for rental CD shops, and the unauthorized re-release and re-compilation of Western artists (e.g. Paul McCartney) by the Western copyright society. This double-edged situation may reflect the *ambiguous* (in terms of Kenzaburō Ōe, the Nobel Prize-winning novelist) position of Japan *vis-à-vis* Asia and the West.

Conclusion

As discussed above, Japan geographically belongs to East Asia but in terms of economy and politics, it is much closer to the West. This ambiguity makes karaoke – or by extension, mass culture in general – in East Asia more complicated than that in the West because it obliges us to reflect not upon two binary relationships (Japan–West, Japan–East Asia) but upon the triple one between the West, Japan and East Asia. The dynamic at work in this triangle is itself a sub-process of what is now called globalization. If we call the globalization within the region *Asianization*, karaoke is 'Asianizing' Asian popular music by way of Japanese intervention in music production, distribution and consumption.

It should be noted that *Asianization* has two dimensions: indigenization of foreign cultures and Pan-Asianization of indigenous cultures. For example, the former is related to the domestication of Japanese-made products like the karaoke machine in each region. The latter is concerned with the rising middle class and their non-Western non-national awareness through transnational technologies such as satellite TV. This Pan-Asian enterprise is often led by the official institutions like broadcasting stations and record companies. Since the mid-1980s, Pan-Asian song festivals have been held in various countries in the area. Their form is more or less akin to that of the Eurovision Song Contest: one singer (or group) represents one nation and the jury elect the best Asian song and artist of the year under a slogan like 'Asia is one'. The artists are usually middle-of-the-road with little local flavour except for their language. The organizers expect the artists to receive Pan-Asian applause. Another example is given by the Asian karaoke contest organized by Pioneer in seven Asian countries. This suggests that the Japanese music industry is trying to create an 'Asian' market under its control.

Unlike the West where Japanese influence is usually limited to audio-visual technology and transnational capitalization, East Asia, in addition to these two factors, receives and appropriates Japanese popular music as well. For example, Japan sells technological products to the West but not Japanese music, just as the purchase of Columbia Pictures and MCA-Universal by Sony and Matsushita respectively will never mean that Hollywood will make samurai movies.

In East Asia, the situation is not the same. Karaoke is an indispensable tool for Asianizing popular music in East Asia because it is basically targeted at the urban middle class, the most influential sector for 'hi-tech'-related consumer culture in the country. Asianization for that class throughout East Asia inevitably implies modernization but results in Japanization since it is this 'economic leader of Asia' who demonstrates to East Asia more effectively than any other country how one 'Far Eastern' state can be economically competitive with the United States and Europe

while domesticating the overwhelming material culture originated in the West. Karaoke in East Asia empowers the triple process of modernization, Japanization and Asianization of East Asia.

As suggested earlier, however, this does not mean that Asian music cultures are homogenized by the loud singing voice from the speakers. It is true that karaoke by necessity institutionalizes non-professional performance in front of bar or box audiences through pre-recorded sound, cheap images and amplified voice; it does not erase the local differences in which the material practice of singing are embedded.

Notes

1 This chapter is based on Ōtake's fieldwork conducted between 1994 and 1996 (Ōtake 1997) and our subsequent discussion thereupon.
2 This does not always mean the impenetrability of Japanese songs in the archipelago. The Okinawans are conscious of the distinction between Okinawan and Japanese songs. Young people, for example, sing Japanese pop tunes in karaoke boxes as their Tokyo counterparts do, but not in the family and local festivities. Thus, they articulate their double identity.
3 Not coincidentally, the first Okinawan-run record label, Marufuku, began operating in Ōsaka in 1927. This label, the most powerful distribution medium for Okinawan music, is still operating in Koza, Okinawa.
4 Some 90 per cent of the Japanese nation identify themselves as 'middle class' and the economic discrepancy between the affordable and the unaffordable is smaller than in many other countries.
5 There exists no 'Asian' pop but various forms of pop music in Asia. Because of linguistic variety and ethnic diversity, it is unlikely to create pop music that can appeal to the whole nations in the area. The only *lingua franca* in pop music in East Asia may be English, a global but foreign language for everyone. Just like TV programmes, songs in a foreign language may appeal only to a limited sector of the people. Whether the lyrics are poetic or banal, the sound of familiar words is indispensable for nationwide popularity.

References

Adams, Vincanne (1996) 'Karaoke as modern Lhasa, Tibet: western encounters with cultural politics', *Cultural Anthropology*, vol. 11, no. 4, pp. 510–46.
Berland, Jody (1992) 'Angels dancing: cultural technologies and the production of space', *Cultural Studies*, vol. 6, no. 1, pp. 38–55.
de Certeau, Michel (1980) *L'invention du quotidien*, Paris: UGE.
El-Shawan Castelo-Branco, Salwa (1987) 'Some aspects of the cassette industry in Egypt', *World of Music*, vol. 29, vol. 2, pp. 32–45.
Hosokawa, Shūhei (1984) 'The Walkman effect', *Popular Music*, vol. 4, pp. 165–80.
Hughes, David. G. (1992) '"Esashi Oiwake" and the beginnings of modern Japanese folk song', *World of Music*, vol. 34, no. 1, pp. 35–56.
Ishihara, Shintaro (1991) *The Japan That Can Say No: Why Japan Will Be First Among Equals*, New York: Simon and Schuster.
Iwabuchi, Koichi (1995) 'Return to Asia? Japan in the global audiovisual market', *Media International Australia*, no. 77, pp. 94–106.

Lee, Jang-Jik (1996) 'Karaoke in Korea', paper presented at the Asia Forum in Ishikawa, Kanazawa, Japan, August 1996.

Lent, John A. (ed.) (1995) *Asian Popular Culture*, Boulder, CO: Westview Press.

Lum, Casey Man Kong (1996) *In Search of a Voice: Karaoke and the Construction of Identity in Chinese America*, Mahwah, NJ: Lawrence Erlbaum.

Mahathir, Mohama (1994) *Nō to Ieru Ajia* [The Asia That Can Say No], Tokyo: Kōbunsha.

Manuel, Peter (1993) *Cassette Culture: Popular Music and Technology in North India*, Chicago and London: University of Chicago Press.

Morley, David and Robins, Kevin (1992) 'Techno-orientalism: futures, foreigners and phobias', *New Formation*, no. 16, pp. 136–56.

Ōtake, Akiko (1997) *Karaoke Umi o Wataru* [Karaoke crosses over the sea], Tokyo: Chikuma Shobō.

Shirahata, Yozaburō (1996) *Karaoke Anime ga Sekai o Meguru* [Karaoke and Animation Go Around the World], Kyoto: PHP Institute.

Sutton, R. Anderson (1985) 'Commercial cassette recordings of traditional music in Java: implications for performers and scholars', *World of Music*, vol. 27, no.3, pp. 23–45.

Suzuki, Masaru (1996) 'Karaoke Angya ni Yoru Chūgoku Toshi Gaido' [A guide to Chinese cities through a karaoke tour], *Chūō Kōron*, May, pp. 216–27.

Tobin, Joseph J. (ed.) (1992) *Re-Made in Japan: Everyday Life and Consumer Taste in a Changing Society*, New Haven and London: Yale University Press.

Wong, Deborah (1995) 'Thai cassettes and their covers: two case histories', in John Lent (ed.) *Asian Popular Culture*, Boulder, CO: Westview Press, pp. 43–60.

Zhang, Xiao Bo (ed.) (1996) *Nō to Ieru Chūgoku* [The China That Can Say No], Tokyo: Nihon Keizai Shinbunsha.

INDEX